THE POWER
OF THE CENTER

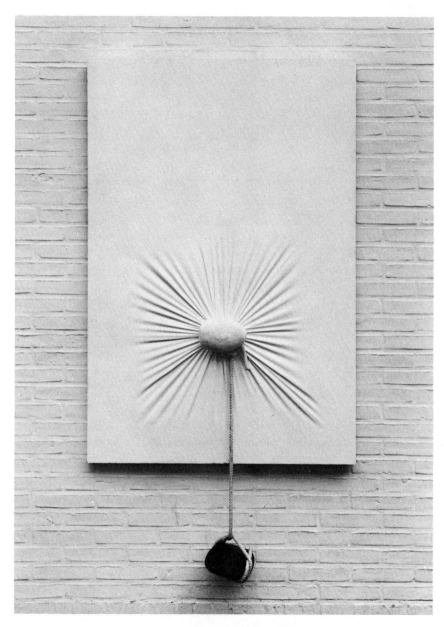

Nobuo Sekine, Phases of Nothingness. 1971.
Louisiana Museum, Humbleback, Denmark.

THE POWER
OF THE CENTER

A STUDY OF COMPOSITION
IN THE VISUAL ARTS

RUDOLF ARNHEIM

UNIVERSITY OF CALIFORNIA PRESS

BERKELEY · LOS ANGELES · LONDON

University of California Press
Berkeley and Los Angeles, California
University of California Press, Ltd.
London, England
© 1982 by
The Regents of the University of California

Library of Congress Cataloging in Publication Data
Arnheim, Rudolf.
 The power of the center.
 Bibliography: p.
 Includes index.
 1. Composition (Art) I. Title.
N7430.A69 1982 701'.8 81–10332
ISBN 0–520–04426–6

Printed in the United States of America

1 2 3 4 5 6 7 8 9

CONTENTS

Introduction vii

I. WHAT IS A CENTER? 1

The Center and the Middle, 1. Around the Balancing Center, 5. In the
Third Dimension, 7.

II. THE STRONGEST CENTER AND ITS RIVALS 10

The Pull of Gravity, 10. The Viewer as a Dynamic Center, 12. Looking Up
and Looking Down, 16. Weight Produces Centers, 21. Applications to
Sculpture, 28. Applications to Painting, 36.

III. LIMITS AND FRAMES 42

Comprehension Requires Boundaries, 42. Once More, the Viewer, 49.
The Frame and the Outer World, 51. The Frame and the Inner World, 54.
Various Formats, 60. The Limits of Sculpture, 62. Competition for the
Balancing Center, 63.

IV. THE ACCENT ON THE MIDDLE 71

The Center Contributes Stability, 72. Playing Around the Center, 78.
Dividing in Two, 87.

V. THE INVISIBLE PIVOT 92

The Shapes Create the Hub, 92. Upright Compositions, 99.
Horizontal Compositions, 102. Diagonals Support and Divide, 106.
Noli Me Tangere, 112.

VI. TONDO AND SQUARE 115

Floating Shapes, 115. Responses to the Round Frame, 119. The Tondo
Stresses the Middle, 122. Disks and Spheres, 130. The Oval, 135.
Character Traits of the Square, 139. Albers and Mondrian, 145.
A Square by Munch, 151.

VII. VOLUMES AND NODES 153

Vectors Control Meaning, 154. Kinds of Nodes, 155. The Human
Figure, 159. Faces and Hands, 162. Hands in Context, 167.
Singing Man, 169.

VIII. MORE IN DEPTH 172

Objects Behaving in Space, 172. The Added View of Projection, 181.
The Charting of the Vista, 185. Looking into Odd Spaces, 194. The Two
Interpretations, 198. The Basic Compositional Systems Once More, 207.

IX. PERSISTENCE IN TIME 209

Glossary 215

Bibliography 221

Acknowledgments 224

Index 225

INTRODUCTION

This book derives from a single idea, namely that our view of the world is based on the interaction of two spatial systems. One of these systems may be called cosmic, the other parochial.

Cosmically we find that matter organizes around centers, which are often marked by a dominant mass. Such systems come about wherever their neighbors allow them sufficient freedom. In the vastness of astronomical space the rotating galaxies and the smaller solar or planetary systems are free to create such centric patterns, and in the microscopic realm so are the atoms with their electrons circling around a nucleus. Even in the crowded world of our direct experience, inorganic and organic matter occasionally has enough freedom to follow its inclination and form symmetrical structures—flowers, snowflakes, floating and flying creatures, mammalian bodies—shaped around a central point, a central axis, or at least a central plane. The human mind also invents centric shapes, and our bodies perform centric dances unless this basic tendency is modified by particular impulses and attractions.

The earth with what it carries is such a concentric spatial system, as we are reminded by Paul Klee, who had a gift for visualizing the fundamentals of nature in images of sweeping simplicity. In the diagram I have used for Figure 1, he presents a cosmic model of our planet with the forces of gravity converging radially toward the center. Our bodies, too, conform to this radial centricity. No two persons standing next to each other, no two buildings, are strictly parallel in their verticals.

But that is not the world we see when it surrounds us. In the parochial view of its small inhabitants, the curvature of the earth straightens into a plane surface, and the converging radii become parallels. Here again Paul Klee helps us (Figure 2). He shows that our view of the world is not merely a distortion of reality. It is a view that has an order of its own, the simplest and most perfect order the mind could seek. Parallelism and right-angled relation yield the most

convenient framework available for spatial organization, and we cannot be grateful enough for living in a world that, for practical purposes, can be laid out along a grid of verticals and horizontals. Imagine the complications if Descartes had had to build his basic analytical geometry on a framework of converging radii; and recall that it took an Einstein before we could cope with a universe that does not conform to a Cartesian grid.

The Cartesian grid is the second of the two spatial systems to which I referred. It is helpful not only for mathematical calculation but for visual orientation as well. Manmade things are not laid out according to vertical and horizontal coordinates just for the convenience of carpenters, builders, and engineers. The right angles of our living spaces, of chests and sheets, afford a visual order that helps make our lives simpler than they would be, say, in a primordial forest. And for the sake of order the Cartesian grid also remains present, actually or implicitly, in our works of art.

With all its virtues, the framework of verticals and horizontals has one grave defect. It has no center, and therefore it has no way of defining any particular location. Taken by itself, it is an endless expanse in which no one place can be distinguished from the next. This renders it incomplete for any mathematical, scientific, or artistic purpose. For his geometrical analysis, Descartes had to

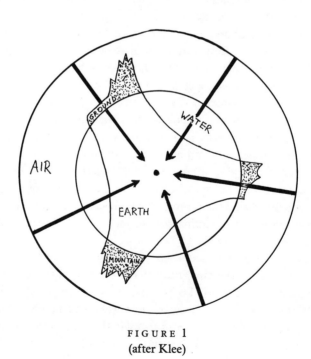

FIGURE 1
(after Klee)

FIGURE 2.
Paul Klee, drawing from *Unendliche Naturgeschichte*, p. 33

impose a center, the point where a pair of coordinates crossed. In doing so he
borrowed from the other spatial system, the centric and cosmic one.

A concentric system is, by definition, organized around a center. The cosmic
onion can be described as endlessly expanding in the outward-bound direction
but coming to a final stop inwardly. That central point allows for orientation.
In contrast to the homogeneity of the right-angled grid, the concentric system
defines each layer by its distance from the middle. It creates a hierarchy.

The concentric system deploys itself around a fixed point. That reference is
indispensable for any spatial statement we wish to make. But the concentric
system rarely suffices to organize what we say and make because, as I have
noted, our living space conforms to the Cartesian grid. We must combine the
two systems (Figure 3). Together they serve our needs perfectly. The centric
system supplies the midpoint, the reference point for every distance and the

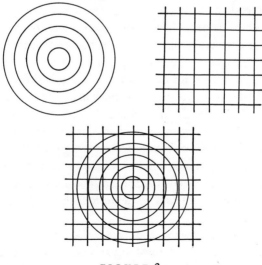

FIGURE 3

crossing for the grid's central vertical and horizontal. And the grid system supplies the dimensions of up and down and of left and right, indispensable for any description of human experience under the dominion of gravity.

Perfectly spherical structures are rare in terrestrial existence, and they are also rare in works of art, which depict that existence. But just as almost every organic and inorganic object is shaped around a center, centricity is an indispensable structural property of any composition in the visual arts. The interaction between the two spatial systems generates formally the complexity of shape, color, and movement that our visual sense cherishes; and it represents symbolically the relation between the cosmic perfection of which any thing or creature possesses a little and the struggle between downward pull and upward striving that marks the drama of our earthly behavior.

The range of these considerations gave me confidence that I had found a key to spatial organization in the arts. And the wealth of revelation that good paintings, sculptures, and works of architecture yielded readily when the key was applied strengthened my conviction. The purpose of this book is to test the approach on professionals and experts, artists and theorists, and especially the general reader.

In a sense I am taking off where my earlier book *Art and Visual Perception* ended. At times I shall have to refer to matters that are more explicitly treated in that earlier book. But whereas in that more elementary study I could draw on experimental findings in the psychology of perception, the perceptual phenomena I will discuss here go beyond what has been tried out in laboratories. This lack of experimental evidence may make this book seem less scientific than the earlier one and the facts less trustworthy, but for the time being that cannot be helped. Confirmation and correction will turn up in due course. Meanwhile we can remind ourselves that in the sciences, ideas are necessarily the first response to the challenging puzzles we encounter.

I do apologize, however, for once again failing to write *more geometrico*, as Spinoza called it, that is, to present my subject in the systematic order to which treatises and textbooks so rightly adhere. I know that many more readers would go away with tidy concepts and handy facts if I standardized my terms, underlined my definitions, and numbered my categories. It is, *hélas*, not in my nature. Once again I must ask well-intentioned readers to watch the flow of observations move past them and reach for a good-looking catch now and then. I have, however, added a glossary of definitions that will isolate and sharpen the principal concepts.

The subject of visual composition concerns me because I believe that perceptual form is the strongest, most indispensable means of communicating through works of art. Why should form exist, were it not for making a content

readable? This book undertakes to describe principles by which the shapes of painting, sculpture, and architecture are organized, but only to show that in each case the visible pattern represents a symbolic statement about the human condition. In this sense, it is a book of interpretations—though not interpretation in the sense of iconographic detective work. My point of departure is not the subject matter, although subject matter, wherever it is offered, must be considered with care. Nor am I trying to discover circles, rectangles, or diagonals by which to reduce intuitively invented form to a blandly pleasing geometry. My work is based on the assumption that the most powerful conveyor of meaning is the immediate impact of perceptual form. And it is this impact that distinguishes art from other kinds of communication.

Because of this preeminent concern with the immediacy of visual expression, I have resisted the temptation to explore the profound connotations of "center" as a philosophical, mystical, and social concept. These deeper meanings are undoubtedly relevant to the full interpretation of the works of art I am discussing. Even so, I decided to carry the quest for significance no further than the direct evidence accessible to my eyes would let me. I deal with symbols only to the extent that shape, color, and motion convey them by their appearance, in the conviction that the directly readable meanings of high and low, central and peripheral, light and dark, and so on, are the key to all artistically relevant interpretation.[1]

More photographic reproductions have proved necessary for the present book than for my earlier publications because much of what I say concerns a given work as a whole. But when I wanted to refer only to a particular feature, I made outline tracings. The selection of examples is inevitably somewhat arbitrary. I have used as illustrations works that happened to strike me as characteristic of the phenomenon under discussion. More could be added; better ones might be found.

A technical matter of diction requires mention here, namely my unwillingness to supplement masculine pronouns with feminine ones. Various devices for coping with the problem have been tried elsewhere with embarrassing results, for the reason that they violate the law of parsimony, omnipotent in science and art. Any statement becomes unreadable when it contains differentiations not relevant to the proposition. No writer would say, "He bites the left or right hand that feeds him." Now that the masculine pronouns, which have always been "unmarked," as the linguists say, are in the process of becoming marked, we can expect our language to supply us soon with terms that

1. For a recent detailed survey on the symbolism of circular shapes, see Maryvonne Perrot, *Le Symbolisme de la Roue* (Paris: Les Editions Philosophiques, 1980).

embrace both genders equally. In the meantime an author who would not know how to discriminate against women should be permitted to obey the demands of his trade.

Among the beneficial influences I wish to acknowledge is that of the hospitality offered me by the Department of Art History at the University of Michigan in Ann Arbor. Since my retirement from Harvard, my friends at Tappan Hall have permitted a mere psychologist to work and teach in their midst. The expertise of teachers and students and the freshness of their observations have helped me immensely. Once again my wife, Mary, has done me the service of typing the handwritten manuscript, and once again Muriel Bell, my editor, has turned the typescript into something more readable. My thanks to them all!

WHAT IS A CENTER?

A FIRST THOUGHT might suggest that a center is always in the middle. Center and middle may even seem to be the same thing. But only in geometry is this always true. The center and the middle of a circle, a sphere, or any other regular figure are in fact the same thing. This is so because geometry deals with the static aspects of things—their size, their location, their orientation in space, or their distance from one another. Therefore in geometrical space, centricity can be defined by location alone.

But even in geometry the center is not simply one point among others. It is the most important point of every regular figure, the key to its shape and sometimes to its construction. Even if someone blindly produces, say, a pentagon by connecting five equally long lines, one after the other, with angles of 108°, there will be a sudden structural transfiguration when the ends meet. The pentagon emerges, and with it the center as its key point.

THE CENTER AND THE MIDDLE

The center may be present without being explicitly given. For a circle, the center is indicated geometrically as the point where the diameters cross. But distances, connections, and locations by and in themselves are invisible; they are made visible only through objects. They can give a center perceptual or intellectual definition by inference and construction, but they cannot make it directly visible. It takes dots, or lines, or other suitable shapes to do that.

A center can be determined geometrically, mechanically, or intuitively. Geometry uses ruler and compass as tools of intellectual construction. Mechanically one can determine the center of an object by weight. For example, one can make a flat figure out of cardboard or plywood and suspend it first by one and then by another point near its contour. The place where verticals dropped from the points of suspension cross is the center of gravity (Figure 4).

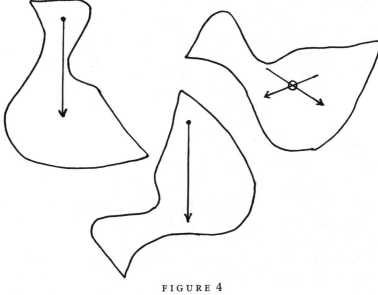

FIGURE 4
From Arnheim (4), p. 13

One can obtain the same result by balancing a flat object on the tip of a finger.

When we use this latter method, we are likely to proceed intuitively, sensing the distribution of weight and figuring out which way to move the point of support in order to achieve equilibrium. Intuitive judgment enables us to distinguish right from wrong through the pushes and pulls we experience in a perceptual medium. Intuition can be used kinesthetically, as in the example just given, but also visually. Visually experienced pushes and pulls guide us when we determine the center of a circle just by looking at it.

Geometrically, only regular figures have centers. But any free form reveals its physical center when it is balanced. How nearly the physical center of gravity coincides with the visual center of an object could be determined experimentally. The two are likely to be close.

I began by saying that only in geometry is a center always in the middle, for the reason that in geometry a center is defined by location alone. In the present book, location will usually be considered a mere consequence of a more general property. When we speak of a center we shall mean mostly the center of a field of forces, a focus from which forces issue and toward which forces converge. Since every dynamic center has the tendency to distribute the forces of its field symmetrically around itself, its location will often coincide with that of the geometrical middle. The geometrical center of a regular polygon will coincide with the dynamic center as long as the figure is empty and not sub-

ject to external influences. But, as we shall see, any visual object at all consti-
tutes a center of forces, and of course it can be located anywhere in visual space.
The interplay between various visual objects as centers of forces is the ba-
sis of composition.

The double meaning of the word "center" will give us a good deal of trouble
throughout this book. Mostly I shall use the term in the dynamic sense just
defined. But sometime I shall have to refer to central location in the geomet-
rical sense of the middle, and it will take some effort on the part of author and
readers to avoid confusion.

Geometrical statements are constructions derived from measurable dis-
tances, ratios, and directions in space. Intuitive statements, on the other hand,
are based on the behavior of visual forces. These forces are the constituents of
every visual experience. They are as inseparable an aspect of what we see as
shape and color. It is convenient to consider them the perceptual reflections of
configurations of forces operating in the nervous system, specifically in those
areas of the cerebral cortex on which optical stimuli are projected. The exact
nature of those physiological processes has yet to be clarified. Fortunately they
need not concern us here.[1] For our purpose it will suffice to acknowledge the
existence of perceptual forces and to study their behavior, their properties,
their influences on the objects of our interest.

In geometry, I said, a center may be determined without being made
explicitly visible. The same is true for configurations organized and held
together by intuitive judgment. The center of a circle can be visually present
without being marked explicitly by, say, a black dot. The black dot would give
the center "retinal presence." This means that it would be represented in the
physiological pattern of retinal stimulation created by a corresponding pattern
in the physical world. A black dot in the center of a circle drawn in ink on a
piece of paper will be registered in the retinal projection of any healthy eye
focused upon that paper. Such a registration, in turn, is the physiological
precondition for the dot's being perceived as a part of the line figure. This is
what we mean when we say that the black dot is "really there," as distinguished
from the center introduced into the visual image indirectly, by induction.

Induction is the perceptual process that enables features to appear in a visual
image without their having retinal presence. Intuitive induction makes the
center of a circle a genuine part of its structure even when it is not "there." An
induction is generated by the perceived structure wherever that structure is
incomplete; it arises from the tendency of every structure to complete itself.
The efficiency of the induction depends on the strength with which the

1. For a more explicit discussion of perceptual forces see Arnheim (4), pp. 16ff. and chapter 9,
on dynamics. (Numbers in parentheses refer to titles in the Bibliography, pp. 221-23 below.)

retinally present part of the structure presses toward completion. When the structure is strong and the retinal counterevidence weak, induced shapes may become actually visible. For example, when a circle with a gap in it is shown in dim light or for a fraction of a second, viewers may see a complete circle.

A center, in the dynamic sense of the term, acts as a focus from which energy radiates into the environment. The forces issuing from the center are distributed around it in what we shall call the center's visual field. In the simplest case the energy is evenly distributed in all directions; the field of forces is centrically symmetrical. Constraints can narrow the field to particular directions, as in the case of a floodlight. Any obstacle in the environment will modify the range of the field; so will any asymmetry in the generating object. A piece of sculpture, for example, will modify the space in front of its principal view more strongly than the space behind its back.

The most important center a person comes to know is that of his own self. The personal center of the perceptual world is normally experienced as being between the eyes or the ears. When I look at the open landscape before me, my self reaches out to the horizon, which separates the lake from the sky. Turning around I see at shorter distance the woods and the house, and even more close by the ground beneath my feet. All these sights are experienced as being seen from the seat of my self, and they group themselves around it in all directions.

Looking around more sensitively in such an environment, I notice that my spatial relationship to the various objects is not adequately described by giving distances and locations. Rather the relation is dynamic. As I sit in my study, for example, my glance runs into the bookshelf and is blocked from further progress in that direction. The bookshelf responds to my approach by a counteraction: it advances toward me. But as my eyes rest on it, I can also make it display the opposite tendency, namely that of yielding to my approach by moving, somewhat heavily because of its great visual weight, away from me, thus joining the direction of my glance. Every visible object exhibits this twofold dynamic tendency in relation to the viewer's self: it approaches and recedes. The ratio between the two tendencies varies. Some objects more readily approach, others more readily recede. Although physically objects may stand still at a distance that can be measured with a yardstick, perceptually that standstill corresponds to a delicate balance between approach and withdrawal.

The foregoing is a distinctly egocentric way of experiencing the visual environment. It is, however, the primary way suggested spontaneously by what our eyes see. The world we see before our eyes exhibits a particular perspective, centered upon the self. It takes time and effort to learn to compensate for the onesidedness of the egocentric view; and throughout a person's

life there persists a tendency to reserve to the self the largest possible share of the power to organize the surroundings around itself as the center.

AROUND THE BALANCING CENTER

Overcoming the egocentric view amounts to realizing that a center is not always in the middle. When the self looks at the world with some mature objectivity, it can claim only in rare instances that it is the center of its environment. More often the environment is dominated by other centers, which force the self into a subordinate position. For example, whatever the optics of perspective may tell my eyes about a particular situation, I may have to realize that I am standing in a corner or sitting in the midst of an audience. Speaking generally one can assert that every visual field comprises a number of centers, each of which tries to draw the others into subservience. The self of the viewer is just one of those centers. The overall balance of all these competing aspirations determines the structure of the whole, and that total structure is organized around what I will call the balancing center.

Think of two centers of equal strength anchored at some distance from each other. A common balancing center, located between the two, will result from their interaction. Similarly, a triangular configuration will balance in a center that we can pinpoint intuitively. As I mentioned earlier, every visual configuration, however complex, possesses such an overall balancing center.

A strong dynamic connection tends to develop between any two centers. It is owing to such induced connections that we may see two dots as a line or three as a triangle. In this sense, the lines we draw with a pen to actually connect the dots are redundant. They are already given by induction before they are drawn. The pen executes and reinforces what the structure suggests.

If we look at a line microscopically, so to speak, we find it to be a continuous row of centers, each of which creates around itself its own field of forces. The simple directionality inherent in their combination allows us to perceive the totality as a single extended center—the line. The line is a center of a higher structural order than any one of the point-sized foci it comprises. Similarly, a triangular configuration adds up to a single dynamic center of a higher structural order. The dynamic action of such a higher center, in keeping with its complex shape, is also more complex. The field it creates is not homogeneous in all directions like that of a point-sized focus. The combined effect of the overall structure is to strengthen action in certain directions and discourage it in others.

Take as an example the shape of a circle or of a series of dots forming a circle. Each of the dots in isolation would create a homogeneous field around

itself. But through the collective effort of all of them, action is strengthened in some directions and neutralized in others. The confluence of the radial vectors will create the center of the circle, much as the focus of a lens is created by the combined action of the light rays issuing from each of its points.

Any reasonably complex visual pattern is a hierarchy of structural levels. At each level the centers of the higher level subdivide into groups of a lower order. When we deal with such a pattern it is rarely convenient or necessary to descend to the lowest level, that of the point-sized centers. Instead we approach the structure at the level more appropriate for the processes that interest us. In trying to see a work of art, for example, one must often explore various structural levels, starting from the broadest overall pattern. The configuration at this top level influences what is going on at the subordinate levels. The exploration stops short of the level at which the structure crumbles into mere particles.

As long as the centers of a configuration are in perfect equilibrium, the whole is in a state of repose, which means that the centers hold one another in such a way that it seems they would stay where they are even if they were free to move. We experience no pressing for changes of location or shape. It is true that a pattern as a whole, e.g., a circle, may exhibit a tendency to enlarge or constrict. But such a change in size would be a mere transposition along the existing structural radii. It would neither change the structure nor upset its balance. This does not mean that balanced percepts are devoid of dynamics. To see the whole and its parts held in equilibrium is a dynamic experience.

What happens when a small visual center, say a spot of ink, is placed somewhat off the middle of a circle? The eccentric spot will exhibit a dynamic tendency, probably a pull in the direction of the centric position. This pull comes about because the eccentric placing of the dot disturbs the circle's equilibrium, which tries to reestablish itself. At the same time, the dot's field of forces loses its own centric symmetry, which it too strains to reestablish. If the dot were mobile, it would give in to the onesided pressure and move to the centric position. But being a spot of ink drawn on paper, it cannot change location. It is frozen in its position. This makes the onesided pressure permanent. The spot displays forever a directed tension in the direction of the balancing center.

A local imbalance can be remedied by a corresponding imbalance in the opposite direction. A second spot, countering the eccentricity of the first, will reestablish the equilibrium of the circle by confirming the center in its rightful place. The example can be generalized: the overall balance of a visual pattern can be, and often is, obtained by the interplay of directed tensions created by the imbalance of local centers. These local tensions enrich the structure of the whole, making it look alive.

IN THE THIRD DIMENSION

As long as one is dealing with a pattern in a two-dimensional plane, the center around which the whole pattern balances can readily be determined by intuitive inspection. This is true for drawing and painting. It is also true for architecture as long as we are looking, for example, at the centerpiece of the façade of a building or at an obelisk marking the center of a square (Figure 5). Finding the center becomes more difficult in a truly three-dimensional situation. How, for example, does one determine the center of an interior? The task is complicated when the viewer, instead of being stationed outside the structure, stands somewhere inside it. Since he himself is a center with its own field of forces, he may have to move around a while to compensate for the effect of particular locations and perspectives. Even the final result is likely to be influenced, legitimately, by the viewer's presence as one of the centers that constitute the architectural experience. Whereas the center of a small cube may coincide with its geometrical middle, the balancing center of an architectural interior may be located closer to eye level.

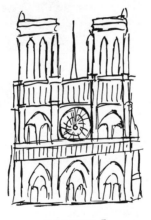

FIGURE 5

When a building is looked at from the outside, its balancing center does not necessarily coincide with that of the interior. It is a center which, like that of any other three-dimensional object, is located inside the object. Actually, however, since the perception of a balancing center presupposes that the object be surveyable as a whole, more often than not the size of a building prevents us from determining its center with any confidence. A small model will facilitate the task, but it will also show that the answer to our question is not necessarily simple. One notices, for example, that relatively independent parts of a building will exhibit balancing centers of their own, whose position may

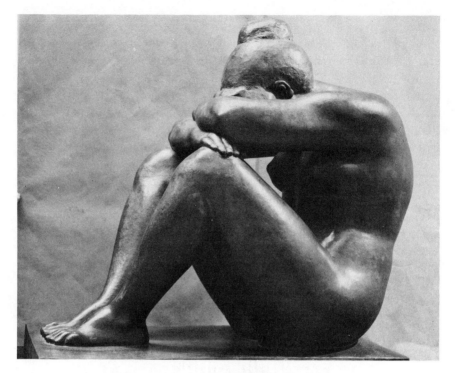

FIGURE 6.
Aristide Maillol, Night. 1902–1909.
Albright-Knox Art Gallery, Buffalo.

depend on the context of the whole. The basilica of a traditional church may displace its center somewhat toward the front when seen in relation to a weighty façade. The placement of the balancing center depends also on whether the building is seen in isolation or as part of a larger setting. In the broader context the building's perceived center may be some place that would not seem centric if the building were considered by itself.

In sculpture, too, the balancing center is seen as located inside the body of a work. Its precise location is determined by the sculpture's external configuration. Since that configuration changes with the particular angle at which the work is viewed, so does the location of the center. Walking around the sculpture, the viewer tries to integrate its various aspects in one objective form, and this search for the form "as such" involves finding *the* balancing center of the work. The effort is by no means unnecessary. The visual organization and the meaning of the sculpture can be understood only in relation to its balancing center.

For a striking example we turn to Aristide Maillol's crouching female figure *Night* (Figure 6): The body is curled into a compact cubic mass—the image of an inward-directed, closed-off mind. The sculptural volume centers around a place somewhere in the dark chamber formed by the legs and the torso and roofed by the arms. The head, anatomically the crowning feature of the body, is pulled downward toward that center. Similarly the outward-bound action of arms and legs is stopped and drawn backward and inward. By relating to the center, which is not actually represented by any identifiable part of the body, all components as well as the figure as a whole acquire their dynamics and thereby their meaning.

THE STRONGEST CENTER
AND ITS RIVALS

PHYSICALLY, the world of our daily activities is pervaded by one dominant force, the force of gravity. Everything is constantly being pulled down toward the center of the earth. The movement resulting from this attraction is stopped by whatever support blocks further descent. The book is stopped by the table; the table is stopped by the floor; the floor is held up by the foundation of the house; the foundation is stopped by the earth. Everything is in a state of arrested downward motion.

THE PULL OF GRAVITY

This downward pull dominates all others. We know that in principle every object exerts gravitational attraction, but only the earth is large enough to make it relevant. In physical terms, a person is not significantly attracted by the building next to which he is standing. Nor does his body cast a measurable spell on the apples in a nearby fruit bowl.

The dominant pull of gravity makes the space we live in asymmetrical. Geometrically, there is no difference between up and down; dynamically, the difference is fundamental. In the field of forces pervading our living space, any upward movement requires the investment of special energy, whereas downward movement can be accomplished by mere dropping, or by merely removing the support that had kept the object from being pulled downward.

Human beings experience the dynamic asymmetry or anisotropy of space by means of two senses, kinesthesis and vision. Kinesthesis, the sense that reports on the physical tensions active in the body, interprets gravitational pull as weight. Physically, gravitational pull and weight are the same thing; perceptually, they are different. Perceptually, weight is normally not attributed to the attractive power of a distant center but experienced as a property of the object itself. The object is perceived kinesthetically as an independent center to

10

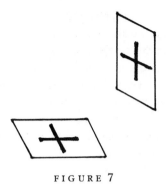

FIGURE 7

which we attribute heaviness. It is experienced not as being pulled, but as pressing, downward. But even though the pressure of heaviness issues perceptually from the object, it is not experienced as under the object's control. Heaviness is an invariant attribute, which cannot be modified but only counteracted. Any initiative toward movement, exerted by the object itself or through an outside force, must overcome the inertia inherent in weight.

Overcoming the resistance of weight is a fundamental experience of human freedom. Birds and insects flying through the air display their triumph over the impediment of weight. But any motion at all represents a similar victory. To spontaneous perception, motion is the characteristic undertaking of living things, whereas dead things are ineluctably possessed by their heaviness.

Walking downhill, dropping, or falling is experienced kinesthetically as passively acceding to one's own weight. One is being pushed downward by a force that inhabits and dominates the body. But such a downward motion also presents just about the only situation in which one senses the attraction of a center outside oneself; one feels like a defenseless victim of the magnetic earth. Otherwise it takes a special mental effort to become perceptually aware of the physical situation. Standing upright I can let myself be pulled down by the floor beneath my feet. This involves emptying my body of its weight. I feel like a mere husk. All my muscles relax; limbs and torso respond to nothing but the pull from below. The self relinquishes its prerogative as a center of activity and surrenders to a center outside. But to experience this shift of focus is also to realize how atypical it is for normal kinesthetic perception.

The visual experience of gravitational pull is similar to the kinesthetic one only in part. It is best illustrated perhaps by the difference between what goes on visually in a horizontal surface as opposed to a vertical surface. Compare the simple figure of a cross in the two situations (Figure 7). The horizontal cross acknowledges its geometrical symmetry. The two bars have the same

function, and the point at which they cross is clearly the balancing center of the figure. In the horizontal plane all spatial directions are interchangeable unless they are given some particular role. Since all points of the horizontal figure have the same relation to the ground, the two bars balance each other and thereby establish the center around which the figural forces are evenly distributed. If one wished to strengthen this symmetry, one could pierce the center with a vertical axis. This would enhance rather than contravene the structure.

How different is the perceptual effect of the same figure in the upright position! Here a vertical symmetry axis, namely the vertical bar of the cross, is part of the figure itself. From the vertical axis the horizontal bar spreads sideways like the branches of a tree or the arms of a person's body. The center breaks up the unity of the horizontal bar and transforms it into a pair of symmetrical branches or wings. The vertical, by contrast, barely acknowledges the crossing. Strengthened by the gravitational vector that pervades the visual field, it persists as an unbroken unit, for which the particular location of the crossing point is not compelling. The centric geometrical symmetry is reduced to a mere bilateral one by the perceived asymmetry of the vertical field. The two parts of the vertical spine, the upper and the lower, serve different visual functions. They are not perceived as symmetrical since reaching up is different from reaching down. Therefore, visual logic demands that they not be of equal length. When they are, there is a visual contradiction between equality of length and inequality of function. The axial symmetry of the Latin cross serves the upright position better than the centrical symmetry of the Greek cross. When the upper part of the vertical bar is made shorter than the lower, the difference gives visual expression to the functional difference. It also does justice to a fact that will concern us soon: an element in the upper part of a pattern carries more visual weight than one in the lower part and therefore should be smaller if it is to counterbalance a corresponding element below.

The influence of spatial orientation, so evident in the simple figure of the cross, also makes itself felt in complex patterns, e.g., in paintings hung on walls as compared with the horizontality of decorations on ceilings or floors. Examples will be given soon. For the moment it will suffice to note that the center point of a pattern is emphasized in the horizontal orientation but is partly overruled as the dominant structural position in the vertical orientation.

THE VIEWER AS A DYNAMIC CENTER

Spatial orientation is truly understandable only if one considers an additional dynamic center, namely the observer. The observer, an integral aspect of any visual situation, reacts differently to different spatial orientations. Elsewhere I have suggested that the vertical dimension can be considered the

realm of visual contemplation, whereas the horizontal is the realm of activity.[1] Upright things, be they paintings on the wall or a person standing before us, are seen head-on, which means they are seen well. We see them without distortion and from a comfortable distance. This permits us to scan the object as a whole and to grasp its visual organization on its own terms. And although we can step forward and reach the object, we experience it as standing in its own separate space. It belongs, as it were, to a different vertical. Like trees in a forest, vertical objects are parallel to one another, but separate.

Compare this to what happens in the horizontal. Since the horizontal plane is the dimension of most of our actions in space, the floor, when used for visual decoration, has to serve two conflicting functions. Our feet get in the way of our eyes. Would it not be awkward to traverse the floor of a Pompeian villa across a large mosaic representing the battle between Alexander and Darius? There is a disturbing contradiction between the verticality of the viewer and that of the figures represented in the floor. In addition, the close physical relation discourages detached contemplation. The situation is uncomfortable in a purely optical sense. The eyes are meant to look forward, to scan the environment in search of whatever shows up vertically as friend or foe. For the eyes to look down, the head or body has to bend, and even then the object underfoot cannot be viewed perpendicularly. It will be seen at an angle and therefore distorted, and that angle changes continuously as the person, engaged in his business, moves across the floor. The viewer's eyes are too close to encompass and analyze any extended horizontal pattern as a whole. Different portions present themselves in the visual field as the viewer changes position. Only in an aerial photograph can one truly comprehend, for example, the artful geometrical pattern that radiates from the statue of Marcus Aurelius across the pavement of Capitol Square in Rome.

Let me mention here the special case of the stage. Any stage performance is deployed along a horizontal plane for a viewer located at a parallel level. The slope of the auditorium and of the stage itself partially remedies this state of affairs but leaves it basically unaltered. It is as though one tried to read a book with eyes at table-top level. Since the horizontal plane is the realm of activity, it suits the theater as a place of ongoing action but interferes with it as a target of contemplation. The situation predisposes the viewer to active participation in what he sees rather than detached observation. As we know, the stage developed from precisely such a social situation, with performers and participants integrated in a common event. The later separation of the stage from the audience created a spatial dilemma that cannot be truly resolved. The viewer—the dynamic center for whom the show is intended—sees it either

1. Arnheim (5), p. 54.

one-sidedly from the side and therefore compressed and encumbered, or from above and therefore unnaturally. In practice, of course, we manage reasonably well, but the problem raised by the principle is of considerable interest.

Every stage action, a work of choreography, say, requires an organization of its own. It must at every moment have a center or a group of centers forming a composition within the plane of the stage. Although the action is created for the viewer, what happens onstage is by no means identical with the perspective projection received by his eyes. Rather, the optical projection must be designed as a slanted view of a stage composition that has an order and meaning in and by itself. For example, dancers encircling a central figure onstage are meant to be seen not as a distorted circle, i.e., an ellipse, but as a circle viewed from the side. At the same time—to make matters more complicated—the ellipse that is nonetheless seen must present a readable form of its own, a form that significantly interprets the intended circle. Hence the two-fold task of the director, who moves back and forth between stage and audience, trying to organize the stage action according to its own logic and checking on what the projection offers from the slanted perspective of the audience. Hence also the unsatisfactory results of televised sporting events, whose spatial meaning is inevitably distorted by the perspective of particular camera angles. An event not organized for viewing is subjected to viewing nevertheless.

Curiously, the problem recurs in representational painting. Although usually a painting hangs on the wall as an object of contemplation displayed in a vertical plane, the scenes depicted in the pictures are mostly side views. This means that what is represented in the vertical world of pictorial contemplation is a section of what goes on in the horizontal plane of activity. While the pictorial medium treats the viewer as a contemplator, the representation treats him as a participant.

To be sure, abstract, nonmimetic paintings can restrict their compositions to two-dimensionality and often do so. So do the spatial arrangements in certain early types of representation, e.g., children's drawings, or Buddhist paintings in which a central figure is surrounded by a circle of subordinates (Figure 8). Although the figures sit upright, the circular arrangement is depicted literally as a circle. With similar deference to the pictorial medium, certain styles of painting severely curtail the depth dimension. Thus, in one of the Byzantine mosaics at San Vitale in Ravenna, we see the empress Theodora with her entourage displayed in a frontal plane (Figure 9). The depth dimension is limited to the superposition of the row of figures upon an equally flat background. The side view of the scene is essentially reduced to a vertical section.

The problem develops in its full complexity in the realistic paintings of the Renaissance, which display the horizontal dimension in its full depth. Here the dilemma of the stage reappears, though with a decisive shift in emphasis. A

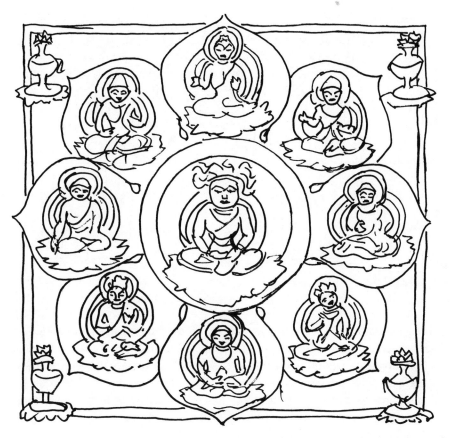

FIGURE 8

theater is an actual physical space, a shared setting that unites performance and audience. Therefore its emphasis is on the three-dimensional event taking place on the horizontal plane of the stage. The view received by the audience, although adapted to the projective needs of its eyes, is essentially slanted information about the "real" space organized on the stage. In painting, by contrast, what has primacy is the two-dimensional projection in the vertical frontal plane. In the projection, the relations between closeness and distance, frontality vs. side view, covering shapes vs. covered shapes, right and left vs. depth, etc., are to be taken literally as the decisive statement. Only indirectly and secondarily does the picture refer to the scene itself as it unfolds in horizontal space. More will be said on this subject in Chapter VIII.

Whereas the spectator in the theater is essentially a potential participant, the viewer of a painting is essentially a detached contemplator. Therefore the pictorial scene tends to remain complete and independent of the viewer, as

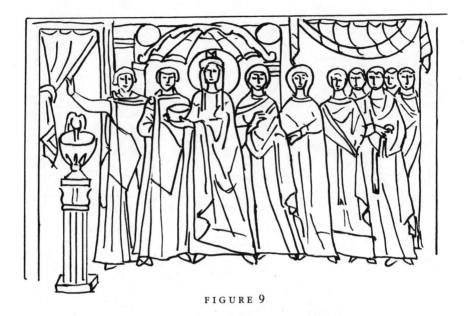

FIGURE 9

though he did not exist. On the stage, a monologue or aria addressing the audience directly is in keeping with the spatial characteristics of the theater. The equivalent in painting is a transgression of the boundary between pictorial space and physical space. Attempts to draw the viewer into the scene by explicit eye contact or gestural invitation are consistent with the developing realism of pictorial depth in the Renaissance, but play dangerously with the spatial ambiguity of the medium.

These observations about the theater and representational painting bring home the disconcerting fact that we look at our world sideways. Instead of facing it as spectators, we are in it and of it, and we therefore see it partially and from a private perspective. Our view interprets but also misinterprets our position in the world, a dilemma resulting from the ambiguous function of the human mind. In a typically and perhaps exclusively human way we participate actively in our world while at the same time trying to view it with the detachment of an observer.

LOOKING UP AND LOOKING DOWN

I have pointed to some of the consequences of the fact that in every visual situation the viewer creates a decisive center. What is seen and how it is seen depends on the viewer's spatial position. His involvement, as mentioned earlier, has definite consequences for pictorial decoration in the horizontal

plane. But what I said about floor decoration is not equally applicable to the ceiling. A ceiling painting is distant and detached from the viewer. The distance is often great enough so the viewer can encompass the whole composition within a relatively narrow angle of vision. Without moving his head he may be able to hold in his field of vision the fresco of a Baroque ceiling, together with the accompanying circle of related scenes.

More influential than the range of the angle of vision, which depends entirely on the viewer's distance from the ceiling, is the viewer's orientation within the spatial framework. An awkward contradiction results when a ceiling is decorated with what was called a *quadro riportato*, namely, an ordinary painting conceived as for a wall. The scene portrayed in such a painting presupposes a viewer looking at it horizontally, his glance parallel to the ground, whereas he is only too aware that he is looking upward.[2] Wolfgang Schöne has pointed out that viewers feel a strong urge to remedy such a situation. They tend to tilt the line of sight closer to the horizontal by looking at ceiling paintings obliquely. In fact, Schöne maintains that the most effective ceiling decorations have been designed for oblique inspection.

This is particularly true of paintings that purport to continue the architectural structure by depicting a heavenly scene as it might appear through the open roof. In such representations Schöne notes a contradiction between the pictorial treatment of the architecture and the human figures populating it. Andrea Pozzo's famous vault in San Ignazio in Rome, for example, presents the architecture as it would appear from a viewing station directly beneath the center of the painting, whereas the figures are depicted as they would look at some distance from that center.

There are several advantages to such a solution. Viewed from directly underneath a human figure looks absurdly foreshortened, whereas a less acute viewing angle lessens the distortion and the figure approaches its normal appearance. In addition, however, the plumbline view from directly beneath the center has two perceptual consequences that are not necessarily welcome. First, any undistorted projection of the depicted scene's overall symmetry would underplay spatial depth. It would shorten the perceptual distance between viewer and ceiling and interfere with the illusion of a heavenly vista. At the same time it would anchor the viewer to the space underneath, which is desirable only under special circumstances, namely when movement is intended to come to a stop, for example, in a rotunda vaulted by a cupola. When, however, the decorated ceiling is applied to a space designed as a link in the visitor's progression through the building, the ceilings of a Pozzo or Cortona

2. In addition to the paper by Schöne (52), see Sjöström on quadratura (56).

let the viewer look forward to what he is approaching, reach a climactic stasis, and move beyond it on the horizontal plane of activity.

So little attention has been paid to the particular perceptual conditions created by the relation between viewer and horizontally oriented art that a recent example merits consideration in some detail. When the city of Cologne rehabilitated its old town hall, badly damaged in the Second World War, the painter Hann Trier was commissioned to create a painted slab to be suspended in the atrium of the building, roughly halfway between floor and ceiling (Figure 10). Daylight enters the court from above through a gridwork of beams. The shape and color scheme of Trier's work are derived from the escutcheon of the city of Cologne, which shows in its upper band three golden crowns on a red ground and in its lower part eleven stylized black flames on white. The traditional coat of arms was designed, of course, for vertical display, and is therefore symmetrical around a vertical axis. To adapt this shape to a horizontal position, the painter eliminated the dominance of the gravitational axis together with the symmetry of the heraldic imagery. Instead he distributed an abstract version of the black flames surrounded by the golden crowns across the surface of a roughly six-pointed star. Central symmetry replaced axial symmetry for another reason as well: the top surface of the slab, viewed from an elevated gallery, received a different design, namely a stylized aerial map of Cologne, looking somewhat like a spider web.

A slab of about nine meters in diameter suspended at a height of six to seven meters above the floor makes for a wide visual angle of about 80°. Instead of inviting reposeful contemplation from a fixed station point on the floor, it calls for viewers to walk back and forth, constantly shifting their focus of attention. Consequently, the composition is diffuse rather than rigidly centered. In fact, in paralleling the floor, the dimension of active locomotion, the pictorial surface of the slab can be said to mirror the comings and goings of the town hall's visitors, who traverse the court in all directions.

Since the slab is suspended in midair above the visitors' heads, it has to display at once both the solidity of a protective roof and the fluffy translucency of a celestial medium. As the viewer raises his head to look at the floating picture he feels safely under cover but also free to roam through uncharted space. Abstract painting offers surface qualities that can meet such dual requirements.

As viewers look down from the gallery, the visual substance of the slab's upper surface must be equally complex. The familiar map of the home town must have the solidity of the earth but, suspended above the ground, must also possess an airy intangibility that distinguishes it from the reliable firmness of the courtyard floor underneath.

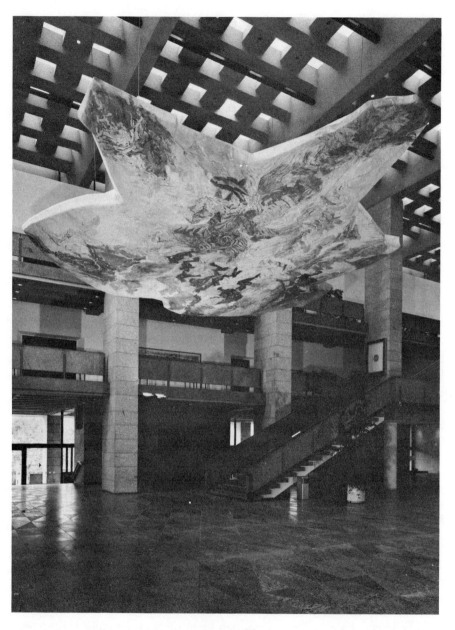

FIGURE 10.
Hann Trier, The Cloud
(painted baldachin). 1980.
Town Hall, Cologne.

Obviously, special conditions call for special effects. Trier's suspended slab, with a shape of its own, is much more independent of the architectural setting than it would be if it were firmly anchored to ceiling or floor and conformed to the shape of the building. A ceiling painting must either partake in the physical solidity of the ceiling or override it, as the heavenly visions of some Baroque vaults do. A floor decoration, in turn, should assure the visitor that he can walk across safely.

There exists a species of pictorial representation that is particularly suited to the horizontal position in relation to the viewer, namely the map or ground plan. A map is one of the few kinds of pictures that actually depict horizontality. Road maps in particular represent the spatial situation of a journey so closely that they involve the viewer bodily. The effect is most direct when the point of departure appears at the bottom of the map, that is, closest in physical space to the point from which the viewer is actually perusing the map. From that base he looks forward toward his destination. This spatial involvement of the viewer diminishes when the scale of the map ceases to resemble the kind of landscape a traveler can actually encompass with his eyes but presents whole continents.

Only now that we regularly see satellite maps and photographs of the earth taken by astronauts have the maps of continents ceased to be abstractions, constructed by inference but not verifiable in direct experience. Even now, however, these world images remain outside our reachable living space. They are objects of contemplation, not features of the realm of our activities. Therefore we view maps of the world as though they were upright rather than horizontal, with the North Pole on top and the South Pole at the bottom, with North America on top of South America. That spatial position looks appropriate to us. Its subject is not close enough to any direct experience to draw the viewer into its spatial framework. Instead, the viewer incorporates the picture in his present visual framework, in which whatever appears at the top of the visual field *is* on top and whatever appears at the bottom *is* at the bottom.

What is more, the perceived framework of the map is independent not only of the spatial orientation suggested by the represented scene but equally of the physical space in which the viewer operates. It makes no difference whether the map lies on the table or hangs on the wall. What appears on top, *is* on top, and vice versa.

The effect of the observer's position upon the way a picture is perceived shows that in the visual world the dominion of the gravitational pull is not uncontested. To be sure, as long as we distinguish up from down at all, we are still under the spell of gravitational asymmetry. But in the case of a representational picture, that distinction is strongly determined by the visual

framework of the observer. What counts in such cases is the relation between observer and object, not the relation of both of them to physical space.

WEIGHT PRODUCES CENTERS

We conclude that gravitational pull, although issuing from the strongest dynamic center in the visual world, competes with the forces emanating from other dynamic centers. We have found the viewer at his location somewhere in visual space to be one such strong center. And there are many others. Weight is not exclusively related to gravitational attraction. It is perceived as a property of all visual objects. And the attractions and repulsions to which a visual object is exposed depend on the relations between the object's own visual weight and that of the other objects within the sphere of mutual influence. The ground underfoot is only one dynamic center, and the strength of its pull depends considerably on how much of it shows in the field. An object in direct contact with the ground will be perceived as strongly attracted by it. But a spherical lamp hanging from a ceiling may look almost entirely free of any downward pull.

Different art media vary in this respect. The visual appearance of architecture is most strongly affected by gravity because buildings are so broadly and firmly rooted in the ground. Sculpture is much less dependent on its base and can even float in the air. Sculptural components of varying visual weight can interact more freely than those of buildings. Framed paintings display even greater freedom. They are removed from the floor, and in most cases they represent a purely visual space, separate from the physical space they inhabit as physical objects. A few examples will illustrate these differences.

Two general rules will be introduced here. One indicates that every visual force has the potential to act in two directions. Take as a simple example a linear shape, the architectural column. Standing upright, it can be seen as pushing upward as well as downward. The ratio of the two tendencies depends on the distribution of visual weight in the particular case. Look, for example, at the twenty Corinthian columns that surround the round temple near the Tiber in Rome (Figure 11). The columns are firmly rooted in the temple's foundation, which reposes on the ground. From that base nearly all the columns' dynamic power shoots upward, where a slight roof proves unable to counterweigh the upsurge. The roof, a makeshift cover replacing the original entablature, is all but flipped off by the assault. Physically, of course, no such risk exists. Visually, however, the slender columns convey an almost unopposed upward thrust. The load they originally counteracted is no longer there.

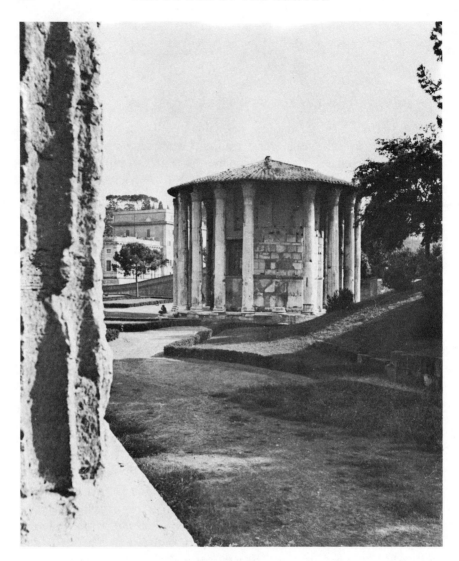

FIGURE 11.
Temple of Vesta, Rome. c. 100 B.C.
Photo, Ernest Nash.

The foregoing example shows that the behavior of visual forces depends on anchoring centers, as they were called in some early experiments of the gestalt psychologist Karl Duncker on the perception of movement. Every visual force issues from its anchoring center. If in the present state of that small Roman temple the upward thrust of the columns looks unbalanced, this is because a

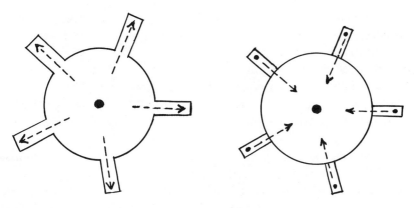

FIGURE 12

strong anchoring center is provided by the ground while no adequate opponent is provided by the roof. The diagrammatic example in Figure 12 may help clarify the matter.

The dynamics of Figure 12 can be perceived in two ways. We can endow the five small towers standing on the spherical base with separate anchoring centers of their own. In that case the towers press downward, attracted by the core of the base. The dynamics is centripetal. Or we can reserve a single anchoring point to the central base. Now the five towers become radial outlets from that base, outlets through which the dynamic forces stream centrifugally. These two ways of viewing the structure operate simultaneously, and the particular ratio between them will determine in each individual case the way it will be perceived as a whole.

The first of the two general principles to be discussed in this chapter thus indicates that visual forces point in two opposite directions, which are determined by their anchoring centers, and that the ratio of the opposing forces varies in each case. The second principle involves the relations between distance and visual weight; it can be subdivided into distance effects and weight effects.

Since we are dealing here with the interaction of several factors, the following synopsis may prove helpful:

A. *Distance* (1) *increases visual weight* when perception is anchored in the center of attraction; (2) *decreases attraction* when perception is anchored in the attracted object.

B. *Weight increases attraction.*

A (1). *Distance increases visual weight.* This statement contradicts what we know from physics. The gravitational law of the inverse square states that physical attraction diminishes with the square of the distance. Since gravitational attraction determines physical weight, it follows that objects become lighter with increasing distance from the center of the earth. To be sure, for terrestrial purposes the effect is minimal. But it predicts the opposite of what we find visually. Under the given conditions, visual weight *increases* with distance.

This phenomenon corresponds more closely to the behavior of potential energy. The potential energy inherent in an object grows as that object moves away from the center of attraction. Similarly, visual experience informs us that in a painting the higher an object is in pictorial space, the heavier it looks. This occurs only when the object is perceived as being anchored to a center of attraction, especially the gravitational base. Under such conditions, the object has to be made smaller or otherwise diminished in weight if it is to equal the weight of a similar object in the lower portion of the picture. One can understand this phenomenon by thinking of the object as attached to the center of attraction by a rubber band. The farther removed it is from the center, the more resistance it has to overcome, and this capacity to resist is credited to it as additional weight.

A (2). *Distance decreases attraction.* In the visual world, weight is not just an effect of attraction from the outside. Visual weight also accrues from an object's size, shape, texture, and other qualities. Therefore even if the rubber band of our example snaps and the dynamics is no longer anchored to the base of attraction but switches to the object itself, the object remains endowed with weight. The object becomes an independent center, and its dynamics changes accordingly. With increasing distance from the base, the object looks freer. Take as an example the head of a standing statue. When the head is seen as attracted by the base, its power to maintain itself at so great a distance adds to its weight. But as we switch the dynamics and see the head as its own anchoring center, the head strains upward, intent on freeing itself from its tie to the ground. The head will actually give a lift to the entire figure, pulling it upward within the limits of its power.

The two ways of perceiving the situation, A.1 and A.2, are contradictory and mutually exclusive. They cannot both be held by a viewer at the same time, although he can switch back and forth between them. For this reason there does not seem to be a direct interaction, which would make the two ways of

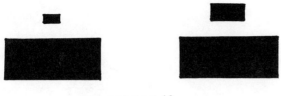

FIGURE 13

seeing fuse in a compromise image. Rather, oscillation produces a balancing of the two opposite versions.

B. *Weight increases attraction.* So far I have discussed the effect of distance on weight. It remains to mention the effect of weight on attraction. The rule states that, other factors being equal, the greater the visual weight of objects, the stronger their attraction to one another. There is an analogy here to the physical law which tells us that the force of attraction between objects varies directly with the product of their masses. Figure 13 is meant to show that when two objects are placed at the same distance from a powerful center of attraction, the larger one will be the more strongly attracted. In the vertical direction this effect accounts for top-heaviness. When an object has too much visual weight it presses downward so strongly that it throws the composition off balance.

A few examples may show how the distance and weight factors operate simultaneously in a given case. A tower rising from a massive building will be seen essentially as an outgrowth of that building, guiding its centrifugal energy upward and letting it evaporate, perhaps through the decrescendo of a tapering spire. Although the tower makes the building reach great height, the building will be judged visually by its principal center of weight, which is quite low down. To make an explicit point of its height, the tower must reinforce its upper section by establishing a definite center of its own. The slender tower of the heavily cubic Palazzo Vecchio in Florence would display little more weight than a factory smokestack were its top not strengthened by the corbelled gallery which provides the needed secondary center (Figure 14). The size and bulk of the gallery seems just right for perfect balance in the context of the building. Although small in relation to the mass of the palazzo, it gains in visual weight by the "rubber band effect," that is, by the tension or potential energy that keeps it away from the center of attraction. But when we switch perception and concentrate on the gallery as a center in its own right, the

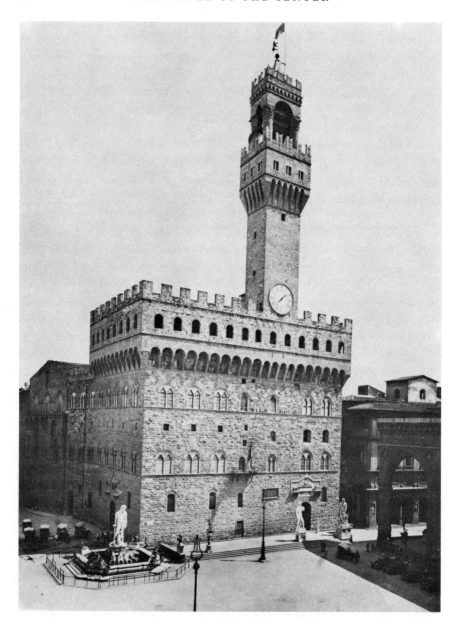

FIGURE 14.
Palazzo Vecchio, Florence. c. 1300.
Photo, Anderson.

relation between the two changes. It is reversed. Now the gallery's weight exerts its own power, and since it remains connected to the mass of the building, it gives the building a lift, pulling it upward within the limits of its strength. It adds the height of a secondary center to an otherwise earthbound mass. If one tried to establish the balancing center of the palazzo, as a whole, one would find that the tower raises that center higher than it would be for the main building alone.

If a tower provided with such an effective secondary center of its own did not have the support of a sufficiently massive building, it would look unbalanced in two ways. In relation to a weak base, the secondary center would look top-heavy. And viewed by itself, it would display so much visual weight as to float away, dragging the rest of the tower with it like a kite's tail. One possible example of such flightiness is the clock tower of the Houses of Parliament in London when it is looked at in isolation from the buildings it surmounts.

We are now fairly well equipped to deal with visual compositions as configurations of centers whose weight and location determine the dynamics of the total work. Gravitational pull, although the strongest of the forces at work, takes its place as one of several within a compositional order. Let me refer once more to the familiar west façade of Notre Dame in Paris (Figure 5). Its balancing center, the large wheel window, looks as though it were located in the middle of the building's quadratic mass. In fact it is quite a bit above the geometrical center. This displacement has several functions. Since the dominant center influences the dynamics of the whole, the raising of the wheel window gives the façade an upward lift. In addition, the central window divides the frontal mass into two uneven horizontal layers, with the higher one being smaller. In this way it compensates for the "distance effect," that is, the greater weight accruing to the upper part of the façade by virtue of its greater distance from the ground. The uneven division also provides the building with a massive lower base. Even so, if the roof were not topped by two towers, the wheel window would look too high; it would upset the cathedral's balance by an excessive upward thrust.

Viewed as a whole, the façade of Notre Dame makes the building repose solidly on the ground. A different effect is obtained by the façade of San Pietro in Toscanella (Figure 15). In this eighth-century basilica, a similar wheel window is placed very high up, just below the roof. From this height the window, instead of marking the balancing center of the whole, counterweighs the powerful portal and raises the building almost to a state of winged suspension. We notice again how the dynamic effect of a strong secondary center influences the behavior and expression of the entire composition.

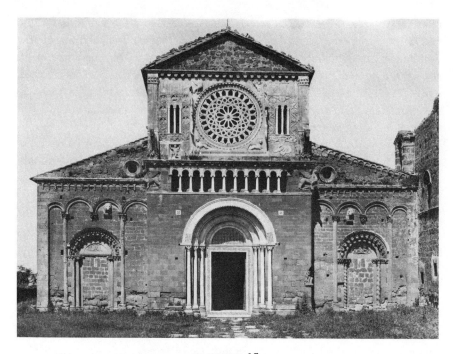

FIGURE 15.
Church of San Pietro, Toscanella. 12th century.
Photo, Alinari.

APPLICATIONS TO SCULPTURE

How do our observations apply to sculpture? First of all, it appears that the dynamic relation of sculpture to the base provided by the ground is somewhere between that of architecture and that of painting. Many sculptures stand on the ground and thus have a direct visual connection with it. But rarely is a sculpture so firmly rooted in the ground that it would seem to sprout from it as buildings commonly do. More often and more clearly than architecture, a piece of sculpture appears as an independent object, attracted by the ground and reaching toward it but organized predominantly around a center of its own. On the other hand, sculpture is rarely as independent of the ground as paintings are. To be sure, a Calder mobile may be suspended in space like a planetary system, but floating sculpture is an exception.

The relation of sculpture to the ground varies with its shape. In general, vertical works, variations of the basic column shape, are most explicitly connected to the ground. When the main dimension is horizontal, the body of the sculpture moves in a direction parallel to the ground and seems barely at-

tracted by it. Similarly a strongly compacted mass, such as Brancusi's egg shapes, looks detached from the ground, not only because it barely touches it but because the work is compellingly organized around an anchoring center of its own. It is held by gravity but can take off to float in space without much effort.

Since the human figure is the most characteristic subject of sculpture, we can use it to exemplify the influence of shape upon the relation between the gravitational center of the ground and the centers inherent in the work itself. A realistically portrayed standing figure tends to be cut in two by the waist (Figure 16). Waist and belly serve as the base between the upper part of the body, which points essentially upward, and the lower part, which points essentially downward. From the compact volume of the belly, the legs taper downward to the narrow platform of the feet. In the opposite direction the chest rises from the waist and is lifted by the head, which can function as an anchoring center of its own. At the same time, the head, pulled down by the "rubber band effect," acts as a kind of lid, which keeps the figure from evaporating into upper space.

Other secondary centers may support the lifting action of the head. In some figures by Gaston Lachaise, large female breasts produce this sort of buoyancy. Michelangelo's St. Petronius in Bologna holds a small fortified town, which adds a strong visual weight to the upper part of the body. Similarly the head of the Medusa cantilevered by the arm of Canova's *Perseus* (Figure 17) helps to lift the figure while at the same time weighing it down with additional gravitational attraction.

These examples show how much more complex is the function of visual weight than what takes place physically. With respect to Canova's marble, the addition of the cut-off head to the upper part of the body makes it physically heavier and increases the downward pressure. The corresponding visual effect is counteracted by the tendency of Medusa's head to act as an independent center, rising like a balloon. Therefore in judging the distribution of weight in certain Baroque works, e.g., some of Bernini's figures, it is essential not simply to apply the criteria of physical equilibrium and to assume that bulk in the upper part of a work makes it top-heavy.[3] A prancing horse or gesturing figure that would topple if made of flesh and blood may be held aloft in the sculpture by the very components that would weigh it down physically.

A dominant head can be strong enough to lift an entire group of figures. In Michelangelo's *Pietà* in the cathedral of Florence, the spire-like hooded head of Nicodemus rises in counterpoint to the sagging body of the dead Christ

3. Chamberlain (21) discusses Bernini's sculpture in relation to physical statics.

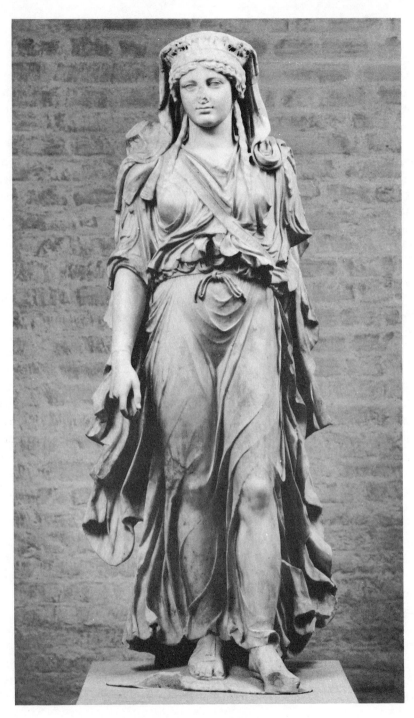

FIGURE 16.
Artemis. Roman, 1st century A.D.
Glyptothek, Munich.

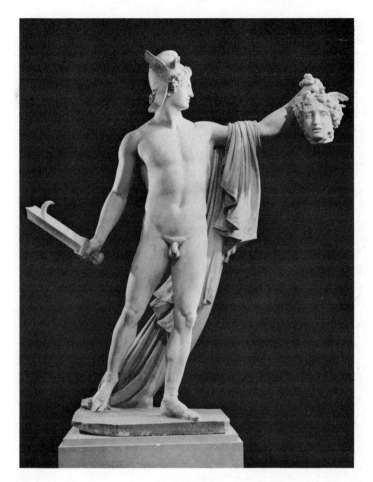

FIGURE 17.
Antonio Canova, Perseus Holding the Head
of the Medusa. 1804–1808.
Metropolitan Museum of Art, New York.

(Figure 18). This theme of opposite forces has, of course, no parallel in the physical situation; all parts of the block of marble press downward.

The segmenting waist is not the only base available for the dynamic organization of a sculptural figure. Any modification of shape or stance can displace the compositional centers or create new ones. In Reg Butler's figure of a girl pulling a shirt off her head (Figure 19), the raised arms lift the entire body so convincingly that the sculptor can have his soaring figure perch quite credibly on a slight metal crossing rather than a solid base.

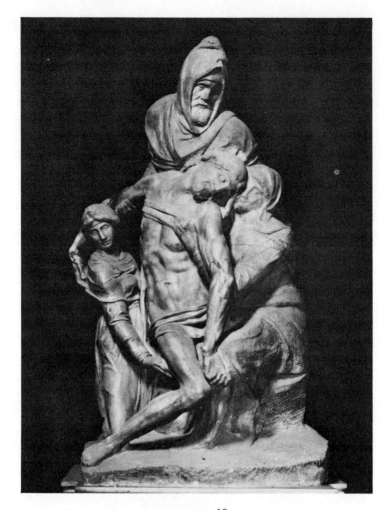

FIGURE 18.
Michelangelo, Pietà. 1550–1553. Santa Maria del Fiore, Florence.
Photo, Alinari.

The relation between gravitational pull and the power of additional centers is illustrated by the standing horse, e.g., in the work of Marino Marini (Figure 20). Here the overall downward pull is strongly counteracted by the horse's body, which acts as a central base for the radial elements, the four legs pointing downward and the neck and tail pointing upward. Even the figure of the rider, although accented by its ball-shaped head, issues from its seat on the horse, with the torso rising and the legs descending. Freely suspended in midair, the animal's body is a proud challenge to the tyranny of the ground.

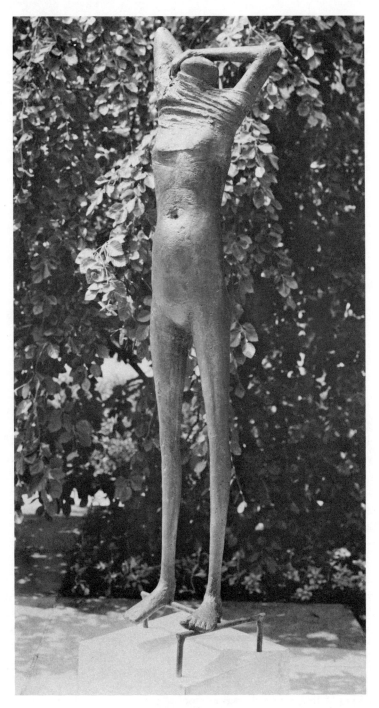

FIGURE 19.
Reg Butler, Girl. 1953–1954.
Museum of Modern Art, New York.

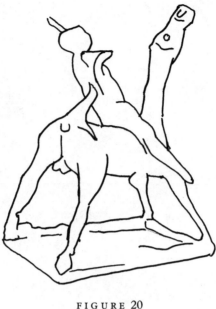

FIGURE 20
(after Marini)

A geometrical abstraction can display with particular clarity some of the dynamic forces constituting a composition. At first approach, Barnett Newman's sculpture *Broken Obelisk* (Figure 21) shows a pyramidal base from the top of which rises a column. But this reading is immediately modified by the shape of the upper element: irregularly interrupted on top but sharply pointed at the bottom, the obelisk is directed downward. It balances on its head like an acrobat—a position that would seem precarious if the central vertical, like a powerful steel spine, did not hold the work together.

Any pyramid, taken by itself, rises from the broad base of the ground and condenses its energy to a maximum of force at the point. Rarely do we read a pyramid in the opposite direction, namely as a crescendo originating from a point and unfolding as it descends. In the Newman sculpture this alternative reading is made plausible by the relation to the center created by the meeting of the two components, the pyramid and the obelisk. The pyramid displays its double nature. It rises from its base toward the confrontation, and in a gush of energy spreads outward and downward from the center.

Looking at that point-shaped center we may think of an arc lamp, whose incandescent electrodes generate a light of glaring intensity. The sculpture's compositional center is located below the geometrical middle of the 26-foot-

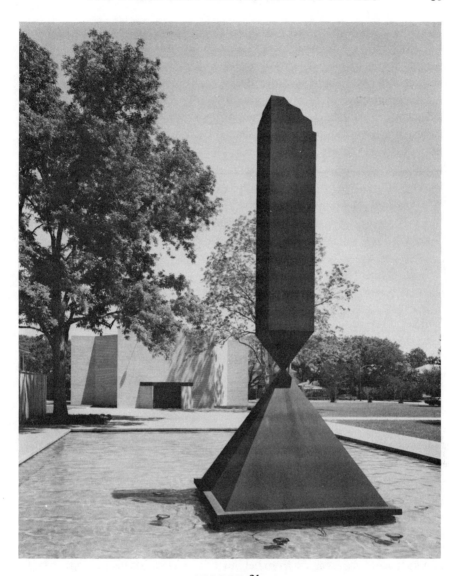

FIGURE 21.
Barnett Newman, The Broken Obelisk. 1968.
Rothko Chapel, Houston.

high monument and probably also below the visual balancing center of the work. This displacement causes much of the weight to sag toward the bottom, thereby stressing the downward thrust of the inverted obelisk. But the clash of the two elements is counteracted by a connection that fuses the two pyramidal

tops. They both peak with the same angle of 53°, and this creates a unifying symmetry and a sheaf of crossing edges. A crossing is not a clash, and the combination of clash and crossing produces a counterpoint between head-on collision and harmonious continuation.

The composition of Newman's sculpture, somewhere between a monument and a work of art, derives from the interplay of our two spatial systems. In its Cartesian aspect, the columnar landmark rises from its base, contradicts its primary upward thrust, turns back in a countermovement, and contends like a homing rocket with its base, hitting it and fusing with it. In its centric aspect its mass is compacted symmetrically around the central vertical, which holds the work together. It also creates a focus of high energy, a point-sized center of a field of forces, which spring from it and converge toward it, filling the surrounding space with their concentric action.

APPLICATIONS TO PAINTING

The principles we find at work when we turn to painting are by now familiar. Once again, gravitational pull is represented by its visual equivalent. It produces an anisotropic space, to whose influence all pictorial objects are subjected. This influence is diminished , however, by the particular perceptual properties of the painter's medium.

A framed picture on the wall enjoys a high degree of independence—for two reasons. First, more often than not, pictures present a perceptual space of their own, separated by the frame from the space that surrounds them. This separation enables the painter to handle the dynamics of pictorial space as he pleases. He can distribute weight in such a way that it presents a visual analogue to the downward pull of gravity. Or he can distribute it so evenly that his composition looks weightlessly suspended. Second, the separation obtained by the frame is enhanced when a painting hangs at some distance above the floor and is correspondingly less affected by the floor's attraction. To be sure, the canvas is in direct contact with the wall, which also acts as a dynamic center. It attracts the canvas from behind, but because this visual magnetism is perpendicular to what goes on within the pictorial surface, it imposes no directional bias. Being a strongly two-dimensional surface, however, the wall does influence pictorial space in the sense of flattening it. It strengthens the frontal plane.

Once again we have to consider the viewer as a powerful dynamic center. Standing before the picture, he acts as a component of the comprehensive space that involves viewer and picture. His eyes scan the pictorial surface in order to perceive its composition as a whole. Inevitably, at any given moment,

the eyes single out a particular spot, making it the center of attention. A center of attention creates weight, just like any other center, and therefore for the time being it dislodges the inherent hierarchy of the composition. It upsets balance and meaning. It can make a dominant center overbearing or endow secondary centers with undue emphasis. Such momentary onesidedness must be overcome by continuous scanning.

A picture is, of course, a perceptual object and exists only in the consciousness of the viewer. Its properties are aspects of the viewer's percepts. Among these properties, however, it is useful to distinguish those that are contributed by the structure of the pictorial pattern itself from those contributed by mechanisms inherent in the viewer's own behavior. Thus, the location and strength of the various dynamic centers in a composition are data generated by the work itself, whereas the focus of attention, for example, depends entirely on the viewer. Among the factors attributable to the viewer are also certain aspects of lateral directionality imposed upon the visual field. As far as actual eye movements are concerned, scanning from left to right and vice versa occurs somewhat more readily than scanning up and down. In addition there is a well-known tendency, largely independent of actual eye movements, for viewers to perceive the area in the left corner of the visual field as the point of departure and the entire picture as organized from left to right. Also contributed by the viewer is the downward pull—the perceptual counterpart of gravitational attraction.

Less obvious is the influence of the viewer's position upon the depth dimension in pictorial space. Of the three spatial dimensions only the two in the frontal plane are directly given, whereas the third can be perceived only indirectly, by means of superposition, perspective gradients, and similar devices. Pictorial depth is contradicted by stereoscopic vision, motion parallax, and the so-called accommodation of the eyes' lenses, which explore the physical situation and report that the picture is a flat plane. The sense of touch also testifies to the flatness of the surface. If nevertheless the depth effect of pictures can be quite compelling, this is due in part to the dynamism of the observer's glance. As the glance strikes the picture plane perpendicularly, it strives to continue in the same direction and in doing so digs into the depth dimension. The glance provides the pictorial composition with an additional axis, which reinforces any depth-directed vector offered by the composition itself, e.g., by central perspective. This means that merely by looking at a picture, the viewer gives it more depth than the structure itself contributes.

As far as lateral directionality is concerned, let me repeat that it is largely independent of eye movements. What is involved here are vectors inherent in the field of vision, which probably are generated by the physiological asym-

metry of the cerebral hemispheres in the brain. In the interval since I discussed this phenomenon in an earlier book, studies of the differing functions of the two cerebral hemispheres have suggested new ways of understanding it.[4] The right hemisphere of the cerebral cortex turns out to be more congenial to visual perception and its organization. We can accordingly expect asymmetry in the visual field. The left side of the field, corresponding to the projection areas in the right half of the brain, is endowed with special weight. It serves as the dominant center of the visual experience and the reference point for the rest of the pictorial field. Objects placed on the left assume special importance: they enjoy the security of things located close to a strong center, and the viewer identifies with them first. From this anchoring of percepts in the left half of the visual field there results an uneven distribution and evaluation of weight, which can best be understood by comparison with what happens in the vertical direction under the influence of gravity. We noted that a composition can afford weightier objects in its lower region, which is nearer its gravitational center, than in the more remote upper region. Applied to the asymmetrical distribution of weight in the horizontal, this means that the left side of the field, as the home base of vision, can accommodate weightier objects, whereas objects located on the right receive additional weight through their distance from home base—the "rubber band effect." Therefore they should be weaker in themselves or the composition will be off balance. An object moved from left to right becomes heavier. It also looks more conspicuous since it appears away from the main center, with which the viewer primarily identifies.

It should be understood that the factors imposed by the viewer upon the structure of the projective image compete with properties inherent in that structure itself, and that the overall perceptual result derives from the interaction of these various contributions. Thus the anchoring center in the left side of the visual field will compete with other centers introduced by the composition as well as with the overall center of the composition around which the pattern balances as a whole.

For a concrete illustration of the forces pervading a pictorial composition, I have chosen Henri Matisse's still life *Gourds* of 1916 (Figure 22). We can trace, first of all, the effect of the downward gravitational pull. All five objects stand upright, as distinguished from what their spatial orientation might be if they floundered in weightless space. In spelling out the vertical explicitly in its axis, the white pitcher acquires a dominance that is hard for the other objects to match. The lower half of the canvas is occupied by two large, compact objects, which compensate for the anisotropy of weight in the upright dimension and

4. An extensive literature on hemispheric specialization is now available and becoming popular. For a recent critical review, see Corballis (23).

FIGURE 22.
Henri Matisse, Gourds. 1916.
Museum of Modern Art, New York.

give the whole picture a solid mooring. Turning the picture upside down makes it clear how excessive the weight of these two objects would be if they occupied the upper region.

Each of the five objects is endowed with properties that make them strive against the gravitational pull: the large blue gourd reaches upward with its neck; the pitcher is dominated by the crescendo of the opening cone and a handle whose center lies high up; the little red funnel has its maximum expansion at the upper rim; the handle of the pan cover makes it seem ready to lift off; and a yellow gourd on the plate points upward like a chimney. Together the five shapes form a chorus of uplift, which strongly influences the mood of the entire performance.

So much for the gravitational effects. It is also true, however, that we see Matisse's five objects floating in space like balloons. Only the gourds lying on the plate rest on a solid support. The black and blue background of the painting serves no such function although the objects look somewhat attached

to it. Essentially the objects are controlled by their own weight, held in place by their mutual attraction and repulsion. Quite noticeably also the rectangular contour of the painting acts as a dynamic center in its own right. The white pitcher is attracted by the upper border as though suspended from it. The tilt of the large blue gourd is seen as due to attraction from the left border. Thus the downward pull is by no means uncontested.

The effects of the five objects upon one another depend upon their relative visual weight; and the weight is determined first of all by their size. The larger objects exert a stronger attraction than the smaller ones. But other visual properties influence weight as well. The explicit volume of the pitcher and the plate makes them heavier than the flat objects. As already mentioned, the pitcher profits also from its conformity to the picture's vertical axis. Equally stabilizing is the horizontal coordinate, to which the covered pan and the base formed by pitcher and funnel respond. The large gourd seems to lose some of its weight because of its tilted position, whereas the small funnel gains much weight from the intensity of its red color. Any strong contrast in color or brightness contributes to weight. Finally, complexity of shape and color, as on the plate, makes an object heavy.

The various weight qualities are intuitively evaluated by the eye. They determine the distances between the objects, delicately chosen by the painter. It would be tedious to assess these relations in detail. In a general way we understand that the two lower shapes, because of their heaviness, must keep a greater distance between them than the smaller shapes, whose mutual attraction is weaker and therefore requires less constraint. In the overall composition, the various components are felt to balance out fairly near the geometrical center of the rectangular picture.

Also an essential part of the structure are the connections established by similarity. The red objects are tied together, as are the yellow ones. The blue gourd is linked by color to the right side of the background and by shape and size to the plate. I will not discuss here the function of the divided background, but will only mention that the slight tilt of the dividing line is pressed into an indication of depth by the viewer's glance.

The grouping of elements around the middle is overlaid by the effect of the aforementioned tendency to read a picture from left to right. Under this asymmetrical influence, the blue gourd in the lower left corner becomes an influential countercenter for the whole composition, the base point from which it all starts and to which it all relates. There is some tendency in the viewer to identify with that base and to perceive, for example, the pan on the upper right as a distant object, conspicuous and weighty because of its remoteness from the anchoring center.

The foregoing analysis should have given the reader some inkling of the complexity of a composition that after all is relatively simple. The various structural principles overlay one another and frequently endow a particular element with contradictory characteristics and functions, making it at once central and peripheral, strong and weak, detached and connected. The artist organizes this rich web of relations with what may be called his intuitive intelligence; and the richness of the formal structure reflects a corresponding profusion of meaning.

My description of the Matisse still life refers not only to the configuration of elements but to the dynamic structure that governs their relations and organizes them all in the total composition. In practical usage the two concepts, configuration and structure, are often confused, as though any configuration or pattern were ipso facto a structure. The difference, however, is fundamental. A configuration taken by itself—for example, the four dots corresponding to the corners of a square—is not held together by dynamic forces. The four dots on a piece of paper are not dynamic centers in the sense I have been using. As physical objects they have no appreciable weight, they exert no attraction, and they do not connect to form a square. Ignorant of one another, lifeless, they happen to lie in the same plane, and even when projected upon the retinas of a pair of eyes they acquire little if any connection. It is only in the visual projection areas of the brain that they evoke centers of energy, which can interact and thereby create a visual structure. Only as components of a percept can they be compared to the sort of physical structure formed, for example, in a magnetic field. To be sure, the purely geometrical properties of a given configuration are of fundamental importance for the structure that emerges. The stimulus properties, as the psychologist would call them, of the Matisse painting help determine the structure that constitutes the viewer's experience. The size, shape, color, and location of the five objects make up the pattern, which is worked into a structure by the nervous system of the viewer. This is the decisive step that transforms a piece of canvas covered with bits of pigment into a painting.

LIMITS AND FRAMES

T HE VISUAL WORLD is endless. It surrounds us as an unbroken space, richly subdivided but without limits. When we isolate a portion of the world for a photograph or realistic painting, for example, it is always with the understanding that the world continues beyond the segment's borders. The visual world overrules the delineation of territories; it denounces artificial partitions, such as the political boundaries of nations traced on the continuous relief of the earth's surface.

While the visual world resists boundaries, it takes more kindly to the establishment of centers. It is populated with, in fact constituted by, centers that dominate their surroundings in the large and in the small: the sun ruling the landscape, a house in the midst of fields, red apples on a tree, two eyes in a face. The web of interacting fields of forces, generated by these centers, constitutes the structure of what we call the visual world.

COMPREHENSION REQUIRES BOUNDARIES

Nonetheless we can neither perceive nor understand nor act without carving limited areas out of the world's continuity. Not only does the range of the endless whole and the place of each part in it surpass our comprehension, but the character, function, and weight of each object changes with the particular context in which we see it. A bird confined to its nest is not the same thing as the bird with its nest in a tree; and by the time the tree becomes part of a landscape, characters and functions and visual weights change again. A small landscape, extirpated from the background of a painting and enlarged as a picture in its own right, can become unrecognizable. This means that the nature of an object can be defined only in relation to the context in which it is considered. To keep an object constant, one has to put a frame around it—and keep the frame unchanged.

What matters for our present investigation is that in most compositions the center is decisively determined by the pattern's limits. The boundary indicates what belongs and what does not, and only after that range has been defined can the components of a composition be seen to organize around its center. It is for this reason that in the following pages I explore the conditions and functions of boundlessness and boundaries in some detail.

We can isolate an object and set it against a plain ground, but only with the understanding that the ground does not represent an empty world but a null context. An elephant shown in an empty world would be a falsification, distorting the animal's nature intolerably. But an elephant drawn on a blank piece of paper or modeled in clay and placed in an unrelated space is acceptable if the statement leaves open all the contextual extensions that define the animal in its world.

An animal painted on the wall of a prehistoric cave is essentially unrelated to what occupies the space around it, although in a purely visual sense the paleolithic artist may display some sensitivity to the distribution of shapes on a surface. In spite of all the crossings and overlappings, the artist seems to focus on the single animal, devoid of context. But as soon as art undertakes to show man in his world, it must show him in space; and to show him in space, a definite delimitation is almost indispensable. A frame of a particular size and shape defines the location of the things within its space and determines the distances between them.

Even murals generally need clearly defined borders. This does not mean they are independent of their surroundings. On the contrary, murals conceived and made for a particular place in a building cannot be seen correctly in isolation. For example, the long mosaic friezes on the walls of the nave in San Apollinare Nuovo in Ravenna must be seen as twins facing each other and directed toward the altar of the church. They are really elements of a larger and comprehensive work of art, namely the interior of the building as a whole.

Only when a work occupies a central position in its larger spatial context can it be truly self-sufficient and at the same time an integral component of the whole setting. Leonardo's *Last Supper* with its symmetry and highly controlled order is as self-contained a composition as anyone can think of (Figure 23). Its only open dimension is the one toward the front, and it is that dimension by which the painting relates to the axis of the refectory on whose head wall it was painted. Since the surrounding interior does not deflect any aspect of the painting's compositional framework, Leonardo's composition can be safely inserted into the architectural setting. Its integrity is threatened neither by the continuation of the perspective nor by the light that seems to be thrown on the depicted scene through the refectory's windows.

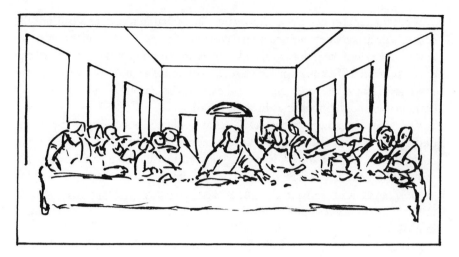

FIGURE 23
(after Leonardo)

In sculpture, too, works made for a context depend on that context. This is true, for example, for the rows of statues in the deeply recessed jambs of Gothic churches. When they are removed from their place, for example, as plaster copies, the figures of such a group lose their size, their spatial accents, their meaning—not to mention the deformation that occurs when one of them is singled out for solitary display. Or look at the two giant Dioscuri (horse tamers) in front of the Quirinale Palace in Rome (Figure 24). Their poses add up to a single action, even though at their present placement on the fountain, an obelisk stands between them. In relation to the whole arrangement, the men are placed on the outside, the horses on the inside—a decisive compositional distinction that would be lost if one of the sculptures were shown in isolation.

Works of architecture are more nearly complete in themselves, although they, too, mostly belong in a larger spatial context. A church pointing eastward needs to be seen in its dependence on the morning sun. Four buildings defining a square belong together although they may also be perceivable by themselves as single compositions. Their orientation toward a common center in the square will accord with the orientation each of them has by itself. For example, the center may lie at the crossing of their symmetry axes (Figure 25).

I will refer only briefly to the unintended influence visual objects can have upon one another when they are seen together in the same space. Elsewhere I have reported on experiments showing the changes that occur in paintings when they are perceived along with adjacent paintings.[1] There are effects of

1. Arnheim (13), p. 61.

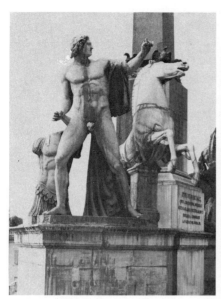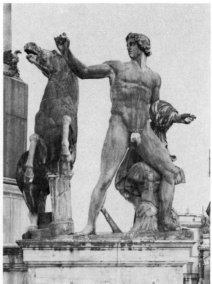

FIGURE 24.
Horse Tamers. Roman replicas
of Greek originals of 6th–5th century B.C.
Piazza del Quirinale, Rome.

contrast, by which the pictorial depth in one painting may become too shallow because of the greater depth in its neighbor. There are also assimilation effects, by which the movement in one picture may be enhanced through the strong movement in another picture beside it. One might say that the natural continuity of the visual world exacts compensation when we try to create strictly self-contained entities.

In what ways does a work of art legitimately reach beyond its physical limits? A building creates a field of forces around itself. As a dynamic center the building shapes the space of its surroundings. Depending on its visual weight and the direction of its vectors, it demands a definite amount of unoccupied space, more in front, less in back. A cylindrical tower creates a symmetrical field all around it. A wedge-shaped building needs a right-of-way for its concentrated thrust.

Sculpture similarly calls for the appropriate space around it and shapes it in accord with its own structure. A special problem arises when the subject matter of a work alludes to elements outside the composition. A well-known example is Michelangelo's *Moses* (Figure 26). If one wished to maximize understanding of the story, its representation would have to include the crowd

FIGURE 25

of Israelites worshiping the golden calf. But a misguided visitor trying to "complete" the sculpture by imagining that it included the distant crowd would simply destroy the composition. The figure of Moses, instead of acting as the only center of the work, would become one of two competing centers, and the two would be balanced around a third, somewhere between them. Moreover, the figure would now have an inner and an outer side—one facing the scene on Moses's left, the other facing away from it. This would interfere with the frontal, somewhat symmetrical view, which is intended to dominate the work. The weight of all the elements in the work and the relations between them would be altered, and the figure would become unreadable.

Viewed correctly, the deflection of the lawgiver's head and the fierce concentration of his glance introduce an oblique vector that moves outward like the beam of a lighthouse. But no goal object is included: the beam of energy evaporates with increasing distance from the center, and the compositional arrow it creates has to be offset and is offset within the dynamics of the figure itself.

An equally well-known instance is Velázquez's painting *Las Meninas* (Figure 27), in which a small mirror image of king and queen appears in the background. The scene makes physical sense only when the royal couple is taken to stand this side of the depicted space, somewhere in the vicinity of the viewer. But the painting is destroyed and its meaning falsified when the viewer includes the extrapolated couple as part of the visual image. In that case, the

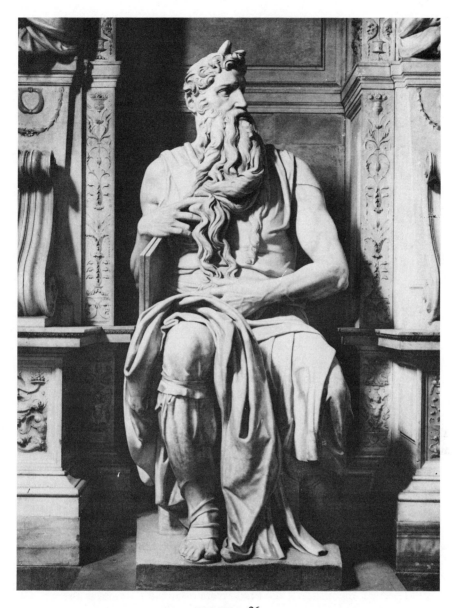

FIGURE 26.
Michelangelo, Moses. 1514–1516. San Pietro in Vincoli.
Rome. Photo, Alinari.

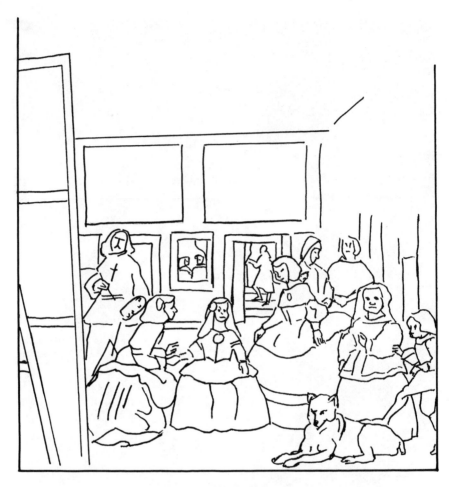

FIGURE 27
(after Velásquez)

painter and his model are no longer the central subject of the scene; they become the object viewed by king and queen, who would then stand in front of, not behind, what is happening. The sin of not taking the picture literally would prevent the visitor at the Prado from giving due weight to the symbolism of the statement that the sovereigns are small, confined, and in the background, whereas the painter stands large in the spacious foreground, turned away from their majesties. He is subservient only to his work, the large canvas that stands before him.[2]

2. Many interpretations of the *Meninas* could be cited to illustrate the misconceptions that result when a work of art is confused with the physical situation it represents. Since Velásquez

ONCE MORE, THE VIEWER

There is one external entity, however, which is indeed a genuine component of the pictorial situation, namely the viewer. Not that he could ever become a part of the work itself, in the sense, for example, that work and viewer would become elements of a composition whose balancing center would lie somewhere between them. The viewer looks at the work from the outside. Nevertheless, in pictures especially, there are aspects that make sense only in relation to a viewer. This is true, first of all, of the picture's flatness. In being visible only from the front and not from the sides or back, a picture indicates that it exists only on a particular condition, namely in its relation to the viewer. For truly correct communication the viewer has to stand in front of the picture and look at it perpendicularly. The location of an appropriately placed viewer is a prerequisite of the picture's existence.

As I pointed out earlier, the viewer's presence can also have a bearing on the content of the picture. The frontality of a figure or object in the picture may come to mean that it faces the viewer. This is not true for early forms of art, such as children's drawings, in which frontality does not yet represent a specific aspect of appearance that distinguishes it from other aspects and carries a meaning of its own. But in most religious images, for example, the icon does indeed face the visitor. Another telling example is erotic exposure. A Titian Venus does not recline privately on her couch but exposes herself to the viewer.

Note here a subtle distinction: With respect to the flatness of the picture as a medium, the viewer indeed acts as the anchoring center of the perceptual situation. But when it comes to the content of the artistic statement, he is only the target, not an active contributor to the field of visual forces. Just as Michelangelo's Moses radiates ferocious displeasure toward a particular direction of the environment, so the Venus exposes herself to the outside, but no responding recipient is admitted to complete the scene from the outside. Titian's composition is carefully and completely balanced within its frame.

It is risky, therefore, for an artist to have figures in his paintings flirt with the viewer. They may be made to look at the viewer as though they had just become aware of his presence, scrutinizing him as though to gauge his reaction, or inviting him to join the scene.[3] Such dubious tricks become acceptable with the Renaissance, when the sure sense of the ontological difference

wanted the royal couple in the background, who are we to move them to the physical space in front of the canvas? It is one thing to deepen one's understanding of a work by bringing knowledge about the subject matter or the artist to it; it is quite another to try to widen and reshape the visual range of the work by enlarging the composition through one's "imagination." See, e.g., Brunius's defense of contextualism (17); also Volk (62).

3. See Neumeyer (43).

between image and physical presence begins to give way and when self-conscious illusion tries to compete with representation.

A comparison of pictures with practical objects such as a chair or a pair of scissors might sharpen the argument. A chair is indeed incomplete without the body of the person intended to sit in it. In addition to the "retinal presence" of the chair, there is the induced presence of the sitter, who adds an important visual countercenter to the composition. Similarly, the metal loops of the scissors call for the fingers of the user as an integral part of the situation. The designer has the difficult task of inventing a form that makes the object look balanced and complete by itself and at the same time capable of being integrated in the larger whole, which includes the user, his body, and his limbs. No such specific role exists for the viewer of a painting, although there is the medium's general need to be looked at.

Architecture offers examples similar to the chair and the scissors. Neither a portal nor a bridge nor a public square is complete without its users. It is true, however, that architectural shapes are less directly determined by contact with human bodies than chairs and scissors. Therefore, they function more independently as artistic statements in their own right. Frank Lloyd Wright's Guggenheim Museum may be said to need the stream of visitors moving down its spiral, but even as an empty shell it has a complete beauty of its own.

Sculpture alone seems to neither admit nor require the active presence of the visitor. Granted that a congenial setting such as a sanctuary or the Lincoln Memorial in Washington can define a statue as poised to receive the worshippers, but without that help the sculpture seems to repose in its own being. Even the great Buddha of Kamakura is immersed in his meditation, incapable of admitting any interlocutor. This is all the more true for works that have been deprived of their public function, or never possessed one. Michelangelo's *David*, removed to the rotunda of a museum, no longer calls to the citizens of Florence and is unaware of their calling on him. There is nothing in the composition of sculpture that derives its meaning from the viewer's presence. Even the difference between the dominant aspect, for example, the frontal view, as against subordinate side views cannot be said to serve primarily for the viewer's guidance. Rather, the dominant aspect rules the hierarchy of the sculptural composition, which can be explored by the viewer but which makes no advances to him. Canova's marble figure of *Paolina Borghese* (Figure 28), although approaching the flatness of a relief, exposes the frontality of her body much less explicitly than does the coerced access to the Titian Venus. One can walk and should walk around *Paolina*, and thereby relate the principal view of her to the array of subsidiary ones.

Architecture and sculpture dwell in the physical space they share with visitor and viewer. They differ thereby from painting, which creates pictorial

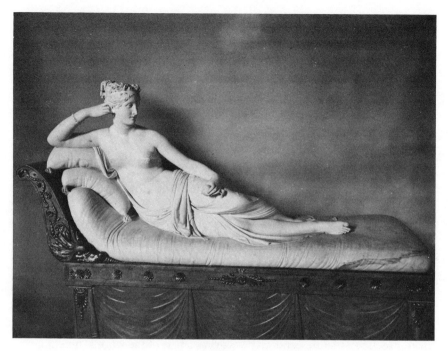

FIGURE 28.
Antonio Canova, Paolina Borghese. 1805. Galleria Borghese, Rome.

space the viewer can never enter. Any attempt at interpreting pictorial space the way it would be seen by a hypothetical viewer inside the picture would intolerably contradict the perspective demanded of the actual viewer standing in physical space outside the picture. This point is worth making because some theorists have tried to explain the misnamed "inverted perspective" in early styles of art in terms of an "internal" viewer.[4] Since I have discussed this problem elsewhere in some detail, here I will say only that a purely intellectual construct can never be maintained when it violates the perceptual conditions of a given picture. The geographical location of the viewer, as reflected in the structure of the picture, can only be outside, in front of the canvas.

THE FRAME AND THE OUTER WORLD

The range of a work of art, which is what we are discussing here, is strictly confined by picture frames in painting. The framed picture develops in Europe roughly in the fifteenth century as the external manifestation of a social change. Until then pictures were integral components of architectural settings,

4. See Arnheim (7) and Uspensky (61), chapter 7, on internal and external points of view.

commissioned for a particular place and designed to meet a particular purpose. When Van Eyck's altarpiece was temporarily moved from Ghent to a Berlin museum as booty during the First World War, it was deprived of its life-giving setting and its magic. There was no way to make it work as mobile merchandise. But when artists began to produce their Bible stories, their landscapes, their genre scenes for what we would call the market, i.e., for a whole class of customers rather than to meet a particular commission, the works had to become portable.

Aesthetically, the frame does not only limit the range of visual objects intended to constitute the work. It also defines the reality status of works of art as distinguished from the setting of daily life. The frame makes its appearance when the work is no longer considered an integral part of the social setting, but a statement about that setting. When the work of art becomes a proposition, its changed reality status is expressed by its visible detachment from the surroundings. Boris Uspensky relates the function of the frame to the phenomenon of *ostranenie*, estrangement. The frame indicates that the viewer is asked to look at what he sees in the picture not as a part of the world in which he lives and acts, but as a statement about that world, at which he looks from the outside—a representation of the viewer's world. This implies that the matter seen in a picture is not to be taken as a part of the world's inventory but as a carrier of symbolic meaning.

When, for example, Poussin in one of his paintings shows Jupiter as an infant being nursed by a goat, he presents the scene in an open, continuous landscape, indicating that we look at a limited episode extracted from boundless space and time (Figure 29). But visually as well as representationally, the scene also has its own completeness. And the spectacle of adults caring for a child under makeshift conditions in mountainous wilderness has a human validity and significance that transcends the particular episode, especially when we understand that the infant is the future powerful ruler of the gods, protected against the murderous intentions of his father. The picture acts as a proposition.

Although the frame indicates the altered reality status of the work of art by detaching it from the setting, it also serves as an intermediary between the two worlds. In relation to its inside, the frame confines the range of the picture; in relation to the outside, the frame makes the picture a physical object, a piece of furniture. Artfully carved and gilded, the frame associates the painting with chairs and tables and gives it the style of the room. The simple geometry of its shape sets it off against the background. The circular *tondo* in particular, as we shall see, provides a radical separation by defying the gravitational pull reflected in the vertical and horizontal patterning of walls, doors, and furni-

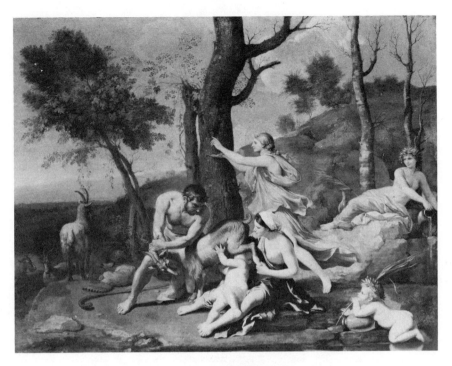

FIGURE 29.
Nicolas Poussin, The Nurture of Jupiter. 1635–1636.
Dulwich Picture Gallery, London.

ture. A square frame conforms to the gravitational framework of physical space but ignores the qualitative difference between horizontal and vertical. Only the rectangular frame, by far the most frequently used, acknowledges this distinction. A horizontally extended picture stresses the stable reposefulness of the room, whereas a vertical format pushes upward and raises the height of the ceiling.

Less simple shapes are rare. Very recently we have seen occasional examples of free forms used for frames. They provide a lively interaction with the surroundings, thrusting into the outside like amoebas and withdrawing under the impact of external pressure. They promote a transition from painting to sculpture.

The four sides of a rectangular frame have a characteristically ambiguous function. On the one hand they can ignore gravity and be equally oriented toward the center of the rectangular space. As the top border presses downward toward the center, the bottom border presses upward symmetrically, and the two lateral borders press inward. There is a centrifugal expansion in all

four directions as well. Ornamental frames promote this centrically symmetrical version when their design is the same on all four sides. Conceived in this fashion, the frame underplays the importance of the vertical and horizontal coordinates and stresses the center. It is a conception better suited to the square than to the rectangle and resembles the tondo in its effect. E. H. Gombrich has written: "The frame, or the border, delimits the field of force, with its gradients of meaning increasing towards the center. So strong is this feeling of an organizing pull that we take it for granted that the elements of the pattern are all oriented towards their common center. In other words, the field of force creates its own gravitational field."[5]

FIGURE 30

On the other hand, the frame can be treated gravitationally as a kind of post-and-lintel construction, in which the top reposes on the two sides. It is a view that is made explicit more often in the frames of windows and doors than in those of pictures because the former are more directly committed to the surrounding building than the latter. The top may be emphasized by an arch or cornice, the sides stress their verticality by colonnettes, and the bottom becomes a base or sill (Figure 30). Best suited for an upright format, such a window or door is symmetrical in relation to a vertical axis and underplays the balance around the center point. If applied to paintings, this design suggests compositions with a strongly vertical dominance.

THE FRAME AND THE INNER WORLD

Consider now the frame in relation to the picture it contains. I have already noted that every frame must be thought of as a center of energy, whose particular effects depend on its shape and spatial orientation. Here again,

5. Gombrich (33), p. 157.

ambiguity in relation to the force of gravity plays a role. Gravitationally the bottom edge of the frame attracts the content of the picture most strongly. The sides act more nearly as parallels to the vertical shapes in the picture. Apart from the effect of gravity, however, all four borders exert their attractive power more or less equally, as the example of the Matisse still life has already shown (Figure 22).

The power of the frame as a center of energy is determined, first of all, by its own appearance. A heavy, bulging, gilded frame carries much weight, but it may also detach itself from the picture through its color, texture, and volume and thereby reduce interaction. A simple wooden strip, preferred by the modern taste, relieves the borders of some of their weight; but even an unframed canvas exerts considerable influence through the geometric simplicity of its four edges.

The more visual affinity there is between frame and picture, the more they can influence each other. When Seurat painted his frames with the same pointillist texture he used for his paintings and gave each area of the frame a color complementary to the one in the picture on which it bordered, he increased the interaction between frame and picture to a maximum. Decisive for the relation between picture and frame, however, are their locations in space.

As a rule, a picture and its frame lie in different spaces. This is not the case when a canvas is unframed and the picture surface simply comes to a stop at its four edges. Such edges tend to be perceived as the contours of the composition they enclose, which is in contradiction to their intended function in most paintings in the Western tradition. Western paintings are intended to create a pictorial space of their own. This requires more than simple separation from the environmental space, in which the picture dwells as a physical object. The separation is difficult to obtain without a frame that overlaps the pictorial space.

Take the simple case of a child who draws a few objects on a plain piece of paper. The objects will be perceived as "figure" lying on top of the "ground," which continues beneath the objects. The distinction between foreground and background creates the simplest kind of pictorial space, which is strongest next to the objects and evaporates into a spaceless paper surface with increasing distance. The four edges simply confine the piece of paper physically; they have no relation to its perceptual functioning as "ground." The same is true for the sketches of artists when they are not meant as compositions but simply show, say, a single figure. In some Far Eastern scroll paintings also, the paper or silk surface retains some of its material flatness throughout the picture so that the lack of an overlapping frame creates no problem. Compositionally, the rectangular outline of the picture interacts directly with the design, although, as a mere edge, it has limited power.

The traditional Western picture frame, by contrast, creates a window through which one looks into the pictorial space. The frame acts as "figure," which overlaps the picture space as ground. The picture space is perceived as continuing beneath and beyond the frame. How indispensable the frame is for such a picture can be seen when one looks at the reproduction of a painting printed on white paper. There the painting acts as figure lying on top of the white ground, which creates an awkward visual contradiction at the borders. The picture space is required by its nature to continue but instead is cut off by its own contours and thereby defined as a flat surface.

FIGURE 31
(after Mondrian)

When a picture with a solid-color background, such as a Holbein portrait on a blue ground or an icon on a gold ground or simply a drawing on a plain piece of paper, is framed, pictorial space is created next to the frame by the action of the frame alone, which imposes itself as "figure" upon the picture plane as "ground." The picture plane itself makes no explicit contribution. This changes when the frame cuts across shapes that demand continuation. Even a mere line, such as the horizon in a landscape, continues beneath the frame because of its inherent dynamics. So does any incomplete shape. The paradigmatic case of a painting by Mondrian in which a square-like combination of black bars is overlapped by a diamond-shaped frame has been analyzed by Meyer Schapiro.[6] Like all clearly and simply structured shapes, a square exhibits a strong tendency to complete itself when enough of its structure is given. The viewer receives the compelling image of a square or grid overlapped by the frame (Figure 31).

The continuation of shapes beneath the frame is not simply the completion of objects whose shape is known from experience. When, for example, an arm is interrupted by the frame, it will be seen as continuing according to its

6. "In this art which seems so self-contained and disavows in theory all reference to a world outside the painting, we tend to complete the apparent forms as if they continued in a hidden surrounding field and were segments of an unbounded grid. It is hard to escape the suggestion that

general direction, size, and color; but no hand will be seen or readily supplied by the imagination. There are no phantom limbs in visual perception.[7] And there is little difference in this respect between the behavior of representational objects, whose "missing" portions are known from experience, and abstract or nonmimetic shapes, about whose continuation no such practical knowledge exists.

FIGURE 32
(after Toulouse-Lautrec)

The contribution of the viewer's knowledge of the subject matter, however, cannot be discounted altogether. A seated figure cut by the frame below the knees does not behave entirely as would a mass of similar shape and color in an abstract painting. It is true that in both instances the shape will be seen as continuing beneath the frame, true also that no feet will be provided for the figure. But the visual knowledge that a human figure continues at a known length below the knees is likely to displace the figure's center of gravity within the picture. The center will be lower than it would be for the visible part of the figure alone. And if, for example, the frame shaves off the face of a profile head, as it does in one of Toulouse-Lautrec's paintings (Figure 32), the effect is quite shocking—not just because the most important part of the head is missing, but

they extend in that virtual space outside." (Schapiro [51], pp. 238–239.) Schapiro adds that "the root of Mondrian's conception of asymmetrically grouped, segmented forms spanning the field" will be found in the work of Monet, Degas, Seurat, and Lautrec.

7. In the above-mentioned paper, Brunius (17) asserts that the perceiver "will reconstruct the fragmentary bodies inside the frame into complete wholes according to the Gestalt laws. A part of a horse is reconstructed into a whole horse in our experience, etc." This amounts to confusing the spontaneous completion of perceptual shapes, as demonstrated by gestalt psychologists, e.g., in the vision of hemianopics (Gelb [31]), with the completion of familiar objects on the basis of past experience, for which there exists no proof.

because the nearly complete shape of the head in a purely visual sense joins in claiming the missing piece of the structure. We do not object when the frame cuts off a narrow fragment of a circle; but when the decisive weight of a round shape resides in the missing piece, roundness protests against the violation of its integrity.

The fact remains that objects partially cut off by a frame are rarely completed by perceptual induction. Even so, the frame makes the fragmented objects look open and the space continue beyond the borders of the picture. This may seem to create a difficulty since a composition, in order to be readable, balanced, and meaningful, must be complete; and a picture cannot be incomplete and complete at the same time. The problem resolves itself when we realize that the structure of a composition is not determined by the purely quantitative completeness of its visual objects, but by the dynamic centers and the varying weights the structure holds in equilibrium. If the center of an object is firmly anchored in the picture, nothing much is missing when a peripheral piece of it trails off into invisibility beneath the frame. Conversely when a bit of an object shows in a picture with its principal center out of bounds, the contribution of that center is determined entirely by the extent to which its presence is induced by the visible part. An inconspicuous bit of rock or tree reaching into the picture is not strong enough to mobilize the principal weight of rock or tree; but a sheaf of planes or edges converging toward a perspective vanishing point outside the frame may create quite an active weight located at that focus and influencing the composition even without "retinal" presence (Figure 33).

The interruption of pictorial objects by the frame is nothing new. At least since the Renaissance it has been the rule rather than the exception in Western painting. Nevertheless only with the generation of Degas and Toulouse-Lautrec does the effect become patently shocking. We can now define the difference with some precision. In earlier painting, the fragmentation remained peripheral. It refrained from interfering with the essential centers of depicted

FIGURE 33

objects or with decisive characteristics of the subject matter. Traditional painters did not hesitate to cut off the bottom of a figure, the back of a coat, an elbow. They cropped the unbounded landscape or interior. Yet the head or bust of a portrayed person, although belonging to fragmented figures, were viable as independent entities. It is only when in the nineteenth century the frame is made to cut across objects with what may be called "photographic ruthlessness" that interference by the frame becomes conspicuous, dramatic, and significant.

A frame is not just a fence demarking the range of the picture. It also can take an active part in the play of compositional forces. The example of the Matisse painting (Figure 22) showed that the frame can act as a compositional center, attracting or repelling components of the picture. This presupposes, however, that the picture contains definite visual objects. If it displays a fairly even texture, as occurs in the paintings of the Abstract Expressionists, the frame cannot get a handle on the picture, for the reason that the frame acts essentially through the verticality and horizontality of its four sides. In fact, the frame supplies the Cartesian coordinates that the artist otherwise might have to represent within his design. The verticals and horizontals of the frame can suffice to define oblique directions in the composition as deviations from the basic "framework."

The opposite happens when Mondrian, in the kind of example mentioned above, frames paintings in a diamond (Figure 34). Now it is the composition itself that has to supply the basic coordinates. The picture creates an internal skeleton for the deviations perpetrated by the frame. Like the body of a vertebrate the picture is supported by an armature. If one tilts one of Mondrian's upright square compositions, the lack of the basic framework makes for an obvious lack of stability (Figure 35).

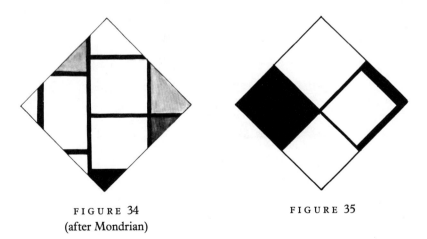

FIGURE 34
(after Mondrian)

FIGURE 35

VARIOUS FORMATS

The format and spatial orientation of a frame are determined by the nature of the picture and, in turn, influence the picture's structure. In representational painting, a landscape or crowd scene will normally call for horizontal extension, whereas a full-length portrait or a waterfall calls for verticality. The upright format strengthens the verticality within the picture. It makes the portrayed figure taller and the waterfall narrower and longer. In a landscape of horizontal format, the waterfall would lose some of its intensifying support, but it would also acquire a particular accent through the contrast it offers with the horizontality of the total scene.

The compositional vectors of a picture are likely to influence the way the proportions of its frame are perceived. This influence may account in part for the differences G. Th. Fechner discovered experimentally between people's preferences for certain proportions of rectangles and the proportions artists preferred for their frames. When Fechner presented observers with rectangles of various proportions (cut out of white cardboard and laid on a dark table), he found they tended to prefer ratios approaching that of the golden section, which he represented as 34:21. But upon investigation he discovered that other ratios were used more frequently for the frames of pictures in museums. For upright pictures the favorite ratio was 5:4, for horizontal ones about 4:3. This means that the preferred frames were more compact than the golden section, the upright ones to a greater degree than the horizontal. These preferences may simply reflect the requirements of the compositions. But they may also indicate that when a rectangle is filled with a pattern that exhibits certain vectorial tendencies, its proportions look different. Under such conditions the otherwise well-proportioned rectangle of the golden section may look unbalanced. In Figure 36 the 34:21 rectangle is subjected to two different directional stresses.

FIGURE 36

A similar problem arises for architectural interiors. The four walls of a room may be called its frame. A rectangular room will emphasize the longer extension and will have some of the connotations of a passageway. It will make a table look longer or shorter, depending on which way the table is placed (Figure 37). It will also give the table the connotation of either conforming to the flow of action in the room or blocking it as a counteragent. Here again, the content of the room may influence the appearance of the room's proportions. When Palladio designed his rooms according to the simple ratios that correspond to the basic musical harmonies, he based his reasoning on abstract geometrical shapes.[8] Such a formula could not include the modifying effect of the patterns structuring ceiling, walls, and floor, or the arrangement of furniture. The position of light sources, the distribution of brightness and color values, as well as the placement of doors and windows, will also affect the perceptual appearance of a room's basic proportions.

FIGURE 37

Pertinent here, furthermore, is the ambiguity of enclosures mentioned earlier with reference to frames and windows. The four walls can be conceived, on the one hand, as all serving the same spatial function, a condition favored by a square-shaped room. In that respect the walls create a kind of centricity and favor the focal point in the middle. By distributing the space around the center of the room, they promote a timeless repose, much as a rotunda does. But the longer dimension of a rectangular room will tend to create a dominant direction and produce an axial rather than a central symmetry. This spatial axis will introduce a time factor with the directed movement it suggests. Now the functions of the four walls are no longer equal. The shorter walls serve either as base of departure or as goal, depending on the direction of the room's movement, and the two longer walls become the lateral bed of a channel.

The difference between the two conceptions is reflected also in the different function and perceptual character of the corners. In the centric version, the corners are merely breaks in what is essentially a unitary wall, enclosing the room almost like a cylinder. This view of the corners is made explicit when

8. Wittkower (66).

they are actually rounded off (Figure 38). In the axial version, the walls are seen as crossing each other at the corners; they seem to proceed, each in its own direction, beyond the range of what can be seen.

FIGURE 38

THE LIMITS OF SCULPTURE

Frames may be defined as boundaries that are set against the painting or whatever else they enclose. But not all boundaries fulfill this function. The contour surfaces of objects such as chairs or violins belong to the objects themselves. Whatever they contribute belongs to the object's own structure. In fact, the boundaries alone determine a three-dimensional object's visual structure whenever the outside is all we get to see. This is the condition of sculpture. As long as a sculpture is not made of transparent material, its outer shape is our only information about the volumes of which it is composed. The two-dimensional surface of a sphere, for example, is seen as a three-dimensional sphere, and that means a centrically symmetrical configuration of forces.

The boundary surface of such a sculpture defines not only the configurational forces that constitute the work but also establishes the limits that these forces are permitted to reach. This does not mean, of course, that the vectorial effects stop at the boundaries of the sculpture. On the contrary, I have taken pains to point out that an object's visual forces spread beyond its confines into the surrounding space. But the range of that spread is determined by the size and shape of the object that carries the dynamics. The conical hood of Nicodemus in Michelangelo's Florentine *Pietà* (Figure 18) lunges into space, but only as far and in such direction as is dictated by its size and shape. Like a flame, its energy reaches so far and no farther.

When sculpture displays a diversified silhouette, it plays with the surrounding space in a variety of ways. It pierces and pushes it; it also creates,

through its own concavities, externally based counterforces, which invade the sculptural body. The simpler the shape of the object, the simpler is the pattern of its interaction with the surrounding space. A complex sculpture intertwines with that space in an elaborate tongue-and-groove action and is therefore inseparably connected to it, whereas a simple cube or sphere looks quite detachable.

Keep in mind here that such externally established countercenters are not a part of the composition (cf. p. 46). Only their effect belongs to the sculpture, as a passive quality. A concavity is perceived as the impact of an external source, but only the impact, not the source, belongs to the sculpture. The arrow that pierces the back of Niobe's daughter in Rome's Museo delle Terme is a part of the marble figure, but the wrathful gods who did the shooting are not.

Sculpture has none of the spatial openness that characterizes most paintings as limited segments of a boundless world. But a work of sculpture shares the painting's capacity to act as a microcosmic symbol of the world at large. Within the boundaries of a successful sculpture the relations between framework and deviations, unity and multiplicity, contrast and parallelism, advancing and yielding, rising and falling, etc., form a closed image of the human condition. Only when sculpture is made part of a larger compositional whole, usually in its relation to architecture, does it act as a component of a more comprehensive statement, as a center among centers.

COMPETITION FOR THE BALANCING CENTER

I will return to painting and to the particular problem of the relations between the center established by the frame and the dominant centers introduced by the composition. We have noted that every regular geometrical figure possesses a center, which can be established with ruler and compass. This is true also for elaborations of regular geometrical form, such as the quatrefoil frames of certain Gothic or Renaissance reliefs (Figure 39).

The geometrical center of the frame corresponds approximately to the visual center of the space it encloses. There are minor deviations. Owing to the gravitational pull, the balancing center of an upright square or rectangle will lie somewhat higher than the geometrical center, thereby compensating for the greater weight of the area's upper half. But such discrepancies are small.

The balancing center of the frame is decisive in determining the center of the composition it encloses. That overall center results, of course, from the interplay of all the visual centers that constitute the composition. Here again minor deviations may be observable, but by and large the center of the framed

FIGURE 39

picture coincides with the center of the empty frame. One might ask why this should be so. Examples in the next chapter will show that compositions are often dominated by a principal center that may lie far off the middle. Why should not the composition balance around that dominant center? An example will provide the answer.

Monet's painting of St. Lazare Station (Figure 40) is built upon two principal spatial accents. The roof of the station peaks on the central vertical of the canvas. The dominant mass of the composition, the dark locomotive, from which smoke spreads throughout the upper area of the shed, is located in the lower right corner of the picture. Its deviation from the spatial symmetry of the context invests the locomotive with a strong tension, which, together with the perspective foreshortening, points to potential mobility. But the locomotive's powerful visual weight is counterbalanced by the rest of the composition in such a way that the painting remains centered around the middle of the canvas.

Suppose now that Monet had balanced his picture around the off-center theme of the locomotive. What would happen? A strong incompatibility would develop between the center of the pictorial space and the center of the composition. The eccentricity of the dominant center, no longer confirmed by the equilibrium of the framed space, would offer the spectacle of a situation artificially prevented from attaining its final state. The viewer would be faced with the contradiction between the locomotive's being in the center according to the weight distribution of the composition and off-center according to the pictorial space. His response would have to be: "I don't know what you are trying to tell me! Let your picture take its course, and we shall see what it says when it has found its definitive order." The composition might seem to want to shift leftward behind the frame to enable the locomotive to find its place in the middle. This would resolve the conflict, but we would lose the picture.

FIGURE 40.
Claude Monet, Gare Saint-Lazare. 1877.
Fogg Art Museum, Cambridge, Mass.

In comparison, the composition created by Monet leaves no doubt about the nature of his statement. He shows a powerful eccentric element in relation to the symmetrical whole of which it is a part. This theme, with its accompanying symbolism, comes across only because the eccentricity of the crucial element with all its consequences is established by the composition. There can be nothing transitory or provisional about a pictorial statement if it is to be understood and accepted.

Let us now alter our thought experiment and suppose that the viewer, faced with the composition as Monet has given it to us, decides to take the situation into his own hands. To look at the picture, he places himself in front of the locomotive rather than opposite the middle of the canvas. This will shift much of the visual weight to the locomotive, which will no longer be off-center. It will sit there paralyzed as a static mass, devoid of the animating tension it derived from its eccentric position. But actually the viewer would not feel free to examine this state of affairs. He would be bothered by the sensation that he

was standing in the wrong place. His body would feel out of line with the framed picture as an object on the wall. The picture insists on coordinating the viewer with its own structural framework. He would feel the discomfort we know well from times when we are forced by circumstances to look at a picture obliquely. The viewer would also feel that he was unable to see the composition correctly.

Note here that when a picture is looked at obliquely, certain purely optical distortions occur. Strictly speaking, these distortions are always present since a projection remains undeformed only when it is received perpendicularly. This optimal condition is available at any one moment only for a small area of the picture. All the rest shrinks and shears. The size of the effect depends on the steepness of the viewing angle. The perceptual consequences of these optical distortions have been studied experimentally. They are offset in part by the so-called constancy of shape and size, a perceptual tendency that depends on how strongly the viewer perceives the tilt of the picture plane and how clearly the projective distortions appear as deviations from structurally simpler shapes.

What interests us here is that people seem to mind those inevitable distortions less when they stand right in front of the picture than they do when they stand off center. The difference is not due simply to the degree of distortion. The discomfort engendered by the distortion increases when it is experienced as being caused by an inappropriate viewing position. In practice, of course, viewers often do not remain anchored at one spot, even though it may be the optimal, central position. Unless a picture is very small, they walk back and forth in front of it. But in doing so they must avoid shifting their conception of the center of the composition to whatever spot happens to be directly in front of them. They must look at the picture from any position as though they were looking from the middle. It is as though someone stood in the Pantheon in Rome and looked at the cylindrical space from some point away from the center of the floor. He will understand what he sees only if the particular deviation of his vantage point from the symmetry of the vaulted interior is built into his percept. He will then compensate automatically for the optical distortion caused by the accident of his position.

The need to conform to the structure of the pictorial composition creates a tricky problem when it comes to a particular device for representing space in Western painting, namely central perspective. Just as one does not receive an undistorted optical projection of a square unless one faces it "squarely," a perspective projection becomes distorted unless it is seen from the correct vantage point. I am not sure why this particular manifestation of the phenomenon has aroused such special concern, but we are often warned that perspec-

tive constructions must be viewed from the correct position, whereas much less attention is paid to similar potential distortions of other shapes.

What happens when a purist, faced with a picture done in central perspective, insists on taking up his position opposite the vanishing point as the rules of optics prescribe? His response works well as long as the vanishing point coincides with the balancing center of the composition, as, for example, it does in Leonardo da Vinci's *Last Supper* (Figure 23). Such cases, however, are quite rare. Artists are free to place the vanishing point of one-point perspective—the simple construction to which I am limiting myself—wherever they please, and they do just that. We are alerted that something is wrong with the purist's procedure when the vanishing point lies outside the picture frame, as it sometimes quite legitimately does. Is our purist going to face a spot on the wall beyond the picture and look at it from there? He would be equally off base, as we know from the example of Monet's locomotive, if he tried to treat any eccentric point within the picture as the balancing center of the work.

The vortex of converging edges and planes created by the center of one-point perspective is a focus of compositional energy like any other, albeit a particularly weighty one. In Tintoretto's *Discovery of the Body of St. Mark* (Figure 41), for example, the vanishing point lies close to the left edge of the painting, at the saint's raised left hand. Despite its eccentric location, this point is the strongest center in the composition because the architecture of the entire loggia converges toward it. Since visual vectors operate in both directions, one can also say that the entire internal space is generated by that distant focus. The focus is increased in visual weight by virtue of being located at maximal depth, i.e., at the greatest distance from the viewer. Such a strong center must be carefully counterbalanced in the rest of the composition, or the whole will topple.

The strength of the perspective pattern would become overpowering if the viewer were to position himself in front of the vanishing point. The depth effect is most compelling when observed from the optically correct location—more compelling than the composition permits in our particular example. In addition, however, the entire meaning of the painting would be distorted if the viewer were to center it around the figure of the standing saint. It is the essence of Tintoretto's conception that a paradoxical discrepancy be created between the narrative and visual prominence of St. Mark on the one hand, and his off-center position on the other.

A similar tension is deliberately produced by the relation of the viewer to the architectural space of Tintoretto's picture. If the viewer were to face the vanishing point of the perspective "correctly," his line of sight would coincide with the framework of the loggia. Instead, when he faces the center of the

FIGURE 41.
Jacopo Tintoretto, The Discovery of the Body of St. Mark.
1562–1566. Pinacoteca di Brera, Milan.

canvas, his line of sight crosses the axis of the loggia. The viewer's position is made to be at odds with the structure of the world he is facing. To establish contact with the scene in spite of this spatial discord requires a particular effort, characteristic of the challenge offered to viewers by Baroque art.

But the viewer is at odds with more than the framework of the compositional space Tintoretto offers him. By the rules of projective optics, the situation is not only awkward, but impossible. If the loggia in which the miracle takes place were not a picture but physical reality, and if the viewer were to walk from the left wall to the center of the loggia, the vanishing point would travel with him toward the right. In the picture, however, the vanishing point remains immobile and thereby commits the viewer to the corresponding place

near the left side of the frame. If, as the composition demands, he insists on walking toward the center of the canvas, the change would correspond in real space most nearly to a rotation without displacement, as indicated in Figure 42. This is only approximately true; I am assured by experts that such a rotation would subject the projective setting to a shearing effect, to which the picture does not do justice.[9] Strictly speaking, the view received by a person standing in front of the picture's center is optically impossible.

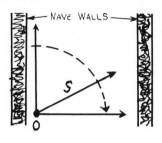

FIGURE 42

Why does this discrepancy matter so little in actual experience? Let us recall, first of all, that in Western painting pictorial space is separated by the frame from the viewer's space. Only under special conditions does an artist attempt to bridge that separation and, as I pointed out, he does so at some risk. In making a painted figure look at the viewer or inviting the viewer to join the painted world, the artist risks an uncontrollable extension of his composition, which will make it ambiguous, self-contradictory, unreadable. Such a unification of picture space and viewer's space is presupposed when the viewer is forced to conform to the perspective in the picture. It pulls him in and makes him help offset the center of the picture.

Note that in the special case of Leonardo's *Last Supper*, the risk is avoided. There the center of the perspective coincides with the center of the composition, and the prescribed line of sight corresponds sufficiently to the axis of the refectory at Santa Maria delle Grazie. As I pointed out earlier, the composition around the painted supper table remains undisturbed by the outer environment, which conforms to it.

Such exceptions apart, the viewer looks into the space of a Western painting as an independent world, separate from his own. He may see a landscape while he himself stands in a room. He may see the interior of a building whose axis runs at an angle at odds with the axis of his own space. When the picture shows two objects partially overlapping each other, that overlap persists unaltered,

9. Arnheim (9), and critical comments in subsequent issues of *Leonardo*.

no matter where the viewer stands. The very unalterability of the pictorial space is incompatible with the viewer's space, which changes whenever he moves. Any displacement of perspective needs to be evaluated in this context. It is no more "wrong" than the rest of the picture. But it is peculiar in that it offers the unique experience of a visual world that can never be seen. It is not the world as someone else could see it—nobody could ever dwell in a visual world whose orthogonals converged in a point removed from the horizon point of his own line of sight!—but the direct experience of a world that has been sidestepped, made unreal, detached. It is an estrangement from experience accomplished within that experience—an effect comparable only to those of modern surrealism.

THE ACCENT ON THE MIDDLE

W HEN THE EYES meet a particular picture for the first time, they are faced with the challenge of the new situation: they have to orient themselves, they have to find a structure that will lead the mind to the picture's meaning. If the picture is representational, the first task is to understand the subject matter. But the subject matter is dependent on the form, the arrangement of shapes and colors, which appears in its pure state in "abstract," non-mimetic works.

As one approaches Franz Kline's *Painting # 2* (Figure 43), one sees at first a mere assemblage of shapes distributed all over the canvas, running in different directions, crossing each other, etc. To understand why they belong together and what they are doing to one another, one has to ascertain how they balance around the center of the total composition. In Kline's painting that center is not explicitly given. Two central bars enclose it from above and below as they move from left to right. The cluster of smaller shapes near the upper border of the frame defines itself as perched above the center. The bar standing on the left side tilts away from its vertical stance by leaning toward the center, from which it is, however, quite remote. It differs from the heavier bar on the right, which would reach the center if it smashed down like a barrier, pivoting around its base at the frame. In relating to the center of the picture, the elements relate to one another and let the viewer sense what the work is about.

The balancing center of Kline's painting is intuitively determined by the interrelation of the shapes. In omitting any more explicit indication, the painter increases the to and fro of movement. He underplays the restful stability of the whole. He also keeps the viewer on special alert because to perceive the painting's equilibrium under these circumstances requires a major organizational effort.

FIGURE 43.
Franz Kline, Painting #2. 1954.
Museum of Modern Art, New York.

THE CENTER CONTRIBUTES STABILITY

It follows that in cases where a sense of stability is to prevail, the center will probably be distinguished by a special marker. This is likely to be true particularly for compositions at an elementary level of visual conception. To give tangible presence to the reference point of orientation facilitates the task of both draftsman and viewer. Elementary visual logic also dictates that the principal subject be placed in the middle. There it sits clearly, securely, powerfully. At a more advanced level, the central object is promoted to heading a hierarchy.[1]

Through the ages and in most cultures, the central position is used to give visual expression to the divine or some other exalted power. The god, the saint,

1. In a book of 1922 Hans Kauffmann (36) pointed to a centrically symmetrical "style ornament," which, in his opinion, characterizes the composition of Rembrandt's figure paintings. A dynamic system of radii is said to create centripetal rosette shapes and centrifugal star shapes around a compositional center. Since I no longer have a copy of the book available, I am citing from a review by Ludwig Münz in *Kritische Berichte zur kunstgeschichtlichen Literatur*, Leipzig 1927-28 and 1928-29, pp. 149-160.

the monarch, dwells above the pushes and pulls of the milling throng. He is outside the dimension of time, immobile, unshakable. One senses intuitively in looking at such a spatial arrangement that the central position is the only one at rest, whereas everything else must strain in some specific direction. In the Byzantine churches the dominant image of the divine ruler holds the center of the apse. In portrait painting, a pope or emperor is often presented in a central position. More generally, when the portrait of a man shows him in the middle of the framed area, we see him detached from the vicissitudes of his life's history, alone with his own being and his own thoughts. A sense of permanence goes with the central position.

One of the attractions of country fairs in my childhood was a large wooden disk, rapidly rotating like a merry-go-round, which with its centrifugal power would throw us off when we tried to sit on it. The center of the disk was the only spot where one could stay in relative security, and the competition for space near that center was frantic.

Geometrically, of course, a center is a point. Perceptually it reaches as far as the condition of balanced stability holds. It may be a small spot or the head of a person or indeed a whole figure. It may also be a compact cluster of objects, such as a bowl of fruit. In the extreme example of a Byzantine painting of the thirteenth century, the Madonna with her child and the cylindrical throne surrounding her may be said to be one large center, which nearly fills the total picture space (Figure 44). Although there is much differentiated detail, the entire theme partakes of the immobility of the central position.

Symmetry, in particular, creates centricity, and therefore makes the center extend as far as the symmetry reaches. It may be a central face with its vertical axis and its pair of eyes, or a figure with symmetrical limbs, or the façade of a building. The frame around a picture, by virtue of its symmetry, may be called an external center, whose stability holds the composition together from the outside, just as the middle supports it from the inside. Through this double constraint a kind of pincer movement contains the free flow of life, which is the picture.

Since the middle position is the place of greatest importance, the viewer attributes weight to whatever he finds in that position. In a triptych, for example, the picture in the middle draws special attention. Or when Ingres depicts Oedipus solving the riddle of the Sphinx, he indicates by the central position granted the hero that the story is about Oedipus, not about the monster (Figure 45). Centrality can serve in this manner to convey the intended hierarchy of the composition. It can lend special distinction to an object of relatively insignificant size. For example, in Michelangelo's *Last Judgment* the figure of Christ is no larger than the many other figures crowding

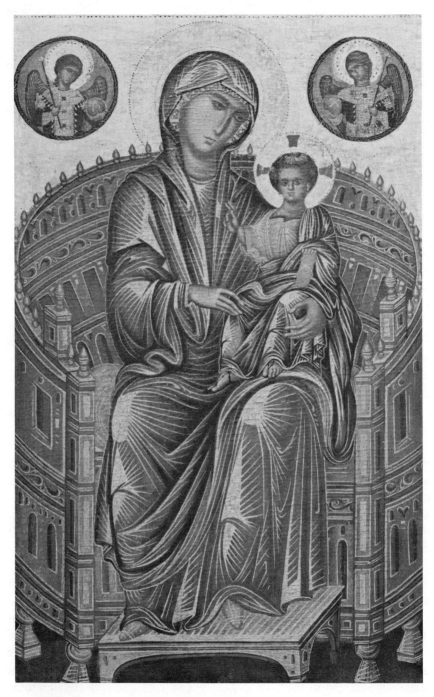

FIGURE 44.
Enthroned Madonna and Child. Byzantine School. 13th century.
National Gallery of Art, Washington, D.C.

FIGURE 45.
(after Ingres)

the scene. His central position is one of the visual attributes by which he is
made to stand out.

The power of the center can be exploited to create a teasing contradiction
between an element kept deliberately small and its crucial importance for the
story being presented. The tension generated by such a paradox was much in
vogue during the Mannerist phase of Baroque art. For example, Pieter Brue-
gel's complex landscape with the fall of Icarus (Figure 46) is centered around
the tiny figure of a shepherd, who peers searchingly at the deadly spectacle in
the heavens. Although his is the only response to the cosmic tragedy taking
place, the viewer's attention is distracted by the large and colorful plowman,
who, right next to the shepherd, turns his back, concentrating on his own
business. Once discovered, however, the little man, spellbound by his central
position, holds the key to the entire scene.

When a part of a larger object, for example, the head of a person, is caught in
a central position, it can become so strong as to sweep the rest of the body
behind it like a comet's tail. This can be observed in Gentileschi's *Young
Woman with a Violin* (Figure 47). The girl's head is fastened to the central
vertical and thereby confirmed as a dominant center. It supplies the oblique
movement of the figure with a mooring in pictorial space. At the same time the
head is too far above the midpoint of the picture to serve as the composition's
balancing center. By contrast, when the body of a figure is gathered around the

FIGURE 46.
Pieter Bruegel the Elder, Landscape with the Fall of Icarus.
1558. Musées Royaux des Beaux-Arts, Brussels.

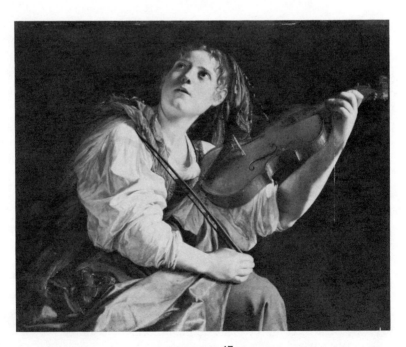

FIGURE 47.
Orazio Gentileschi, Young Woman with a Violin. 1611–1612.
Detroit Institute of Arts.

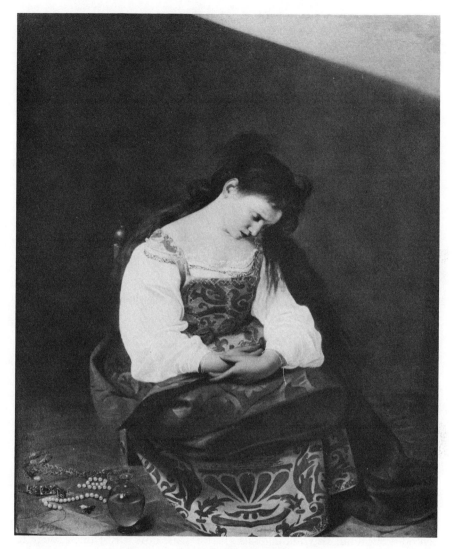

FIGURE 48.
Michelangelo Caravaggio, St. Magdalen. 1594–1596.
Galleria Doria Pamphili, Rome. Photo, Alinari.

central vertical while the head alone sharply deviates from it, as in Caravaggio's *Magdalen* (Figure 48), the head looks all but decapitated—much more so than it would if the figure were located in another part of the picture space. In this example, the balancing center of the composition is clearly defined by the folded hands and the similarly folded red bow of the belt. The head's fall from symmetry is all the more shocking.

PLAYING AROUND THE CENTER

Much tension can be created when a strong compositional center is given a somewhat eccentric position. In Rembrandt's *Self-Portrait* at Kenwood, the head is placed to the left of the central vertical (Figure 49). But since its dominant position is not challenged by any representative of the basic compositional framework, the head is strong enough to impose a framework of its own upon the picture. It shifts the central vertical to the left, thereby upsetting the equilibrium and creating a discrepancy between the rectangle framing the painting and the composition. The relation between the squeezed space to the left of the head and the expanded area to its right looks provisional.

By this reading, the picture displays the powerfully dynamic image of an old man who keeps a deviant balance of his own by pulling himself away from the framework prescribed by the world. His repose is maintained at the price of constant resistance to the magnetism of the central vertical. But there is also another, more stable way of perceiving the picture. In this second version, the central vertical wins out. The figure arranges itself obligingly around that vertical, the head to the left and the countercenter of palette, left hand, and brushes to the right. Now the figure, instead of rebelling against the framework of the composition, is sustained by the central axis and in turn sustains it. The painter is at peace with the world.

It seems to me that the ambiguity, which encourages both these readings, is characteristic of the Baroque. The Baroque style is known for generating tension in many different ways. In this case it achieves the effect through the viewer's vacillation between two equally significant views, which are close enough to combine in the unitary image of an intrinsically contradictory stance.

As a further example of this kind of ambiguity I will cite the placement of the kneeling Christ in El Greco's *Agony in the Garden* (Figure 50). The figure is close enough to the balancing center of the painting to be perceivable in two contradictory ways. It can be seen as located off center, straining toward the central vertical but also holding back. At the same time it is strong enough to claim the central vertical and pull it toward its own axis. The rock, which surrounds the figure, holds it back, but the dialogue with the angel promotes a pull in the opposite direction. The dialogue ties the figure of Christ to a secondary balancing center between the two figures. This union of the two principal figures is reinforced by the dominant color scheme, with the triplet of the primaries presented by Christ's red garment, his blue coat on the ground, and the angel's yellow robe. The primaries demand one another for their completion and thus tie the two figures together. When the viewer tries to reconcile the dynamic effects of the various relations, he comes to sense the

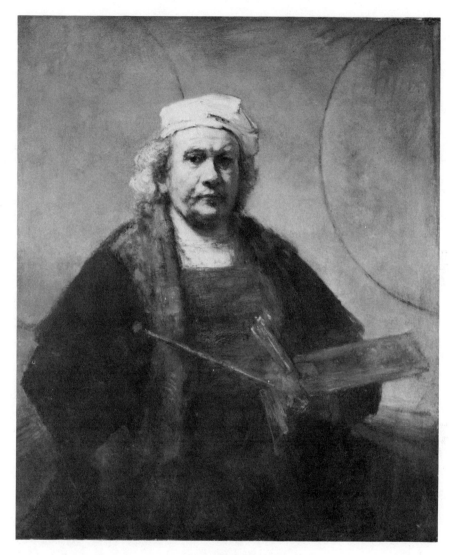

FIGURE 49.
Rembrandt, Self-Portrait. 1660.
Iveagh Bequest, Kenwood, London.

complexity of the Mannerist composition, a tug of war that may offer no definitive outcome. The tension between advance and hesitation in the location of the central figure conveys a problematic state of mind, possessed by conflict.

Our examples show that artists at sophisticated levels of conception often are not content to mark the balancing center of a composition with a clearly

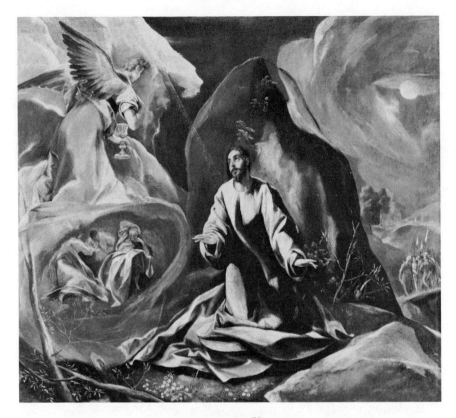

FIGURE 50.
El Greco, The Agony in the Garden. c. 1510.
Toledo Museum of Art, Spain.

defined object. Symmetrical patterns can spin out centricity over a wide area.
The winged staff of Mercury, the caduceus, with its two serpents winding
symmetrically around the stick, is a playful, animating variation of the central
axis (Figure 51). We observed that Rembrandt endowed his self-portrait with
a dynamic equilibrium by balancing the head of the figure at the upper left
against the palette and hand at the lower right. Such enriching variations are
particularly applicable to the stance of the human figure. In simple, early
images of the crucified Christ, the human figure is sometimes as schematically
symmetrical as the bars of the cross. At more complex levels of style, e.g., in a
Michelangelo drawing of the same subject (Figure 52), the axis of the body is
differentiated into a tilted head, a chest slanting in the opposite direction,
another countermotion in the legs—all of which add up to a series of deviating
elements, which oscillate as the viewer's eyes move along the suspended body.

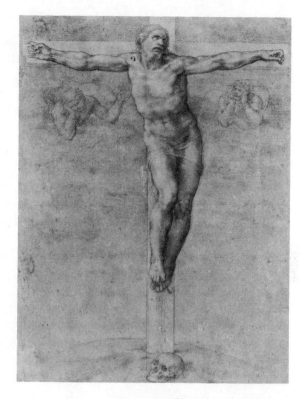

FIGURE 52.
Michelangelo, Crucifixion for Vittoria Colonna (detail).
c. 1538–1541.
British Museum, London.

The dynamic counterpoint created in this manner expresses tortuous pain, but more generally conveys a sense of animation as well.

Such examples illustrate the counterposition or *contrapposto*, introduced for variety's sake to enliven the basic symmetry of the human body, which governed archaic sculpture, as in the Greek figures of standing youths, the *kuroi*. The classical prototype of the *contrapposto* became the spear carrier or Doryphorus of Polyclitus, known to us through a Roman copy (Figure 53). By shifting the weight of the body to the right leg, the artist tilts all horizontal axes and converts their sequence into a play of oscillation. The central axis is not given explicitly but is arrived at by induction from the swinging axes of the counterbalancing knees, hips, and shoulders.

In classical practice the *contrapposto* is essentially a variation within the principal, frontal view, that is, within the second dimension. This early version

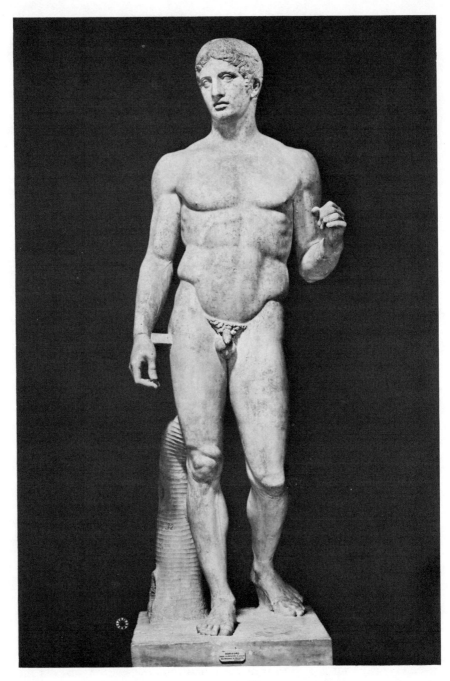

FIGURE 53.
Doryphoros. Roman copy after Polyclitus statue of 5th century B.C.
Museo Nazionale, Naples. Photo, Anderson.

of the device is carried into the third dimension, as David Summers has shown, by the Italian artists of the Renaissance. At that time the oscillation of the frontal figure develops into the continuous movement of the serpentine figure, which spirals around the internal axis of the sculpture. Read from the bottom up, the movement of Michelangelo's sculpture *Victory* (Figure 54) begins with a steep diagonal, created by the ascent from the standing right leg to the bent left leg. From the hips the torso continues the counterclockwise twist toward the shoulders, where the spiral is suddenly and violently reversed by the clockwise turn of the head.

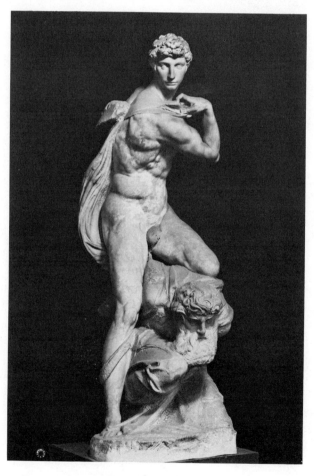

FIGURE 54.
Michelangelo, Victory. 1532–1534.
Palazzo della Signoria, Florence. Photo, Anderson.

Such a dynamic rotation stabilized by the central axis inspired William Hogarth in the eighteenth century to what he called "the line of beauty." He depicted it as a serpentine line inscribed in a pyramid (Figure 55). We may take the liberty of perfecting his figure a bit and envisaging it as a spiral inscribed in the pyramid in such a way that it twines around the central vertical, thus growing in size from top to bottom and creating a crescendo from an obliquely oriented movement. The movement changes its direction continuously as it rotates around the central spine. The static, immobile axis has acquired a dynamic variation, which nevertheless preserves its overall balance and symmetry. This combination of action and repose embodied Hogarth's ideal of beauty.

FIGURE 55

We have observed that a central position conveys stability. At any other location, objects are possessed by vectors that point in one or another direction. The central object reposes in stillness even when within itself it expresses strong action. The Christ of El Greco's *Expulsion from the Temple* (Figure 56) is a typical *figura serpentinata*. He chastises the merchant with a decisive swing of the right arm, which forces the entire body into a twist. The figure as a whole, however, is firmly anchored in the center of the painting, which raises the event beyond the level of a passing episode. Although entangled with the temple crowd, Christ is the stable axis around which the noisy happening churns.

A similar effect is obtained by Giotto in his *Deposition* (Figure 57). Here again the agitation of the mourners had to be counteracted by stabilizing factors, to impart the surpassing dignity and significance of the scene. The sweeping gesture of the bending disciple is fastened by the position of his head to the balancing center of the composition. This stabilization compensates for the momentariness of the gesture and gives it the permanence of a monu-

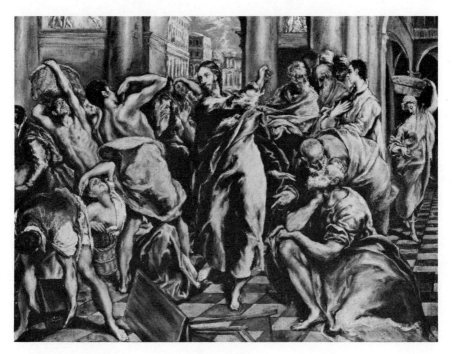

FIGURE 56.
El Greco, Expulsion from the Temple. 1595–1605.
Frick Collection, New York.

ment—a monument to grief. If the figure were placed away from the center, this effect would not obtain.

In a profile portrait by Picasso (Figure 58), a long neck sustains the heavy mass of the head like a tree trunk. The striking simplicity of the large eye adds so much weight to the face that it would throw the head off balance were it not placed on the central axis of the painting. By virtue of its location the eye becomes a countercenter, capable of sustaining weight that would otherwise act as an unwieldy cantilever and make the head tip over. Tied to the central axis, the head's bold thrust is held in a repose that underscores the classical beauty of the face.

In architecture also, the stabilizing effect of the central position is commonly used, in the vertical as well as in the horizontal dimension. I referred earlier to the pivoting function of wheel windows in church façades. A similar role is played, to cite one example, by the circular opening in the cupola of the Pantheon. This oculus provides the central peak to which the radial structure responds, converging or expanding. It also marks the vertical spine around

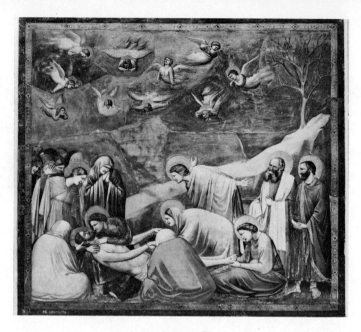

FIGURE 57.
Giotto, Deposition. 1304–1306.
Cappella degli Scrovegni, Padua.

FIGURE 58
(after Picasso)

which the cylindrical drum turns. In a longitudinal building, such as a basilica, the ridge of the roof provides a symmetry axis.

DIVIDING IN TWO

Thus far, the central vertical has been considered as supporting the spine of the composition. But it also serves an almost opposite function, marking the line along which a composition most easily breaks into two halves. The subdivision of a whole into its parts is determined by its structure. An asymmetrical separation, such as that in Figure 59a, cannot effectively break the structure in two because the larger area on the left bridges the center and thereby holds the rectangle together. But Figure 59b splits easily along the structurally prescribed fissure, dividing the rectangle symmetrically into two equal pieces. The Chinese philosopher Chuang Tzu's celebrated cook comes to mind; the master craftsman's knife never needed sharpening because he had studied the skeletal anatomy of animals so thoroughly that a mere touch of the knife at the right place made the joints come apart almost by themselves.

FIGURE 59

As soon as we split the compositional space down the middle, its structure changes. It now consists of two halves, each organized around its own center. The pattern represents the two symmetrical partners in a dialogue, balanced along their interface. Of course, the separation must remain partial lest the picture break up into two unrelatable pieces. Appropriate compositional features must bridge the boundary. Fra Angelico's *Annunciation* (Figure 60) at San Marco, for example, is subdivided by a prominent frontal column, which distinguishes the celestial realm of the angel from the earthly realm of the Virgin. But the division is countered by the continuity of the space behind the column. The space is momentarily covered but not interrupted by the vertical in the foreground. The lively interaction between messenger and recipient also helps bridge the separation. A bridging device of this kind might appropriately be called a "latch."

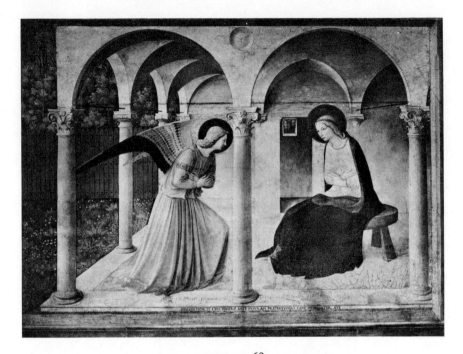

FIGURE 60.
Fra Angelico, Annunciation. 1439–1445.
Museo di San Marco, Florence. Photo, Alinari.

FIGURE 61
(after Tintoretto)

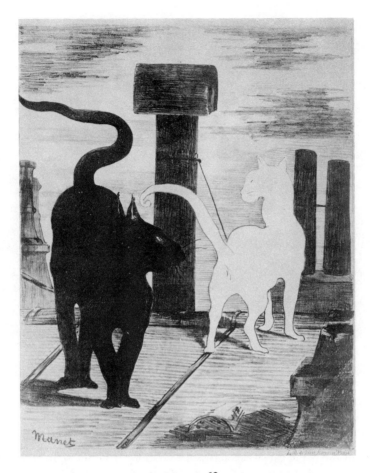

FIGURE 62.
Edouard Manet, Le Rendez-vous des Chats. 1870.
Boston Museum of Fine Arts.

One might study the role of the tree in the representations of Adam and Eve. In most cases the tree occupies the center like a column separating the tempting woman from the tempted man, but it also serves as a link between the two partners in the dialogue. The theme offers innumerable variations. In Tintoretto's version (Figure 61), Eve holds onto the tree as though to a possession. At the same time she reaches across the trunk in such a way that the apple, the *corpus delicti*, dominates the compositional center and is responded to by both figures, actively by the woman, passively by the man.

Similarly, Edouard Manet in his *Rendezvous of the Cats* (Figure 62) bridges the chimney, which separates the realms of darkness and whiteness, by having

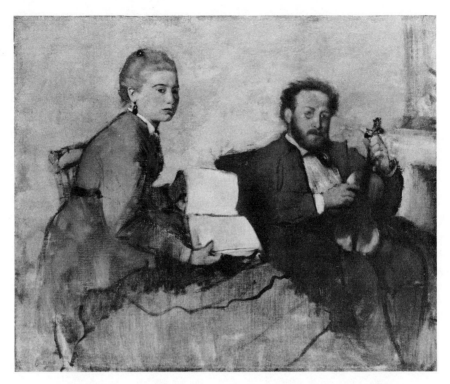

FIGURE 63.
Edgar Degas, Violinist and Young Woman. 1870–1872.
Detroit Institute of Art.

the tail of the white cat sweep across the chimney from the right and the head of the black cat poke into it from the left. It takes much delicacy to balance separation and connection successfully. Picasso, too, divides the scene of his etching *Minotauromachy* into the realm of darkness on the left, inhabited by the creatures of light, and the realm of light on the right, occupied by the monster of darkness. The Zoroastrian duality of light and darkness can be conceived as a struggle between contending powers, or as the interplay of complementary agencies in the spirit of yin and yang. The subdivision of an image into two halves serves to describe the various ways in which separate centers of energy can deal with each other, as friends or enemies, complementing or feuding with each other. The multiplicity of possible relations is reflected in a corresponding wealth of visual interactions between themes that are at once separated and connected by the central boundary.

An object placed centrally between the two halves of a composition necessarily has a double function. It divides and it connects. What is the function of the conspicuously open but empty book between the violinist and the young

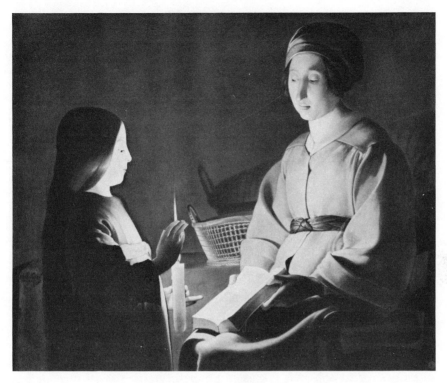

FIGURE 64.
Georges de la Tour, The Education of the Virgin.
Frick Collection, New York.

woman in Degas's double portrait (Figure 63)? It is the vehicle of the woman's advance toward the man, but she is as distracted as he is by a matter of common interest outside the space of their communion. Their interrelation is limited to the parallelism of their responses. They both do the same thing, which makes them ignore each other, and the blatant whiteness of the heavy upright book provides the visual barrier between two persons who paradoxically share the same narrow space.

No such disturbance interferes with the importance of the central object in La Tour's *Education of the Virgin* (Figure 64); but here, too, the book makes for a division. Instead of the open disclosure of its emptiness, with which the book shocks us in the Degas, the message of the brightly lit prayer book in the La Tour provides the substance that attracts the concentrated attention of both mother and daughter. And yet the very radiance of the object, which lightens the child more intensely than the mother, serves to point up the gulf between the terrestrial and transcendent realms.

THE INVISIBLE PIVOT

A CENTRAL POSITION conveys weight, stability, and distinction—this was the gist of the preceding chapter. The power of the center was shown to exert itself anywhere along the central vertical. It acquires particular strength, however, in the middle of that vertical, which acts as the balancing center for the entire composition.

THE SHAPES CREATE THE HUB

The balancing center is perceptually present whether or not it is marked by an explicit visual object. It is created by the interaction of all surrounding forces. Franz Kline's *Painting #2* was our first example (Figure 43). I tried to show that the various elements derive their function and meaning in the composition from the balancing center, which in that example remains unmarked. Depending on whether an element is placed above or below the center, to its left or right, close to it or farther away, the element's particular dynamics will be determined by this spatial relation. The same is true for the relations between the various elements.

For a simple physical analogy to this principle of visual behavior, consider a pair of scales. In itself the center tells us nothing. It acquires meaning by being the point at which the two weights balance; and the role and function of the two vectors of the scales can be understood only when they are considered from the reference point of the center. Similarly, visual compositions can be understood only when their components are viewed in relation to the balancing center.

Roland Barthes, as quoted by Bruno Zevi in his book on the language of modern architecture, has pointed to cities in which the center is not the "culminant point" of any particular activity, but a kind of empty focus for an image created by the community. He speaks of a "somehow empty image needed for the organization of the rest of the city."

The balancing center is generated by the components of the visual pattern, and in turn it gives meaning to them. In a work of art, the composition may be based mainly on the weight of two elements, which balance each other like the two pans of a pair of scales. This is the case in an *Annunciation* or any similar dialogue between two figures. But the number of determining elements may also be greater, as we saw in the Matisse still life (Figure 22), composed of five objects. In fact, the painting's space may be so evenly filled that the balancing of the whole is barely present and is diminished in importance. Some of Bruegel's crowded scenes may serve as examples, or the texture paintings of the Abstract Expressionists. The vectors created in such paintings offset one another locally rather than adding up to a concentric pattern. In our Western pictorial tradition, however, such paintings are more the exception than the rule.

The balancing center of a work of art is created by the arrangement of the shapes that constitute the work. More precisely, it is the constellation of visual weights that creates the balancing center. Conversely, however, it is the center that gives compositional meaning to each component, to the extent that that meaning depends on the location of the component in the whole. Therefore, in the process of making a work, the artist deals constantly with two interacting tasks: he shapes and arranges the components so they balance around a center for the composition as a whole, and he determines the nature and function of each component by its reference to the center. This second task derives from the fundamental fact that every component not located in the center needs a justification for that deviation from the base, i.e., there must be a clearly defined force that keeps the object away from that base.

This fundamental phenomenon of visual dynamics can be understood by analogy to diatonic music. In a tonal system, the expression and meaning of every tone or phrase is derived from the force that raises it above or drops it below the level of the keynote. In the same way, the balancing center of a visual composition serves as the tonal base for the "melody" of the work.

A composition may arrange itself around its center in a fairly quiet distribution of weights. Cézanne's painting *The Card Players* (Figure 65) is clearly divided into two halves. The vertical separation is bridged by the central player, the stable horizontal surfaces of the table, and the back wall. The figures of the two players who face each other contain oblique elements, but taken in their overall shape all three men are unmoved columns, each anchored to its own compartment of the picture and attending to its own business. Compare this with *Chastisement of Amor* (Figure 66), a painting attributed to Bartolomeo Manfredi. The three figures twirl around the pivot of the two central hands like the wings of a propeller. These two hands, which represent the balancing center, are of crucial significance. The man's grip on the child's

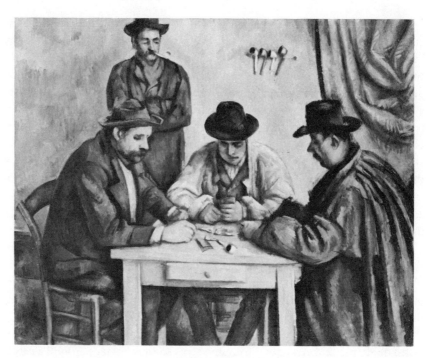

FIGURE 65.
Paul Cézanne, The Card Players. 1890–1892.
Metropolitan Museum of Art, New York.

wrist connects the two antagonistic principals, the man and the boy; it arrests the little love god's naughty activity. We meet here a first example of what I will call a microtheme. The balancing center of a painting is often occupied by an action that reflects and symbolizes in the small the subject of the whole work. This symbolic representation, as we shall see again and again, tends to be a simplifying abstraction, capable of conveying the theme with concentrated immediacy. In this case, the powerful hand of the man restrains the doings of the child much more directly than could be gathered from the full version of the complicated story.

But the main function of the center is to act as a hub. Around it the three figures of the scene thrust outward and inward in three main directions that meet obliquely. The castigator, although serving as the stabilizing central column of the composition, is made up of obliquely directed elements; his figure is tense with the opposition of his spread legs and the contrast within the arch of his two arms, one raised in action, the other pushing down to hold the victim. The arch formed by the spread arms is repeated in the figure of the woman, but at a different angle. And whereas Cézanne's quiet scene stayed

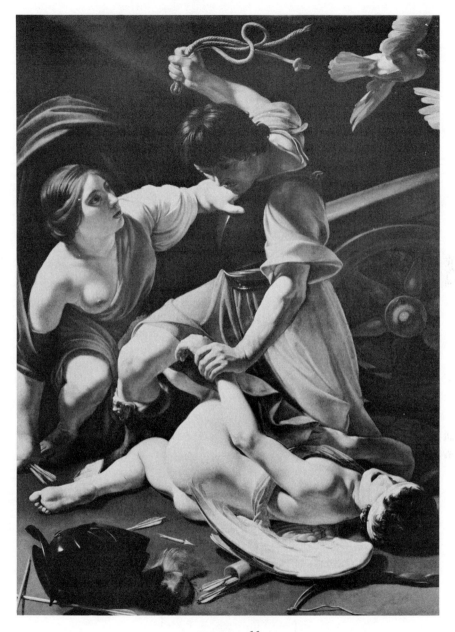

FIGURE 66.
Attributed to Bartolomeo Manfredi,
Chastisement of Amor. c. 1595.
Art Institute of Chicago.

essentially in the frontal plane, the Baroque trio tumbles around its center in all three spatial dimensions. If one were to consider nothing but the vectors sent out by the three faces, one would obtain a diagram of the dynamic crossings of three-dimensional space around the hub of the center.

Thus the spatial orientation of the principal vectors helps determine the tension level of the composition. When the vectors limit themselves essentially to the directions of the vertical/horizontal framework and interact at right angles, as they do in the example of the *Card Players*, the tension level is low. But when the main channels of action deviate from the basic framework by running obliquely, as in the Manfredi, the tension level rises.

Recall, too, that it makes a difference for the dynamics and meaning of visual action whether it runs upward or downward, vertically or horizontally. When adversaries meet on a horizontal base they are equally matched by their spatial position; in a vertical composition, however, having the upper hand spatially constitutes an advantage, whereas being in the lower position means having to overcome the pull of gravity as well as the opponent's onslaught. Thus there is no fair match between the castigator and the boy in the Manfredi. Interaction on more equal terms is reserved to the horizontal dimension of the painting: the woman trying to restrain the man. Similarly, the interaction of Cézanne's cardplayers takes place on level ground, as does any fair sports match. This basic difference in the dynamics of the two paintings is reflected in the format of their frames: the horizontal extension of the Cézanne stresses the sideways exchange between equals; the dominance of the vertical in the frame of the Baroque painting strengthens the theme of violent subjugation.

I must now correct a one-sidedness in my presentation. It was appropriate to stress the decisive function of the vertical, which divides a composition into a left half and a right half. But due regard must be given the other central axis, crossing the balancing center horizontally and dividing the picture space into an upper and a lower half. We thereby arrive at a basic pattern of two axes dividing the compositional space into four quadrants (Figure 67).

FIGURE 67

It takes reflection in a body of water to split the subject of a picture horizontally into two symmetrical halves, and it takes Narcissus to apply this pattern to the human figure. In the painting of Narcissus attributed to Caravaggio (Figure 68), the water's edge is located just below the geometrical center. This distribution of the area increases the dominant weight of the upper half of the picture. How different would be the spatial connotation of a

FIGURE 68.
Michelangelo Caravaggio, Narcissus. 1594–1596.
Galleria d'Arte Antica, Rome. Photo, Alinari.

FIGURE 69

composition in which the reflected person would be divided from the mirror image by a central vertical, as it is, for example, in Picasso's *Girl before a Mirror*! The horizontal dimension, as I observed earlier, provides equal chances for the two partners in the dialogue, and it requires additional attributes to designate either the real person or the reflection as the more weighty presence. In the Narcissus painting the transverse division assigns the superiority of the upper position to the real person and downplays the mirror image as a mere apparition—a Mannerist paradox since this distribution of weight works against the emphasis on the reflection as the target of the young man's concentrated attention.

There is, then, an inherent asymmetry in a transverse division, so powerful that even a symmetrical subject cannot overcome it. This points to a fundamental problem in the representation of the standing human body. Think of one of those figures inscribed in a circle or a square, as in the Vitruvian illustrations of the Renaissance (Figure 69). The balancing center of the figure in the navel or groin coincides with that of the frame. Taken by itself, a human figure would be seen as dominated by the head, the home of the main sense organs and the seat of reasoning—a version supported by the central vertical and the bilateral symmetry it controls. But no such symmetry exists visually around the central horizontal. The balancing center challenges the dominance of the head and proposes a structure organized around the pelvic area.

This creates an ambiguity that has been the inspiration and vexation of artists in representing the human figure through the ages. The formal ambi-

FIGURE 70.
Francisco de Goya, La Maja Desnuda. 1795–1797.
Museo del Prado, Madrid.

guity symbolizes the basic antagonism between the spiritual and the animal nature of man.[1] The artist, by presenting the figure in particular attitudes and contexts, suggests particular interpretations. In a reclining figure, for example, the head surrenders some of its prerogative; a transverse symmetry is created around the balancing center, which reduces the head to a counterpart of the feet. The oblique position of Goya's *Maja Desnuda* (Figure 70) plays with the teasing ambiguity derived from the competition between the two centers. The lady's inviting eyes attract the viewer's attention while the balancing center of the whole painting supports the appeal of her sexuality.

UPRIGHT COMPOSITIONS

The upright format of Daumier's lithograph *The Nights of Penelope* (Figure 71) indicates that a statement will be made on the relation between high and low. The lonely woman's unhappy darkness fills the lower half of the picture and even invades the upper region, threatening to swallow up the remaining light. In that upper half, horizontal interaction presents a struggle between darkness and light. The push of the light area beyond the central vertical produces what I would like to call a "piston effect." The narrow dark area on the right looks squeezed; it tries to relieve its compression by straining toward an equilibrium in which darkness and brightness would be of the same weight. Penelope's head stretches above the horizontal dividing line into the

1. See Knott's article on Klee and the mystic center (40).

FIGURE 71.
Honoré Daumier, The Nights of Penelope. 1842.
Stanford University Museum of Art.

realm of dream and happiness and unites with the picture of her missing husband. The obliqueness of her stance introduces the only strongly dynamic element in the otherwise static framework of the composition. This obliqueness is, as we know all vectors to be, ambiguous: in relation to the horizontal coordinate Penelope sinks back, overcome by her weakness; in relation to the vertical, she is drawn upward toward the desired reunion.

Verticality is especially pronounced, owing to the narrowing of the principal scene, in Vermeer's *Woman Receiving a Letter* (Figure 72). As happens quite

FIGURE 72.
Johannes Vermeer, Woman Receiving a Letter.
1667. Rijksmuseum, Amsterdam.

often in Baroque works, the balancing center is not sharply identified. It hovers somewhere between the head of the seated woman and the compact, weighty lute in her lap. Correspondingly the horizontal divide can be placed at more than one height, and this significantly enriches the meaning of the composition. From the base at the lute level the action rises, with the letter as the decisive initial impetus, and leads to the head of the addressee. She, in turn, extends the action to the maid by means of her questioning look. In the head of the maid the action stops. This progression on the scale of height is paralleled

by a progression in depth: the letter in the foreground overlaps the recipient, who in turn overlaps her confidante. The obliqueness of the zigzag connection between the three stations supplies the basic visual dynamics of the theme.

But the horizontal dividing line can be easily raised to the border of the gilded background panel, which crosses behind the head of the central figure. Viewed in this way, the scene clearly detaches the maid and removes her to the upper region. She stands freely, unimpeded by the sort of encumbrance that blocks off the space around her mistress. Upright like a tower, she dominates the scene, whereas her seated lady is confined in what might be described symbolically as the nether region of middle-class fear and prejudice.

Both readings seem to be relevant to the meaning of the scene. Relevant also is the sight of the total composition, to which one returns by stepping back from the principal theme and seeing the golden and bejeweled central figure securely entrenched in her symmetry. She holds the middle of the total setting with unshakable stability. We realize that the zigzag of the letter episode is nothing more than a minor flash in a solidly fortified existence.

HORIZONTAL COMPOSITIONS

How different from the stepladder of relations in vertical compositions is the world of the horizontal format, which stresses enhanced or impeded interaction. In Edvard Munch's lithograph *Jealousy* (Figure 73), the diamond-shaped face of the husband, whose hunched body is barely visible, seems suspended around the central horizontal axis in unstructured darkness. That axis is not explicitly drawn, but it cuts across the picture at the level of the man's eyes like a broiler spit. His whole being, uprooted in its detachment from any base, is concentrated around the one thought that leads from his eyes to the mid-sections of the guilty couple.[2] Yet the bridge of communication is cut by the central vertical division, and the difference between the two worlds is fundamental. The white face of the man is all openness, pointing outward with the concentrated stare of his eyes, whereas the man and woman on the right are enclosed in their dialogue. They are also removed to the freedom of the upper right quadrant of the picture space and surrounded by a wildly active setting. There is no actual symmetrical correspondence between the two worlds. As the viewer enters the picture from the left, he identifies with the intensely compacted face of the jealous man; and it is from the perspective of this weighty base that he perceives the scene of adultery.

2. Isak Dinesen, like Munch a Scandinavian, observes in one of her stories, "The Bear and the Kiss," that jealous persons "when they are sitting and guarding someone . . . like a cat in front of a mousehole, they take one's breath away so that it is difficult to move—and they themselves shrink until there is life only in their eyes."

FIGURE 73.
Edvard Munch, Jealousy. 1896.
Art Institute of Chicago.

In Munch's composition the interaction demanded by the horizontal format is explicitly broken by the white vertical divide. By contrast, Titian's painting *Holy Family* (Figure 74) is based on communication as its central theme. In few renderings of this subject is the figure of Joseph permitted to dominate the center. But in Titian's painting Joseph's central position is justified by his twofold role as a mediator and protector. Color offers an important clue. The foreground composition is based on Titian's favorite theme of blue and red. These two stable primaries are reserved for the Virgin and the shepherd boy, whereas Joseph is clad in the secondary colors purple and orange. Secondaries, being combinations of two colors, express transition. Thus the theme of mediation between the object of adoration and the earthly worshipper dominates the scene.

Joseph's head is anchored in the central vertical at the apex of the triangular scene, but his body emerges obliquely from the right lower quadrant, the realm

FIGURE 74.
Titian, Holy Family. 1516.
National Gallery, London.

of the ordinary mortal, from which Joseph himself originates. The ambiguity
of diagonals is nicely illustrated in this example. On the one hand, the leaning
figure of Joseph conducts the boy to the sacred scene of mother and child. On
the other hand, Joseph withdraws from him toward his family, thereby ex-
pressing the protective detachment of the sacred from the mundane realm.
This separation is explicitly represented by the vertical boundary line of
Joseph's staff and by his fist, which blocks the boy's view. The boundary,
however, is not strong enough to disrupt the central avenue of communication,
which reaches across the picture, connecting mother and child symmetrically
with the head of the boy.

 Two further examples will illustrate more specifically the function of the
vertical boundary in a horizontal composition. Bellini's *St. Francis in Ecstasy*
(Figure 75) shows the response of the monk to a divine apparition. The man
and his abode are confined to the lower right quadrant of the pictorial space.
The target of his ecstasy is outside the picture, indicated only by the oblique
direction of his glance. The figure advances toward the vision but at the same

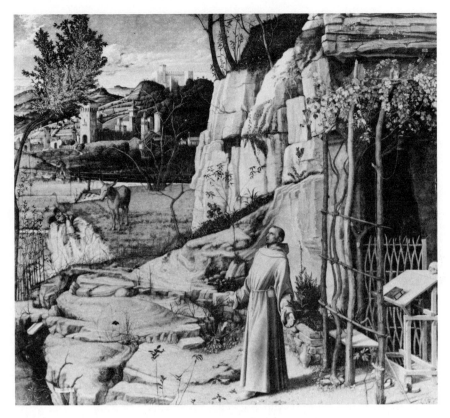

FIGURE 75.
Giovanni Bellini, St. Francis in Ecstasy. 1480–1485.
Frick Collection, New York.

time falls back in a gesture of passive surrender. This indirect representation of the source of Francis's ecstasy might be too weak were it not that the role of the divine apparition is taken over to some extent by the central vertical, whose presence is underscored by the edge of the rock and the tree trunks on top. The monk's attitude defines this boundary as the barrier he must not transgress.

Gauguin's portrait of Van Gogh (Figure 76) might remind one compositionally of Michelangelo's *Creation of Man* on the Sistine ceiling. In both works the gap between two lateral centers is bridged by the arm of the creator. The creator on the right faces the mass to be animated on the left, and in both cases the slightest touch of the fingers accomplishes the miracle of creation. But the resemblance ends there. In Gauguin's painting, the palette as the mediator between the maker and his work marks the central boundary between

FIGURE 76.
Paul Gauguin, Portrait of Vincent Van Gogh. 1888.
Stedelijk Museum, Amsterdam.

the two masses, which lean away from each other like the arms of a V. It is as though the clustered sunflowers were reluctant to receive the animating touch, and the head of the artist also withdraws as far back as his body and the picture frame will let him. His hand, which extends into the left quadrant, looks as though it were controlled more directly by the attraction of the flowers than by active innervation issuing from the artist's head. Creativity is portrayed here as a problematic matter. This impression is strengthened when we notice that Van Gogh's head, although located in the upper half of the picture, that is, in the region of dominance and freedom, is also tied to the ribbons of the landscape. They hold him down, rendering him submerged, almost suppressed.

DIAGONALS SUPPORT AND DIVIDE

Several examples have shown that visual action is conveyed primarily through obliqueness. This may seem surprising since the most direct action could be expected to be expressed by a motion straight up and down or

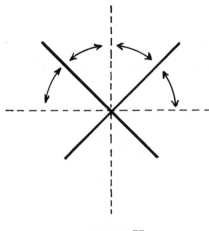

FIGURE 77

sideways, that is, by the most direct rising and falling or lateral advancing. However, when the directions of vectors coincide with the vertical and horizontal framework, they move along the paths of greatest stability, and therefore dynamic tension is minimized. Obliquely directed objects owe their strong dynamics to their deviation from the axes of the basic framework. In relation to the vertical they rise or descend while at the same time in relation to the horizontal they advance or recede. In each case the relation may be either active or passive (Figure 77). Actively, the object either moves toward the coordinate or withdraws from it; passively, it is either attracted or repelled by it.

Diagonals, however, are not exclusively characterized by their deviation from the vertical/horizontal framework. They are also structural axes in their own right. Although secondary to the principal coordinates, they, too, give stability to shapes coinciding with them. The result is the kind of axial framework diagrammed in Figure 78. Consider as an example David's portrait of Napoleon on horseback (Figure 79). Horse and rider pivot around a center located in the area of the rider's knee. Strong dynamics is generated by the deviation of the main compositional axes from those of the basic framework, which is barely indicated in the upright torso of the emperor. At the same time, however, one senses that the diagonals have a stability of their own, holding horse and rider in position as though we were looking at a monument. In spite of the intensity of the action, it seems frozen in a classical pose.

It is worth noting here that the diagonal connecting the upper left with the lower right performs such a holding action more effectively than would its

FIGURE 78.
From Arnheim (4), p. 13

symmetrical counterpart. This is so because its direction opposes that of the viewer's glance, which originates in the lower left and stops, as it were, the advance of the rising horse. If one looks at David's painting in the mirror, one sees the horse bounding much more freely.

In the David painting, the diagonals are explicitly embodied by the figures of horse and rider. In Cranach's *David and Bathsheba* (Figure 80) a diagonal theme is created more indirectly, by the connection between the king watching from the upper left and the woman seated in the lower right. In keeping with the vertical format of this picture, the action is not an interplay between equals but an imposition of power from above upon the victim below. But clearly, without the obliqueness of the principal connection, the mere layering of the two settings, one over the other, would have produced a much more static scene.

An analogy to the use of the diagonal theme as a compositional device in painting may be found in the floorplan of the theater stage. It has been codified, for example, in the tradition of the Japanese Noh drama (Figure 81). On the square-shaped plane of the Noh stage, which is marked by four corner pillars, the principal actor (*shite*) is based at the rear left pillar, whereas his antagonist or respondent (*waki*) operates from the near right. This creates a diagonal

FIGURE 79.
Jacques-Louis David, The First Consul Crossing the Alps.
1800. Musée de Versailles.

line of action, a visible reflection of the drama's dynamics. In a more informal way, similar spatial arrangements are used by Western stage directors for similar purposes.

Like verticals and horizontals, diagonals serve not only to support or create shapes, as in the preceding examples, but also to create separations. Seurat's *Le Chahut* (Figure 82) illustrates this point. The realm of the dancers is cut off from that of the musicians by a diagonal trench. Here again the separation

FIGURE 80.
Lucas Cranach the Elder, David and Bathsheba.
1526. Staatliche Museen, Berlin (West).

FIGURE 81

FIGURE 82.
Georges Pierre Seurat, Study for *Le Chahut*. 1889.
Albright-Knox Gallery, Buffalo.

looks quite stable because it reposes on the implicit diagonal across the rect-angular frame. This stable separation endows the violent action of the cancan with an almost static permanence. The sheaf of stretched legs becomes quite comparable to their stable parallel below, the neck of the bass fiddle; and so solid is this diagonal truss that it all but overrules the hefty vertical symmetry of the bass player, who roots the composition in the bottom of the picture.

NOLI ME TANGERE

Let me conclude this chapter with a somewhat more detailed discussion of Titian's *Noli Me Tangere* (Figure 83). The story, as told in the Gospel of St. John, plays on the ambiguity of the Christ figure, removed from mortal existence by his death—an apparition—but still endowed with the visible presence of a living man. He is still tangible but must no longer be touched because, as he explains to the Magdalen, who tries to verify his reality with her hand, "I am not yet ascended to my father." On this ambiguity of the relation between the man and the woman, the young Titian builds his astonishingly profound composition.

The "invisible pivot" of the painting is best defined as the balancing center between the two decisive elements, the heads of Christ and the Magdalen, although when one looks at the bottom scene by itself, the woman's head clearly dominates. In the larger range of the composition as a whole, it is the lower left arm of Christ that marks the middle, separating and connecting the two partners in the dialogue. This dialogue takes place in the vertical dimen-sion, that is, between a dominant and a subservient figure.

The man and the woman are accommodated in the separate quarters of the two lower quadrants, but the Magdalen breaks the central separation by the placement of her head and especially by the aggressive action of her right arm, which approaches the protected center of the man's masculinity. She is unde-terred by his staff, which acts as a visual boundary between the figures. Taken as a whole, the figure of the woman is an active wedge shape, trailing along the ground like a snail, but reinforced by the bright red of her garment. This identification of the woman with the hot color is answered by the cool coun-teragent of the blue water, which envelops the head of the man. His body reacts to the woman's advance by the concavity of withdrawal, brought about mostly by the inclination of the torso. But that inclination has all the ambivalence of a diagonal: when read downward, it makes Christ recoil from the touch; when read upward, it makes him bend protectively to receive the woman. The two centers of this body, head and pelvis, act in counterpoint to represent the ambiguity of the relationship between the two persons.

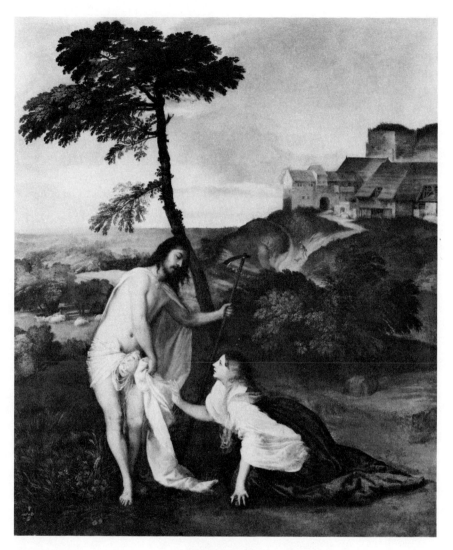

FIGURE 83.
Titian, Noli Me Tangere. 1511.
National Gallery, London.

Although the figure of Christ dominates the foreground scene, that scene as
a whole is, as it were, under water, confined to the lower half of the painting.
This lower region is separated by the horizon from the upper realm of free
spirituality, in which the tree and the buildings on the hill reach heavenward.
Although Christ is already removed from earthly existence, he is shown by

Titian as still sharing it with the Magdalen in this last encounter. He is still held down by the horizon and hemmed in by the trunk of the tree before moving upward to the sphere of transfiguration, in which he will become unreachable.

Titian's painting can serve as a prime example of the particular nature of a great artist's intelligence. It is an intelligence that manifests itself in the pictorial medium. It dispenses with verbal language but incarnates ideas through the symbolic meaning of shape and color deployed in space. A mature, powerful, and subtle interpretation of the biblical episode, its intertwining of religious and human aspects, is achieved and conveyed entirely by visual thinking of the highest order—in no way inferior to the abstract reasoning of the intellect.

TONDO AND SQUARE

SPHERICAL AND CIRCULAR objects are privileged foreigners in our midst. A ball, touching the ground at only one point, is less subject to friction than a cube, a product of the Cartesian grid. The wheel revolutionized transportation because it could roll freely. Since all diameters are equal, no one of them can be singled out. Knowing neither vertical nor horizontal, the sphere or wheel is unrelated to the Cartesian system and exempt from its constraints. It does not belong, and it does not have to obey. Having no angles and no edges, it points nowhere and has no weak spots. It is impregnable and unconcerned. Roundness is the suitable shape for objects that belong nowhere and everywhere. Coins, shields, mirrors, bowls, and plates are round because that makes them move smoothly through space. A round table has no corners to impede traffic. Look at the French miniature showing the Creator as he measures the world (Figure 84). The world is a closed universe, not attached to any particular place in its surroundings. It floats, and the Creator can move it around as he pleases. It has a center of its own, from which the measurement is made. It can turn or be turned without undergoing any change.

FLOATING SHAPES

During the Renaissance the so-called *deschi da parto*, given as presents at the birth of a child, became circular. They were tablets, painted with religious images on both sides. Masaccio's *Nativity* in Berlin and Botticelli's *Adoration* in London were probably intended as deschi da parto. Equally designed for mobile use were the Madonna tondi, such as the well-known Florentine terra cotta reliefs produced by the della Robbias and other artists in large editions as devotional images for private homes. More generally, it was no accident that tondi came into fashion in the fifteenth century, at a time when paintings were no longer exclusively commissioned for particular places but produced for any

115

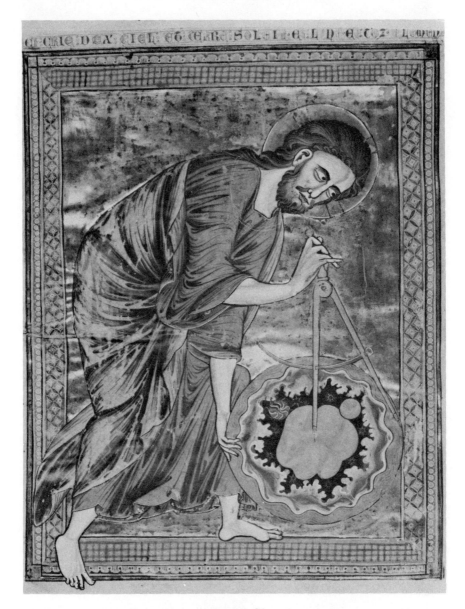

FIGURE 84.
The Creator Measuring the World.
From a French *Bible Moralisée*, probably Reims. 13th century.
National Library, Vienna.

FIGURE 85

place a customer wished to put them. The advent of the framed picture marked the emancipation of paintings as mobile art objects, and the tondo expressed this detachment from place and time most radically.[1]

Once we see round objects playing the role of privileged strangers in the physical world, we understand their analogous significance as visual symbols and art objects. The circle has been universally accepted as a religious image of perfection, a shape of total symmetry, hermetically closed off from its surroundings. It is the most general shape, possessing the fewest individual features but serving at the same time as the matrix of all possible shapes. As the fundamental form of our concentric model of space, it comes about through the expansion of a center in all directions and is characterized as such through its radii and a system of concentric rings. Its function is dramatized through its interaction with the Cartesian model, which generates the square. "The square, in contrast with the circle, is the emblem of the earth, and of earthly existence," says George Ferguson in his book on Christian symbols. This interaction between the concentricity of the cosmic model and the earthly grid of parallels is the basic pattern of visual art. It is represented schematically in a typical form of the Indian or Tibetan mandala, which depicts the integration of mundane nature with the divine (Figure 85).

We can now begin to understand why in the history of art the circular shape has served two quite different functions. It represents the superhuman, which

1. An extensive monograph on the tondo was published in 1936 by Moritz Hauptmann (34). I have also profited from a senior thesis by Elaine Krauss, done at the University of Michigan under my supervision in 1977 (41).

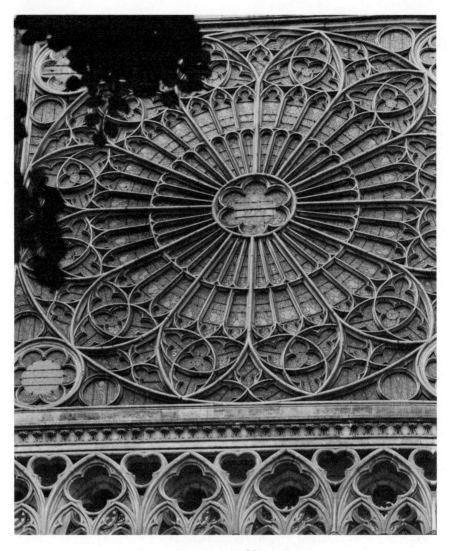

FIGURE 86.
Wheel window, Cathedral of Troyes.
13th century. Photo, John Gay.

is radically detached from the realm of earthly gravity, and also adapts well to playful decoration and frivolity by evoking a "floating world," unencumbered by the burden of human existence.

RESPONSE TO THE ROUND FRAME

Let us look first at the influence of the tondo format on composition. I noted earlier that a frame can be intimately connected with the composition it encases. The enclosing and enclosed shapes may be spatially continuous, and the structural framework of the one may reinforce that of the other. At the other extreme, the frame can act as a window through which one sees a more or less distant scene, extending beyond and beneath the limits of the frame. This spatial gap is particularly compelling when the two structural frameworks are at odds with each other, which will happen, for example, when the frame is circular while the picture is built essentially on a Cartesian grid.

Some conflict between the two spatial systems is almost unavoidable when the picture represents a terrestrial scene with upright figures, trees, or furnishings. Concentric compositions that avoid such conflict occur mostly in decorative work. The most obvious examples are the medieval rose windows with their radial spokes (Figure 86). But even when an essentially decorative composition uses figures or animals—for example, the relief work on medals—the subject matter is sometimes clustered around the center as a compact, nearly circular scene surrounded by a rim of empty space. This creates a centrically symmetrical pattern, in direct harmony with the roundness of the medal and in fact generated by it. More articulately symmetrical than such a cluster are various polygons inscribed in a circle. T. B. L. Webster, in a study of the pictorial decorations of classical Greek bowls, calls centric symmetry one of their main compositional features. He finds many scenes reducible to a triangle, quadrilateral, pentagon, or hexagon placed in a circle. A running figure may rely on a scaffold of three radii, and more complex scenes may make use of what Webster patriotically calls the Union Jack principle, that is, the sunburst formed by the eight main radii, which divide the round surface into eight equal parts (Figure 87). Wherever such an interpretation fits the facts, the composition conforms to our concentric model.

In these examples, a confrontation between frame and picture is avoided. In more sophisticated designs, such as a cup of Duris (Figure 88), an essentially realistic scene is reconciled with the circular frame by an adaptation of the Cartesian framework to the circumference and the radii of the circle. The curved back of Hercules and the gracefully inclined head and neck of Athena conform with ease to the circular border, and the seat and table point radially

FIGURE 87

toward the center without calling forth our protest. This example also serves to show how forcefully the tondo concentrates a composition on its central theme. The pouring of the wine would attract the viewer's attention even in a quadrilateral picture, but the circularity of the frame puts so much emphasis on the center that Hercules and Athena, the two partners in the dialogue, are relegated to the sidelines as though they were mere bystanders. We are made to concentrate on what I earlier called the microtheme: in this case the two small containers, the jug and the cup, acting out a condensed and abstracted replication of the larger subject, namely the relation between hostess and guest, dispenser and recipient. But I am getting ahead of my story.

Sometimes, the adaptation of narrative scenes to the circular borders on Greek cups is performed less skillfully, as when feet are made to run along the curved rim as though it were a baseline. But all such devices are intended to minimize the spatial contrast between frame and picture. The alternative is an outright clash between the two spatial systems. Either the rim is allowed to impose itself upon the scene like a porthole, with little regard to where it interrupts the subject; or the scene cuts across the rim wherever it needs space. The above-mentioned study by Webster offers good examples. On a Laconian

FIGURE 88.
Duris, Hercules and Athena. c. 480 B.C.
Staatliche Antikensammlung, Munich.

cup, "the painter has made an excerpt from a procession in which pairs of warriors carry home the dead after a battle. One pair is complete; on the left the curve of the frame leaves room for the hanging legs of a second dead man and one leg and part of the body of the front carrier. On the right we see the head of a third dead man and one leg and part of the body of the back carrier. The painter has made no attempt to adapt his subject to the circle." In the opposite case, the baseline of a scene is allowed to reach across the circular border to make room for feet, etc.

These are clumsy solutions, which do not really come to grips with what we have come to see as the basic compositional problem, namely the interaction of grid and concentricity. But the same difficulties recur during the fifteenth

century in Florence, when the tondo becomes a favorite format for reliefs and paintings. "Only gradually painting discovers the inherent laws of this species," writes Jacob Burckhardt. "At first it represents its figures and events with the same realism of costume and expression as in paintings of other formats. It places buildings and landscapes in a space equally close to nature. Only toward the end of the century it becomes evident that the circular format has an essentially ideal character, which accepts only tranquil subjects of ideal beauty and does best when it renounces any more explicit background." The early attempts look as though the disk shape is imposed upon the artists by external considerations, and they respond, like their Greek forefathers, by simply clipping the corners of their traditional grid structures. Masaccio's aforementioned nativity scene, for example, is set amidst strong architectural verticals and horizontals that are incongruously overlaid by the circular border. There is no spatial rapport between the two systems, and the center of the picture, promoted by the tondo, focuses as if by accident on a group of visiting women, who distract from the painting's principal theme. Similarly, when Perugino presents the Madonna and her child surrounded by saints and angels in a tondo, we see an arrangement of upright figures who have to tilt their heads sideways to avoid hitting the curved rim.

THE TONDO STRESSES THE MIDDLE

When the tondo defines the center as the place toward which everything converges and from which decisive power issues, it may bestow primacy by mere position on an area or object that would otherwise be visually inconspicuous. The geographical maps of the Middle Ages represented the world as a flat disk with Jerusalem near its geometrical center. The so-called T-O map of Isidor of Seville (Figure 89) used three bodies of water, the Dnieper, the Nile, and the Mediterranean, to subdivide the world into three continents, with Jerusalem understood to be located near the hub. Botticelli, painting an Adoration, could place the Virgin and her child in the midst of a crowd of attendants without distinguishing her visually either by size or by spatial detachment. He had no reason to fear losing her. The compelling geometry of the tondo could be relied on to point to her as the centerpiece of the scene.

When the composition of a tondo scene is derived more consciously from the circular structure, we again find sophisticated microthemes like the one on the cup of Duris (Figure 88). In that composition, the central theme of the jug pouring the wine into the cup is a compelling abstraction, which reduces the subject of the total scene to a much simpler action. Of course, the story of hospitality is conveyed explicitly by the presence and behavior of Hercules and

FIGURE 89

Athena. But the human bodies and their actions are so complex that our understanding of the scene remains fairly indirect. Much knowledge must supplement the directly visible action. In comparison, the central scene of the pouring of the wine is a symbolic enactment of insuperable immediacy. Similar uses of the center can be found among the many tondo representations of the seated Madonna and child in fifteenth-century Florence. For example, the interplay between mother and child in the central area of the composition frequently illustrates the delicate theological problem of the competition between the Virgin Mary and Christ. In Michelangelo's Pitti relief at the Bargello (Figure 90), the right hand of the Madonna offers and supports the book, which stands for the Christian creed. But the child has, as it were, the upper hand, planting his hefty little arm on the book as a column rests on its base. Our eyes have been trained by more than half a century of abstract art to appreciate the physical and visual impact of such elementary action performed by pure shapes.

There are many variations to this symbolic play. Look at the parallelism of the two arms in the center of Raphael's *Madonna della Sedia* (Figure 91). Here the relation is more harmonious but also, perhaps, more complex. Again, it is the mother who offers a base and support, in this case her arm, much larger than her child's. But here, too, it is the child who dominates, and the vigorous downward thrust of his arm is unmistakable. The point of the boy's elbow, pushing toward the viewer, occupies the center of the tondo. We are reminded of the knobs and animal heads that marked the center of lids and mirrors in antiquity.

FIGURE 90.
Michelangelo, Madonna and Child. 1504–1505.
Museo Nazionale, Florence.
Photo, Alinari.

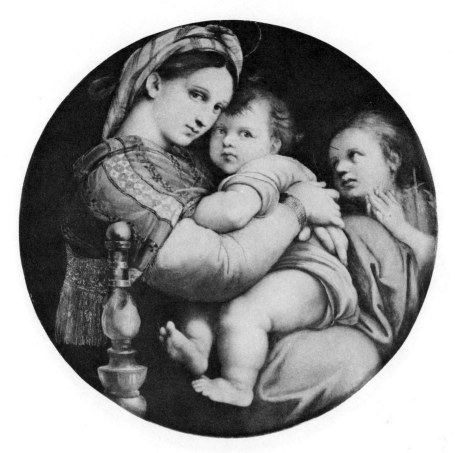

FIGURE 91.
Raphael, Madonna della Sedia. 1514.
Galleria Pitti, Florence. Photo, Alinari.

More variations can be found in the tondi of Botticelli. The Madonna has many ways of supporting her child's body with her hand, each stressing a different nuance of the relation between the two. The child, in turn, has ways of asserting his dominance. In one example (Figure 92) the mother, leaning her right hand on the prayer book, dips her pen into the inkwell; but the boy has placed his hand on her arm as though to control the action. Similarly, his left hand takes hold of the pomegranate, which the mother supports for him.

In these and other examples, an admirable strategy of pictorial composition sums up the theme of a painting in a central abstraction. The microtheme

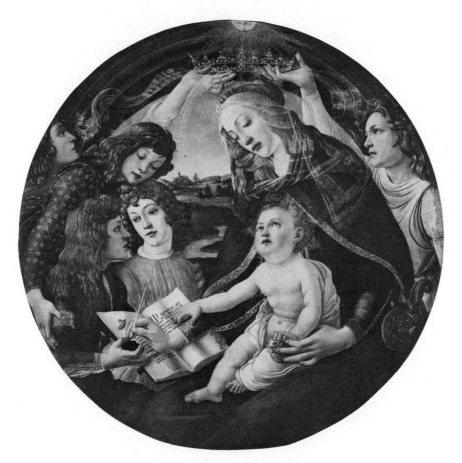

FIGURE 92.
Sandro Botticelli, Madonna of the Magnificat.
1483–1485. Uffizi, Florence.

serves as a timeless symbol, and quite often it is therefore placed at or near the center of the composition, where spatial dynamics is at a minimum. At the same time, the device enables the principal actors to keep their distance from the paralysis of "dead center." When they do occupy the center, they do so to create the specific effect of timeless stability. Sometimes the Christ child lies or sits in his mother's lap as though he were still enclosed in her womb. In Botticelli's *Madonna of the Pomegranates* (Figure 93) the child's head is firmly held by the center of the tondo. As he gives the blessing with his right hand and displays the round fruit like a terrestrial globe in his left, the stasis of his location is justified by his formal enthronement, a playful allusion to the

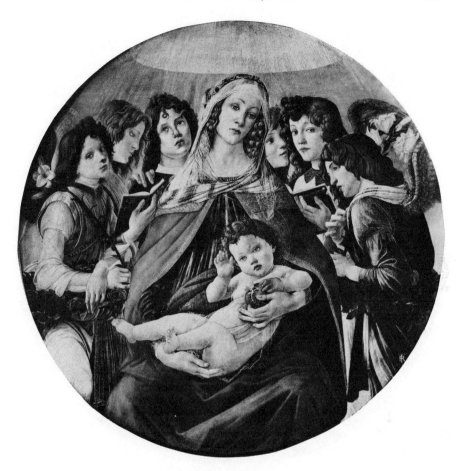

FIGURE 93.
Sandro Botticelli, Madonna of the Pomegranate.
1487. Uffizi, Florence. Photo, Anderson.

traditional stance of the pantocrator. Similarly the Madonna appears as the ceremonial ruler when Fra Filippo Lippi in one of his paintings places her so low in the pictorial space that her head holds the center of his tondo. But more commonly painters prefer to keep their actors off center.

This practice has two functions. First, the concentric layers of the tondo form a hierarchic scale. In Michelangelo's Pitti relief (Figure 90), for example, the child is distinguished by having his head relatively close to the sanctuary of the center and by being turned toward it. In comparison, the mother is distant and remote. Notice, however, that in this example the scale is reversed in the vertical dimension of the implicit grid: there the mother's head towers on the

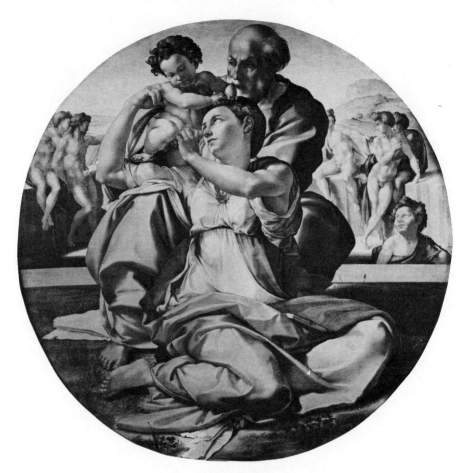

FIGURE 94.
Michelangelo, Madonna Doni. 1504.
Uffizi, Florence.

upper rim, while the child, low and with his head bent, remains subordinate. The contradictory statements by the two competing frameworks leave us with a significant ambiguity.

Removal of principal features from the center has the second function of making the composition more active. As we noted earlier, the center may remain unmarked in itself but serve as the base or tonic for the melody of the action. This function of the center is strongly reinforced by the circular format of the tondo. In Michelangelo's Doni Madonna (Figure 94) the central base is the mother's abdomen, the womb from which the story arose. From it we are elevated by the Madonna's raised arm to the seat of the family constellation.

How much less intensity would we see in the triad of heads if this closely packed group were not placed high above the center!

Not surprisingly we found that the concentric model of composition is enhanced by the tondo format. This does not mean that the Cartesian grid, so strongly advanced by all terrestrial subject matter, is simply suppressed. To be sure, the more fully realized are the compositional requirements of the tondo, the more the grid recedes as a self-sufficient system. Even so, the upright torso and frontal head of the Virgin in Michelangelo's Bargello relief (Figure 90), for example, supplies the work with a strong vertical spine, so strong in fact that as her head breaks through the top of the circular rim the tondo is reduced to a kind of background foil, which does not truly control the composition.

This is quite different in Raphael's *Madonna della Sedia* (Figure 91), of which Burckhardt has written that "it contains, as it were, the entire philosophy of the round picture so clearly that any unhampered look can realize what this most difficult and most beautiful of all formats, and indeed any format in general, means for representation." The tondo may indeed be called the most beautiful format in that it takes us beyond the limitations of earthly gravitational space to the more fundamental model of cosmic concentricity, and it may be called the most difficult format because it would achieve removal to the cosmic sphere too cheaply if it simply abandoned the Cartesian grid. We well remember the boredom and lack of meaning produced by the shields of concentric circles, which some of the "optical" artists of the 1960s used for target practice. William C. Seitz, curator of the 1965 exhibition "The Responsive Eye" at the Museum of Modern Art in New York, wrote on that occasion: "Exaggerated emphasis on centrality and an attempt, which is all but futile, to avoid its tyranny are poles between which perceptual composition oscillates."

In the *Madonna della Sedia* direct references to the angular framework are so thoroughly avoided that the one reminder of verticality, the upright post of the chair, looks almost like a safety device, needed to keep the picture from rolling out of control. Actually that explicit post is by no means the only visible reference to the coordinates of earthly life. Raphael's genius ensures that the shapes which compose and clothe his figures do not simply surrender their own character to the demand for swinging curvature. Each element visibly preserves the norm from which it was bent to assume its present appearance. The inclined neck maintains its potential uprightness, and the arms retain the muscular strength of pivoting limbs. This inherent angularity of terrestrial subject matter, which is made to yield without disguise or coercion to the harmony of the sphere, seems to be the finest solution the art of painting has for the problem of the tondo.

DISKS AND SPHERES

The circular contour stresses the roundness of curves in the composition and gives them special prominence. The closer such an internal shape comes to actual circularity, the more clearly it behaves like a tondo itself. It repeats within the composition some of the effects observed in the relation of the tondo to its environment. Looking once more at Michelangelo's relief (Figure 90), we find that the head of the Madonna comes close to behaving like an internal tondo. Accordingly, it displays a good deal of independence. The impeccable symmetry of the face creates a small encircled entity of its own, untouched by what happens in the rest of the scene but endowed with so much visual weight that it becomes a strong secondary center. It acts as the head of a pyramid, which seems to organize the bodies of mother and child like a sheaf of fanned-out radii.

The disk of the universe in the medieval book illustration mentioned earlier (Figure 84) is such an internal tondo, and so is its smaller counterpart, the head of the Creator, which is made even more geometrical by the halo that frames it. This pair of circles is so strong that it establishes a powerful theme in the right wing of the picture, a vertical axis strengthening the principal dimension of the upright rectangular format. Not supported by a circular frame, the two round shapes differ all the more conspicuously from the rest of the composition. This distinction increases their visual weight. In fact, the entire action of the picture culminates in the interplay between the intensely active head of the Creator and the world he moves and measures.

Explicit circles become rare in realistic painting after the Renaissance. One of Van Gogh's spectacular suns demonstrates how a circular shape, scarcely detached from a similarly colored sky, asserts itself nonetheless against the powerful foreground shapes of the sower and the tree (Figure 95). Although the yellow disk is pinned in place by compositional balance, it is much less subservient to the painting's Cartesian grid than the other shapes. Let loose, it might roll along the horizon. The uniqueness of its perfection gives it so much visual weight that it creates a center on the left, enthroned on the dark figure of the man and attracting the heavy tree from its corner at the lower right diagonally with so much strength that the trunk is barely stopped by the central vertical. Even the perspective lines of the fields seem to stream in the general direction of that glowing focus.

The geometry of the circle rules many of the Constructivist and Suprematist abstractions in the early twentieth century, in works by such painters as Moholy-Nagy, Lissitzky, and Rodchenko. A 1935 relief by Ben Nicholson (Figure 96) will serve to show how a pair of hollow circles creates two conspicuous foci and thereby helps to subdivide the horizontal wooden slab

FIGURE 95
(after Van Gogh)

into two foreground components, one of them large and expansive, the other weaker and compressed. The two hollows, like the nuclei of two rectangular cells, gather the visual weights eccentrically: the larger panel operates like the blade of an axe, from a base on the left side, and in the smaller one the location of the relatively large circle endows the squarish shape with an intense lateral pressure toward the superior adversary. The lateral push exerted by the larger rectangular unit produces what I have called a "piston effect."

Round shapes are not limited in painting to flat disks. Voluminous apples, skulls, and globes populate pictures that represent three-dimensional space. I shall refer to them when I discuss the function of centers in the depth dimension. In the physical world of our environment as well, round shapes play their special role. We meet examples, both flat and spherical, in architecture. I have already discussed the function of wheel windows in the façades of medieval churches. The weight of the entire façade of Notre Dame in Paris (Figure 5) organizes itself around the powerful center, demanding conformity from the horizontal and vertical components of the structure but remaining untouched by them. Nor is this central role of wheel windows a purely formal one. Adolf Reinle has pointed out that they derive from the illustrations of medieval treatises, which represented cosmological schemata in circular drawings, often dominated by the central figure of the enthroned Christ or the sacrificial lamb.[2] The round window, then, stands for the hub of the cosmos; it spells out, in the design of the cathedral façade, a particular relationship between our two basic systems, the concentric and the Cartesian. At Notre Dame, for example, the centrality of the wheel is relatively uncontested, whereas in the later, more Gothic cathedral of Reims, the upward stream of pointed windows and gables strongly challenges the stability of the organiza-

2. For examples see von Simson (55), plates 8, 9, 10.

FIGURE 96.
Ben Nicholson, White Relief. 1935.
Tate Gallery, London.

tion around the center. My earlier reference to the basilica of San Pietro in Toscanella (Figure 15) illustrated the capacity of the wheel window to raise the weight of the entire façade by its own placement near the top of the building. A similar effect can be observed, to name one other example, at San Zeno Maggiore in Verona.

When a whole building assumes a spherical shape it represents the utmost challenge to the rule of gravity short of flying. The architectural balloon touches the ground at only one point and is ready to take off. By virtue of its independence from the rules that govern terrestrial activity, spherical shape is reserved for buildings whose purpose suits such independence. The world's fairs both of New York in 1939 and of Montreal in 1967 featured spherical structures conspicuously and quite appropriately since such pavilions are meant to look like temporary statements, symbolic monuments to buoyancy, rather than utilitarian structures rooted in the common ground of practical business. In a similar mood of exaltation, Etienne-Louis Boullée in 1784 designed a cenotaph for Newton, "a hollow sphere, its vault pierced with holes through which natural light filters, creating the illusion of stars in the night sky" (Figure 97). In this visionary building, visitors were to feel entirely removed from their customary spatial framework and directly exposed to the centricity of the solar system.

FIGURE 97.
Etienne-Louis Boullée, Project for a Newton Cenotaph.
1784. Bibliothèque Nationale, Paris.

It is characteristic of the seclusiveness of round shapes that such spherical structures look all but inaccessible. Holes must cut into the integrity of the shell to admit the viewers to Boullée's vision, and Buckminster Fuller's American pavilion at the Montreal fair had openings pierced for the minirail trains that carried the public into and through the exhibition space. Note also that Fuller's advocacy of the geodesic dome was not limited to the practical advantages of structures that were based on the stability of the triangle and contained the largest volume in the smallest surface. The principle was based on broadly conceived objections to the Cartesian framework, which imposed an alien grid of right angles on a universe based on centricity. The equilateral triangle, the building block of his dome, resulted from the stacking of spheres (Figure 98). The irrational numbers that result when one calculates the diagonal of a square or cube or the relation between circumference and diameter in a circle were, to Fuller, symptoms of the trouble one runs into by forcing the physical world into a Cartesian strait jacket.

Architects also have given us cylindrical buildings and circular city squares—a subject for which I refer the reader to my book on architecture. Here it suffices to point out how in these architectural applications, the round shape lives up to its character. Cylindrical buildings do not accommodate themselves to a city system of linear edges and channels. Therefore, like the

FIGURE 98

cathedral's wheel window, they lend themselves to central locations around which the environment is organized, and to special purposes, such as churches. Wittkower has shown how centralized churches stand symbolically for the perfection of God and the cosmos, of which they represent a small-scale image. Similarly, a circular city square differs in principle from a street crossing, which is derived directly from the linear grid. Bernini's semicircular colonnades in front of St. Peter's in Rome form an enclosure whose timeless stability is hard to reconcile with the moving traffic of the streets feeding into it. As soon as we enter the square we are taken out of transit, even though we are likely to be on our way to the great basilica. As a mischievous example of what circularity and grid can do to each other, one may cite the map of Washington, D.C. There the radial streets issuing from the circular squares throughout the center of the city cross the grid of parallels at irrational angles—to the distress of strangers trying to form a mental image of where to find what.

Once again tension is created through the interaction of our two spatial systems. In the examples just given, this tension manifests itself in the ground plan. Just as in the history of medieval churches the ground plan of the Greek cross, providing centric symmetry and an uncontested focus at the intersection, competed with the Latin cross, which created a linear spine as a channel of advancement through the nave, so most circular buildings are faced with the conflicting demands of the two systems. No problem arises when the baptismal font is placed in the center of a cylindrical baptistery. The building reposes in its undisturbed centrality, paying no architectural heed to the comings and goings of its users. But when, for example, the church service prescribes that the altar be placed peripherally at the far end of the diametrical path that leads

the visitor from the entrance to the sanctuary, a contradiction results, a conflict that produces unresolved tension.

THE OVAL

A discussion of the relations between roundness and linearity should also refer to the shape that tries to integrate the two, namely the ellipse or oval. When the ellipse is perceived as a deviation from the circle, it pays with a loss of centric symmetry for an increase in tension. The Renaissance cherished the circle as the shape of cosmic perfection, whereas the Mannerist phase of the Baroque took to the high-strung ellipse, which plays on the ambivalence of roundness versus extension.[3] It is true that the ellipse has a stabilizing symmetry of its own. Its derivation from the circle is truly compelling only when the distance between its two foci is kept small and its shape approaches circularity. A painter or architect can select a particular shape from a whole series of ellipses, each with its own character and expression. As the ellipse becomes longer and flatter, it takes on the qualities of the rectangle.

Even more than the tondo, the oval is a playful shape, prescribed by the demands of the setting it bedecks rather than those of the composition it encloses. In many routine productions of the eighteenth century, therefore, pictorial subject matter fills the frame without much consideration given to the particular structure congenial to the elliptical format. A landscape stretches through the horizontal expanse, or one of Boucher's young women lounges on her bed. The oval serves to round off the corners and thereby to fit the subject more snugly. The same is true for upright ovals, so frequently used for portraits. We note, however, that, in the case of the portrait the oval lends welcome assistance in the painter's struggle with the human figure, which carries its head high above its center. The upper focal point of the ellipse offers the head of the portrayed figure a compositional resting place not available in either the tondo or the rectangle.

Compositionally the ellipse is the format of choice for the presentation of a duet or dialogue, two antagonists or partners—or more abstractly, two centers of energy coping with each other. This structural property of the ellipse shows up in the workshop practice of Renaissance draftsmen, who constructed approximate ellipses by means of two overlapping circles, the so-called *ovato tondo* (Figure 99).[4] The ellipse can be perceived as the result of interaction between two spheres of forces. An anecdote about the late historian Aby

3. See Panofsky (45). 4. See Kitao (38).

FIGURE 99

Warburg deserves mention here. The Hamburg city planner Fritz Schumacher reports in his autobiography that when Warburg's brothers offered to construct a building for his growing library, Warburg insisted that at the center of the building there be an auditorium in the shape of an ellipse. He had just recovered from a severe mental illness and conceived of the elliptic centerpiece of his library as a memorial to his new health. In a conversation with Ernst Cassirer he explained that the ellipse represented a turning point in human thinking. To Plato, he said, the circle had been the symbol of perfection, the creative figure for the concept of the universe. Actually, however, "the ellipse was this creative figure because its two poles were characteristic of the universe: they controlled the motions of the cosmos, and they were the symbol of man with his polar structure of spirit and soul. Wherever there was life, the duality of the poles was in evidence: not only in electricity but in day and night, summer and winter, man and woman."[5]

The solemnity of this symbolism has failed to reverberate in Western painting because of the lighthearted use to which the elliptic format has been put. Furthermore, the duality of the two compositional centers shows up clearly only in the horizontal ellipse. In the vertical, the symmetry is overlaid by the hierarchic difference between above and below. But in a horizontal oval Boucher, for example, makes good use of the two foci when he shows Aeneas presented by Venus to the other gods. The two groups are more clearly clustered and more clearly detached from each other by the bipolarity of the

5. Cited by Füssel (30).

FIGURE 100
(after Charlier)

elliptic space than they would be in a rectangular frame. Similarly, Jacques Charlier places Leda on the left, the swan on the right (Figure 100).

In the upright oval, the weight of the upper focus can be used, as I mentioned, to make the dominance of a portrayed person's head more convincing. Although the central area of the canvas may be preempted by the decorations of the male or female chest and by the play of the hands, the head, surrounded by the vault of the top, holds the upper center quite firmly. Conversely, a group of persons may fill the bottom of an upright oval as though gathered in a basket around the lower focus of the ellipse, while the top is filled with lightness, the empty space of an interior, or clouds, animated perhaps by a pair of floating putti.

Finally, in an elliptic space, just as in a tondo, visual assonance emphasizes all roundness. The perfect example is Boucher's picture of an egg merchant girl, which plays on the affinity between the oval frame and the eggs in the basket (Figure 101). The analogy is extended by the suitor, who grabs the eggs with his right hand and the chubby girl with the left. The youthful abundance of rounded shapes so crowds the picture space that the agglomeration of spheres all but obliterates any linear structure—a model of composition we found to be congenial also to the tondo.[6]

6. In his introduction to an exhibition of oval paintings Jean Cailleux (19) has written: "In any case we may note that more than one oval painting, especially portraits, could have been rectangular without fundamentally altering the presentation. Even so, it seems to me striking that the oval format permits, encourages, and indeed inspires a play of curves and countercurves within the ellipse of the canvas" (p. 12).

FIGURE 101.
Anonymous (after François Boucher),
Love Allegory (with Egg Basket).
Snite Museum of Art,
University of Notre Dame.

CHARACTER TRAITS OF THE SQUARE

As we turn to the square, we are dealing once more with a centrically symmetrical shape. In this respect a square-shaped frame resembles a tondo. But whereas a circle has infinitely many symmetry axes, the square has only four, the two paralleling the pairs of edges and the two coinciding with the diagonals. The difference is not merely a matter of quantity; it is more importantly a matter of structure. The tondo adheres compositionally to the concentric model. The square, like rectangles, conforms to the Cartesian grid. This means that the square does not, in the manner of the tondo, behave like a foreign object, flown in from outer space, as it were. We found the tondo to be controlled by a structural pattern of its own, closed off from its surroundings, and floating in those surroundings without a confirmed location. The square obeys the structural rules of the vertical-horizontal grid inside as well as outside the frame, and in doing so anchors itself more firmly to a similarly structured environment.

Coming from the tondo, a viewer may find that the location of the square's center lacks precision. Unless explicitly marked, it is a mere crossing point. The central vertical passes through the middle without being stopped by it, and so does the central horizontal. Only the synoptic view of the symmetry axes reveals the center (Figure 102). Think of the difference between a street crossing and a circular city square. Unless the crossing is distinguished by a central island, a monument, or a traffic policeman, it is absorbed by the linear course of each of the streets along which a traveler may be moving. A circular square, as I mentioned before, is confined in its own centricity.

The looseness of connection between the verticals and the horizontals of the square is characteristic of all angular crossings. Straight edges in any two directions slide through each other without much interaction. In consequence,

FIGURE 102

the proportions of quadrilaterals tend to be somewhat indefinite. It is well known, for example, that geometrically correct squares look too high: one has to shorten them a bit in the vertical dimension to obtain the view of a correctly proportioned square. This phenomenon is due to the so-called anisotropy of space, which makes us overestimate distances in the vertical. It is a phenomenon that in principle affects all shapes. Characteristically, however, it has no power over circles. The circle has too much inherent strength to be squashed by this asymmetry of perceptual space. But the square, like any rectangle, is essentially a crossing of two directions, which controls linear relations only approximately. As a practical consequence, we are entitled to speak of square shape even, or perhaps especially, when the height is actually somewhat shorter than the width.

Yet the square differs from rectangles by its centricity. Look at the compositional scheme of a small early painting by Raphael, *The Knight's Dream* (Figure 103). By the standards of rectangular composition, we note an uncomfortable ambiguity: does the sleeping chevalier lie between or below the two symbolical ladies? The grid model offers two clear-cut versions of the theme. In a horizontal format the women would flank the reclining man laterally; in an upright format they would tower over him. In order to balance each other, the two versions would have to be seen as centered around the square's middle. But that middle is too weak. Granted that it accommodates a symbolic microtheme of the painting's subject: the choice between virtue and the pleasures of beauty, between book and flowers. Visually, however, the central area is all but empty. It is explicitly transgressed by the trunk of the tree. And since the composition fails to supply the hub demanded by the format, the picture oscillates between horizontality and verticality instead of integrating the two in a balanced whole.

Centricity does not have the effect for the square that we found it to have for the tondo. It does not raise the subject of a picture above the weightiness of the human condition by supporting religious transfiguration, or keep it below that condition by encouraging lighthearted play. Because of its allegiance to the gravitational grid the square, like the rectangular formats, is well suited to report reliably and seriously about existence in this world. In traditional symbolism the square stands for the earth as against the symbol of heaven; it stands for confinement as against the infinite. Even so, its centricity makes it transcend the coming and going reported in rectangular space. The square achieves this not by removing the scene to a different kind of spatial organization, but by compacting verticality and horizontality in a symmetrical whole of the kind the small Raphael painting vainly tries to attain.

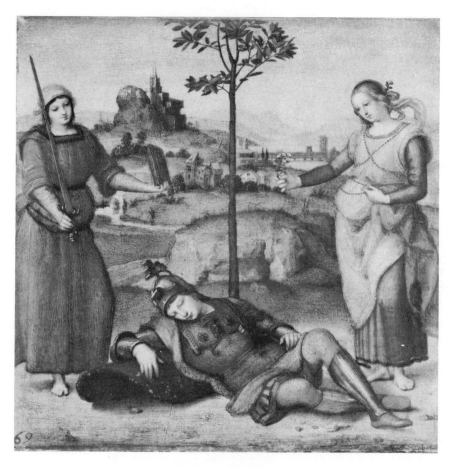

FIGURE 103.
Raphael, The Knight's Dream. 1504–1505.
National Gallery, London.

By excluding the dominance of either direction the square arrests the terrestrial scene and makes it dwell in timelessness. It is a format, therefore, congenial to artists who aim at presenting a stable world. Two paintings by Piero della Francesca may serve as illustrations. His *Resurrection* in Borgo di San Sepolcro (Figure 104) is about 10 percent higher than it is wide; but considering that the painting represents the rise to Heaven, that is, the vertical theme *par excellence*, its near-squareness is striking. In an almost diagrammatic manner it transforms the event of the removal from earth into a hierarchic arrangement of reposeful dignity. The rising Christ has become a statue,

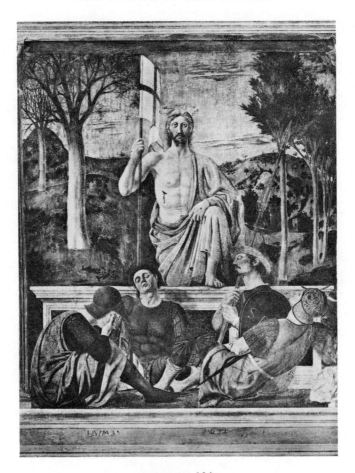

FIGURE 104.
Piero della Francesca, Resurrection. 1463–1465.
Borgo di San Sepolcro.

pinned with the center of his body to the center of the picture space. His raised leg seems not active but monumental. The frontal symmetry of the figure commits it to a presence beyond the vicissitudes of change.

The strong axis of the Christ figure is seconded by the tree trunks but counterbalanced by the horizontal scene of the sleeping guardsmen along the bottom, which is held together by the massive cornice of the coffin. The picture space is divided into three horizontal layers, which overlap but hardly interact. Christ's head and shoulders reach into the sky, and two of the sleeping guardsmen have their heads locked into the middle ground. But just as the

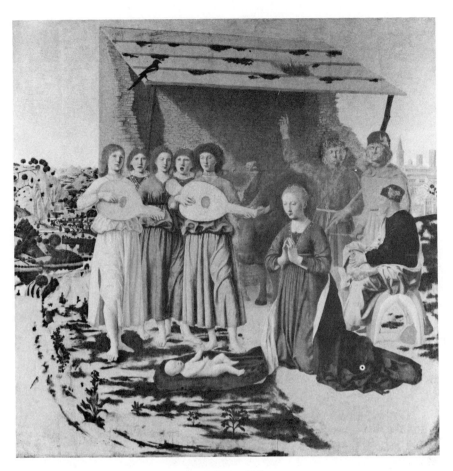

FIGURE 105.
Piero della Francesca, Nativity. 1470.
National Gallery, London.

change of the trees from wintry defoliation to the verdure of summer life is presented not as a process but as the static confrontation of two opposite states, so the event of the resurrection has become a map of separate, immobile states of being: the state of life, which unites earth and heaven in the figure of Christ, and below the cornice, which is marked by Christ's foot as the baseline, the state of insentience. This mapping out of states of being is in the spirit of the square.

Just as Piero's *Resurrection* compresses the rectangular grid in the vertical, his *Nativity* (Figure 105) compresses it in the horizontal. In this instance the

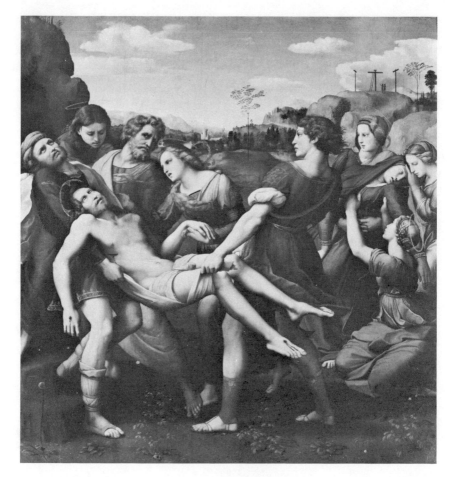

FIGURE 106.
Raphael, Deposition. 1507.
Galleria Borghese, Rome.

centricity of the square checks not the rising and falling but the coming and going on the ground. Divided by the central vertical, the scene is composed of the angelic musicians on the left and the holy family and shepherds on the right. The horizontality of the roof along the top and the parallel row of heads counterbalances the uprightness of the figures. Once again interaction is not consummated. Within the compact square of the scene, which parallels the format of the frame, the angels play and their audience meditates, each group by itself in its own quarters.

The very opposite would seem to be true of Raphael's *Deposition* (Figure 106). There everything sways in the obliqueness of motion, and the vertical

is barely stated by the powerfully upright legs of the two carriers and the straight-necked head of the younger one at right. Even so, the squareness of the format stabilizes the scene in its given location. The performers come from nowhere and go nowhere. They are grouped around the immobile body of the dead man. Even the main dynamic theme, the sagging weight of the corpse, is not permitted to follow its downward impact through. It is checked by the diagonals that hold it in their crossing.

Diagonals, although dynamically active through their deviation from the Cartesian grid, perform like the trusses in a building. By cutting across the dichotomy of vertical vs. horizontal and mediating between the two dimensions, they add stability to the square and emphasize its centricity. Sustained by the V-shape of the two carriers, the central group of Raphael's painting is a solid scaffold rather than a passing scene. And once again the centric symmetry of the format points to a symbolic microtheme in the middle. This time it is the theme of support, acted out in two versions: the dead man's hand raised gently from below by the hand of the Magdalen, and the cloth pulled up robustly from above by the hand of the young man.

ALBERS AND MONDRIAN

There has been a revival of the square format in the last hundred years or so. This is in keeping with a tendency to overcome the sense of weight in the artifacts of our culture. As long as art wishes to reflect the experience of living with the constraints on human existence, it is likely to display the anisotropy of space, the coping with weight. The formats reflect the asymmetry of gravitational space. The horizontal oblong represents the subservience of man and nature to the pull of gravity, the spreading along the ground and the action along that dimension. The upright format depicts the overcoming of weight. The rectangular formats reflect abstractly the struggle with the encumbrances of life, which are spelled out more explicitly in realistic subject matter.

But just as the art of the last hundred years has increasingly detached itself from realism and moved toward abstraction, a tendency toward a more even distribution of visual weight replaces the bottom-heaviness of traditional art. A sense of suspension keeps the work afloat, as we can observe in much modern architecture, sculpture, and painting. The square or cube is in harmony with this tendency. Among the many examples in modern painting, a quick comparison between works of Albers and Mondrian may be instructive. Albers's series *Homage to the Square* offers the more traditional solution in that it explores the role of gravity in a realm of suspended weight.

FIGURE 107

The compositional pattern of Josef Albers's paintings is based on a simple geometrical formula (Figure 107). Knowing the formula in this case helps the viewer to sharpen his perception of the visual effect. The basic module, marked *1* in my diagram, separates the squares from one another at the bottom of the pattern. Doubling that module determines the distance between the squares in the transverse dimension, and tripling it the distances at the top. As a result, the squares are eccentrically displaced against one another by a gradient of distances, 1:2:3. This asymmetry produces the dynamics of the theme, a squeezing below, an expansion above. It promotes a depth effect, which would be counteracted if all the squares were grouped symmetrically around the same center. But the dynamics of the gradient is all but neutralized by the equal distances between the squares in any one direction: this produces a tranquillity of relation that respects and continues the quietness of each square (Figure 108).[7]

7. Although the scheme of Fig. 108 is at the base of all paintings of the series, in practice Albers varies it by omitting one or the other square in some of them. The resulting irregularity modifies the rhythm of the set of squares, but leaves the underlying "beat" of the regular intervals sufficiently evident to the eye. A diagram similar to mine appeared in the catalogue for the Albers show in Hamburg in 1970 (1).

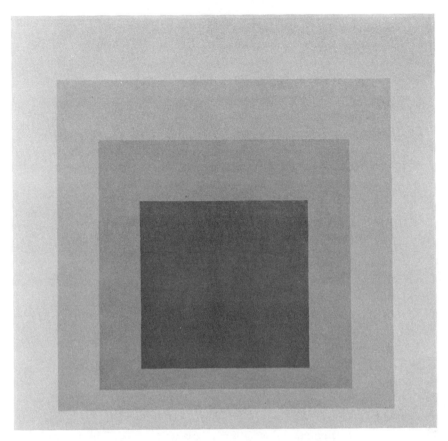

FIGURE 108.
Josef Albers, Homage to the Square: Silent Hall. 1961.
Museum of Modern Art, New York.

I am not concerned here with the interaction of colors, which was Albers's principal interest, but only with the skeleton of shapes on which he hung his colors. The colors, of course, promote centricity by making every square look the same all around. They are not affected by the gravitational difference between top and bottom, nor by the dynamic contrast between expansion and compression. Shape is described by the composition as afflicted by the powers of weight and thereby as interfering with the serene choir of concentric colors. Cosmic harmony comes from color, earthly impediment from shape—the message of a colorist.

Any opposition between frame and picture is eliminated. The frame, reduced to an outer rim, is merely the largest of a series of squares, and as we step

from square to square, centricity increasingly gives way to downward pull. The center of the total picture space moves progressively toward the top of each square as the squares become smaller but is not allowed to lie outside any square's area. (Perhaps for this reason the smallest square supplied by the geometrical schema is not actually used in the paintings.) Because the center of the whole is kept within the area of each square, the center maintains its internal control over each square. At the same time the relation between the geometrical center of the entire picture and the center of any particular square becomes increasingly tense as the squares decrease in size; but the rubber band is not permitted to snap.

As a final symptom of Albers's desire to keep dynamic deflection under the control of a simple order, we note that the arrangement, although asymmetrical, is simply related to the structure of the whole picture space. The corners of the squares converge toward a point that divides the central vertical in the ratio 3:1. This means that the bottom edges lie on the diagonals of a rectangle that divides the total space safely in half. A solid base is thereby provided, on which the sequence of squares can rise with confidence from step to step—not so different from the coffin in Piero's *Resurrection* (Figure 104), from which the movement toward heaven takes off.

At first glance, the late paintings of Piet Mondrian (Figure 109) seem closely related to Albers's squares. Both artists rely on a starkly rectangular geometry, and in fact art history assigns them stylistically to the same generation. Yet the differences are fundamental. I pointed out that in spite of the radical abstractness of his shapes, Albers is still concerned with the traditional problem of how to deal with gravitational weight in a balanced setting. This is a problem posed by realism. Realistic also is Albers's reliance on the entire gamut of hues and brightness values in his color. His palette is as rich as that of nature. Mondrian, on the other hand, limited himself to the three fundamental primaries, whose renunciatory purity conveys a minimum of expression, a minimum of association with the things of reality. The three primaries are structural elements that exclude from Mondrian's late paintings the property on which Albers's entire effort relied, namely mutual interaction. Pure red, blue, and yellow establish three independent, unrelatable poles. They are coordinated, not subordinated, and therefore do not constitute a hierarchy.

This is equally true for Mondrian's treatment of shapes. His mature works exemplify to perfection the tendency of modern art to override the dynamic effect of weight and thereby to evade a fundamental property of realistic space. In his paintings, weight is distributed evenly across the surface of the picture.[8]

8. Mondrian's treatment of visual weight is probably related to his habit of painting on the horizontal surface of a table rather than on an easel. See Carmean (20), p. 37.

FIGURE 109.
Piet Mondrian, Composition. c. 1920.
Museum of Modern Art, New York.

To be sure, there is much variety in size, distance, proportion, and direction. But these local variations offset one another everywhere in such a way that a single element is rarely permitted to act as a center around which neighboring shapes might organize hierarchically. The colored shapes make their appearance here and there, but without calling attention to themselves at the expense of neighboring shapes. The composition is perfectly balanced, but balanced in the manner of a regular grid of verticals and horizontals. There are rich and delicate patterns, but in many instances there is no theme. As Robert Welsh has observed about Mondrian's works, "one's attention to the compositional structure is forced to shift constantly from a single or small group of units to

the next, and . . . a visual comprehension of the total configuration is virtually impossible, except as a broadly perceived pattern."

In consequence, the center of gravity performs no compositional function. The eye cannot pinpoint the middle of the canvas and, in fact, would miss the point of the composition by trying to do so. To be sure, the center acts as the place around which the compositional material balances out, but it serves no theme and is no more important than any other area of the pattern. There is therefore little difference between the various rectangular formats Mondrian employs. The square does not often insist on its particular character. It underplays its centricity.

Having their center everywhere and nowhere, Mondrian's compositions are consistent in meeting the frame with open shapes, which continue beyond the boundary. It is of the pattern's essence that it claims to be basically endless. Observe here that Albers's square paintings, too, are basically endless; but they would grow concentrically by adding additional squares, as the section of a tree trunk adds annual rings. The center would remain, and so would the theme. Mondrian's abstractions would grow instead in the vertical and horizontal directions of the Cartesian grid.

I hasten to admit that my description of Mondrian's compositional principles is one-sided. Some of his paintings are organized around a theme in a classical manner. Some of his square-shaped canvases derive their organization from their squareness. Nor do I imply a judgment as to the quality of his work. I am trying to characterize a development of which Mondrian offers the most significant examples. Color field paintings with evenly stained canvases, abstract-expressionist textures filling the picture space, and other similar procedures show the same tendency, which can be traced back to the Impressionists, most clearly to the late Monet. They all underplay the center, they underplay the constraints of boundary and format, and they replace hierarchy with coordination. They approach the structural level of homogeneity and thereby point to an undifferentiated state of being. In the world at large, the curtain walls of the so-called International Style provide the architectural equivalent. They, too, dispense with organization around a center and could expand and contract their limits without modifying their character.

It is of the essence of Mondrian's geometrical compositions that they consist of open shapes, which continue beyond the frame. This openness is made even more striking in his diamond paintings, square-shaped canvases meant to be seen diagonally. As long as the frame conforms to the Cartesian grid of a perpendicular composition, the openness of the border shapes is less compelling. Their areas are rectangular and as such look complete. Openness is provided mostly by the arrested contour lines, which run into the frame and

are perceived as continuing underneath. But as soon as the frame and the compositional shapes meet at an angle, this easy assonance is gone and the frame crosses the picture area quite harshly.

With a very few exceptions, Mondrian's geometric work shuns oblique angles. In the late 1920s he experimented with diagonal grids, which, however, maintained the right angle as the only relation admitted within the picture. Blotkamp has argued that the diamond paintings developed from these diagonal grids when the painter decided to turn them 45 degrees. What interests us here is the perceptual change produced by such a change of orientation.

Mondrian was uncomfortable with the tilting of his shapes. The stability of the Cartesian grid was fundamental to his conception of the world. It is understandable, therefore, that he should have quickly discontinued the use of diagonals—a practice of which he disapproved in his fellow painters. The diamond frame, however, offered the attractive opportunity to interrupt the continuity of the space inside and outside the boundary of the picture. Whereas the perpendicular frame promotes the concordance between the vertical/horizontal composition of the painting and the prevalence of the same grid in the surrounding room, the diamond frame interrupts this unity almost brutally. It does not interfere, however, with the painter's allegiance to the perpendicular framework. That framework is shown to be able to pierce the resistance of the discordant boundary and to make its own solidity prevail.

A SQUARE BY MUNCH

To complete this discussion, I will refer to one more square-shaped painting, Edvard Munch's Sick Girl of 1896 (Figure 110). Its subject matter recalls the Attic sepulchral monuments of the fifth and fourth centuries B.C., the dialogue between departure and mourning. Munch shows the sick girl as already beyond the realm of the living. Her relation to her mother, who still dwells in the world the girl is leaving, is symbolized visually through the square of the white pillow, which is confined in the larger square of the painting as a whole. The work is centered around the microtheme of the two hands. The mother's hand reaches for the lifeless hand of the daughter but can no longer touch it. There still is correspondence, a parallelism of direction, but the distance between the hands is no longer bridgeable.

Similarly, in the larger realm of the picture the mother can no longer reach the daughter. Her bent head manages to penetrate the enclosure of the pillow, which frames the daughter, but the daughter's glance transcends her mother and loses itself in the infinite. With her head suspended in the center of the pillow square, the girl is beyond the pull of gravity, weightless, immaterial. By

FIGURE 110.
Edvard Munch, The Sick Girl. 1896. Göteborge Konstmuseum.

contrast, the mother's head is bent under the full load of earthly grief, still subject to the law of the living that controls the dark sickroom. Her attempt to reach her child once more is faceless: her eyes and her mouth are hidden. Closeness no longer implies communication.

Once again we see the square format used to symbolize a state of stillness, outside of time. The sick girl is held immobile in her rising, the mother in her advance—the vertical and the horizontal impulses balance and restrain each other in centric symmetry.

VOLUMES AND NODES

THUS FAR this study has mostly been concerned with the compositional structure of works in their entirety. But there have been indications that the principles controlling the whole are also valid for single components. Circular shapes, such as the face of the Madonna in Michelangelo's relief (Figure 90) or the disk of the universe in a medieval book illustration (Figure 84), were found to obey the same rules as the concentric structure of tondos; and the square-shaped pillow framing Munch's *Sick Girl* (Figure 110) behaves toward the inside and the outside in ways we have come to expect from square-shaped paintings. In the present chapter I shall be concerned with the compositional characteristics of individual components, their relations to one another, and their functions within a work as a whole.

Not surprisingly, the two basic spatial systems, the centric pattern and the Cartesian grid, rule the individual units as they rule the whole; but their relative strength is reversed. The spatial constellation of paintings or works of architecture tends to be dominated by the pull of gravity and hence by the vertical axes. This vertical pull is certainly perceivable in individual objects as well, but they tend to be more definitely subject to an energy source of their own and therefore to be organized around their own inner balancing center. This is especially evident in the components of paintings, which are less directly exposed to the gravitational pull, or even in sculpture, in the face or hands of figures.

Composition is concerned with the distribution of visual weight, which must be made to balance around the center of the work. But balancing is a secondary function of composition. Balance is indispensable in that it defines the place of each component in the whole; but such a visual order serves no purpose unless the constellation thus balanced represents a "theme." The theme is the formal pattern that indicates what the work is about. It turns the visual pattern into a semantic statement on the human condition.[1]

1. See Arnheim (6), pp. 29ff.

VECTORS CONTROL MEANING

To fulfill this function, visual weight as such is not sufficient. More significant are, first, the ways compositional elements function as sources of energy, and, second, the behavior of the vectors issuing from these sources. It is useful, therefore, to make a distinction similar to that between mass and directed energy in physics. Just as physicists have done recently, we shall find that the distinction is basically a matter of emphasis; even so, it is a distinction worth making.

FIGURE 111
(after Lissitzky)

We shall distinguish between volumes and vectors, between being and acting. Figure 111 is a simplified tracing of an abstract composition by El Lissitzky. It presents a large disk, which reposes heavily within itself and creates the principal center for the entire pattern. It functions first of all as a volume. A number of linear units point in various directions, away from that center and toward it. Although not devoid of mass, they function mainly as vectors.

Clearly, the disk by itself would present some sort of theme, simply by its location and size; but the statement of that theme would not amount to much, even though the frugal shapes of some present-day artists have reduced our requirements in this respect. The statement of Figure 111 is spelled out explicitly by the vectors inherent in the linear, rectangular shapes. At the same time, the disk itself is not simply an unstructured mass. It, too, is a configuration of vectorial radii, which turn the circular shape into a center of expanding energy. Although the radii are not directly visible but only indirectly induced by the shape of the disk, they belong with the pattern of linear beams to the system of forces that constitutes the work.

We can generalize and say that every visual mass is a constellation of forces, and that forces tend to be embodied in substantial objects. All *being* involves some *acting*, and all acting requires a vehicle. One may think in this connection of the ambiguity in the late works of Mondrian (Figure 109). One can see such a painting as an agglomeration of rectangles and squares held together like a wall of bricks—that is, one can see volumes. Or one can see a grid of lines, moving in lateral and horizontal directions—that is, vectors. Only the integration of both views yields Mondrian's composition.

In cases such as these, both views seem to be in balance. But there are works that vary in their ratio between volumes and vectors, and compositionally the difference matters. It also accounts for important stylistic traits. Certain early styles, e.g., that of the Easter Island statues, rely on compact volumes, and at a more differentiated level classicist and monumental styles show a similar preference. On the other side, the patterns of the high Baroque or of Cubism derive from the tendency of these styles to split and slice volumes into configurations of many individual vectors.

If there were an instrument to measure the level of intensity perceived at any point in a compositional structure, it would register considerable variation in most works of art. To be sure, there are instances in which the visual intensity remains remarkably steady throughout a given work. The crowd scenes of a Peter Bruegel or the texture paintings of Jackson Pollock offer examples. But in most styles of art, the statement to be conveyed by the work calls for high points, which carry the accents of the theme, as against the connecting tissue of in-between areas.

KINDS OF NODES

Volumes, that is, visual objects, provide such variation mainly by the ways they are distributed in space. Articulate still lifes, such as those by Chardin or Cézanne, use clusters to create compositional centers. Apples piled on a plate, touching and overlapping one another, make for intensity mainly by the accumulation of masses. Directional factors play a minor role.

Vectors, by contrast, work through the interrelation of directed forces. The centers deriving from such interrelation may be called nodes. For our purposes nodes may be defined as constellations of vectors, which create centers of visual weight. I will enumerate the principal types of nodes.

(1) There are, first of all, the sheaves of concentric radii that emerge from a center or converge toward it. Light sources, such as the sun, or halos are examples; so are the lines and surfaces converging toward the vanishing points of central perspective. In Moreau's *Apparition* (Figure 112), the head of the

FIGURE 112.
Gustave Moreau, L'Apparition. 1876.
Louvre, Paris.

murdered prophet is surrounded by the splendor of dazzling rays and creates a node of dominant intensity.

(2) Crossings are nodes. Kevin Lynch, in his book *The Image of the City*, speaks of nodes as "strategic spots in a city into which an observer can enter and which are the intensive foci to and from which he is traveling. They may be primarily junctions, places of a break in transportation, a crossing or convergence of paths, moments of shift from one structure to another." The transfer points on a subway map interrupt the linearity of movement for each line and combine the one-dimensional vectors in a two-dimensional network. In a traditional church, the crossing of nave and transept is a node of high intensity, produced by the interaction of two channels, from which it differs qualitatively by being a place of standstill. In general, every node represents a holding point in the composition. But far from being a static point, at which action ceases, the intertwining of differently oriented vectors produces a high-ly dynamic mutual arrest. In this sense, crossings are elementary versions of knots.

(3) Knots provide more of an interruption than mere crossings do because they modify the direction and curvature of the vectors constituting them and therefore are more independently compact. The knot of the red belt around which the figure of Caravaggio's *Magdalen* (Figure 48) is centered has enough shape of its own to serve as the hub of the ring-shaped structure. Its dynamics is quite different from that of Magdalen's folded hands, which parallel the knot but rely on superposition.[2]

(4) The superposition of the Magdalen's hands provides less of an inde-pendent center than the knot but more tension because it interferes more visibly with the integrity of the overlapping shapes. The identity of the two components is preserved, and therefore the mutual interference is more per-ceivable. Nodes based on superposition connect units but intensify their meeting through partial visual annihilation. The Magdalen's right hand has be-come a fragment, but remains enough of a hand to resist the interference. Any superposition involves partial captivity, and the struggle for liberation gives the node its energy. When a musician plays the violin in one of Degas's dance studios (Figure 113), the corner of that picture is filled with a pattern of concentrated visual energy: the player's cheek overlaps the violin, the bow crosses it, the right hand holds the bow, and the left hand grasps the neck of the instrument. The whole constitutes a focus of manifold compression.

(5) The nodes produced by any kind of grasping or surrounding involve superposition but make for a more complete constraint. Tintoretto's Eve

2. On the traditional symbolism of knots, especially in their relation to the one-line paths of mazes, see Coomaraswamy (22).

FIGURE 113
(after Degas)

(Figure 61) embraces the trunk of the tree between her right hand and her head, whereas the left hand with the apple, taken by itself, presents a mere superposition. A hand grasping a cane provides tension for a node, and so does a scarf or hood wrapped around a face.

(6) The convergence of vectors toward a common center generates a node. The keystone in which the ribs of a Gothic vault collect becomes a center of concentrated energy. A group of people seated around a table produces a similar convergence. The climactic encounter of this type is the lovers' embrace, and in a less organized way, any bunching of objects. The three swords clasped by the hand of the father in David's *Oath of the Horatii* act as a counternode to the tight cluster of the three sons. Observe here that the intensity of such a center is greatly heightened when the elements shown in physical proximity are struggling to separate. Think of two prisoners tied together, or of Prometheus or Andromeda bolted to the rock, or of two persons back to back who have nothing to do with each other—a symbol of estrangement used sometimes by Degas.

(7) Any kind of contraction produces nodes. In the depth dimension, foreshortening creates such contractions. A quietly standing horse gains visual intensity when it is seen from the front or back rather than the side. In the dimension of the frontal plane, the bending of joints in the human body offers the most convincing example. The seated figure of a woman in Manet's *Déjeuner sur l'herbe* (Figure 114) is squeezed into a triangle. The torso, the arm, the legs, form acute angles pointing in different directions. The elbow overlaps the knee, the hand is sharply angled at the wrist and grabs the chin, and the neck maintains itself upright against the curve of the back. This sum of contractions adds up to a powerful node. Or recall Rembrandt's Susanna, jack-knifed under the attack of the elder, who tries to pull the towel from her body.

FIGURE 114
(after Manet)

THE HUMAN FIGURE

It appears from these examples that the human figure is particularly well suited to show how volume and vectors join efforts to compose expressive visual objects. In principle, I said, a volume is simply a directionless mass, active only through its weight and spatial location, whereas vectors are disembodied forces. Actually, of course, any volume that possesses shape rather than being an amorphous blob is organized around its center through a system of forces. The Lissitzky example (Figure 111) showed how the large disk serves as the compact base for the compositional pattern but is not separable dynamically from the vectorial units issuing from it, moving toward it, and supporting it. Similarly, the human torso is the centric mass, the base from which limbs and head operate, but it is possessed by inherent vectors at the same time. The Roman torso of the Belvedere, although without limbs, twists and bulges powerfully. At the same time it takes no knowledge of human anatomy to see the sculptural volume of the torso as a fragment, that is, as a beginning deprived of its continuations.

More often than not, it takes the limbs to define and complete the character of the figure. In the Byzantine mosaic at the Mausoleum of Galla Placidia in Ravenna (Figure 115), the Good Shepherd dominates the semicircular scene by his surpassing size and central position. Equally significant, however, is the lively action that distinguishes him from the quiet stance of the lambs. His body, organized around the central column of the torso, is twisted through the turn of the shoulders. This turn is acted out by the lateral position of the arms,

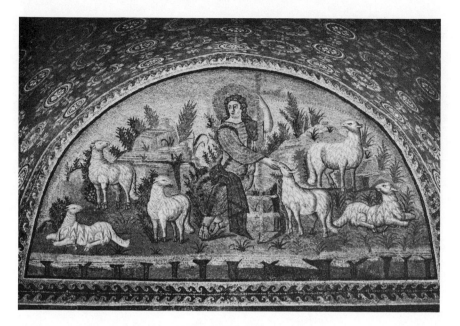

FIGURE 115.
The Good Shepherd. 5th century.
Mausoleum of Galla Placidia, Ravenna.

just as the position of the legs defines and executes the opposing turn of the pelvis. The sideways glance of the eyes, the oppositional gestures of the arms, which combine dominion and compassion, and the enlivening crossing of the feet all characterize the shepherd as the central node of the composition.

An articulated body combines expansive with contractive themes. The torso itself can supply the hollow of the stomach, the swellings of belly and muscle. The composition of Courbet's *Woman in the Waves* (Figure 116) is based on the counterpoint between the outgoing breasts and the arms confining the head. This antithesis of expansion and contraction, of exposure and withholding, characterizes the image of woman as temptress in the arts of antiquity and of the Renaissance. The standard gesture of the *Venus pudica* protecting her sex against exposure still reverberates in the nineteenth century in the resolute gesture of Manet's *Olympia*—a contractive, centripetal vector counteracting the expansive display of the body. The two poles of this range may be illustrated by the compositional schemes of two Munch figures, the defensive contraction in his *Puberty* (Figure 117) and the provocative exposure of *Ashes* (Figure 118), both painted in 1894.

FIGURE 116.
Gustave Courbet, Woman in the Waves. 1868.
Metropolitan Museum of Art,
New York.

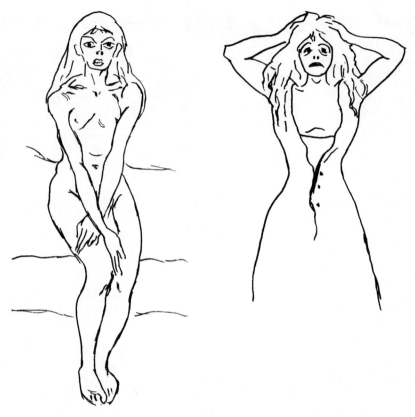

FIGURE 117-118
(after Munch)

FACES AND HANDS

What the limbs do for the body, the face does for the head and the fingers do for the hands. It may seem artificial to distinguish the face from the head in order to separate, once again, volume from vectors. But a glance at the history of sculpture shows that the relation of the face to the skull has always been a problem, which is overcome only in naturalistic representation. In principle, the skull is a sphere, symmetrically organized around its center, whereas the face is a relief surface. Thus in much early sculpture the face is either reduced to a few markings on the ball of the head or conceived as a flat shield, to be somehow combined with the volume of the skull. There is a bronze head by Picasso in which a diamond-shaped face is attached as a separate façade to the ball of the head (Figure 119). At a more differentiated level of composition the

FIGURE 119
(after Picasso)

two elements fuse in a unitary conception, as also happens with the relation of torso and limbs.

Can a face be described as a node, that is, as a constellation of vectors? It can if, as we must, we perceive the facial features not as lifeless shapes but dynamically. The eyes are identified with the powerful directional beams of the glance, which often control the spatial orientation of an entire figure. The lips are an unfolding, outward-directed blossom, and the prow of the nose points forward and downward. The exact constellation of these vectors varies with the particular representation, but typically it contributes a principal node of the body.

Capable of producing a richer assembly of expressive features than any other part of the figure except the hands, the face fulfills different functions depending on its formation. Its symmetrical arrangement can make for an island of classical serenity, often in contrast to a complex pattern of body and dress. But a face can also be loaded with tension, tightened by emotion, foreshortened or tilted by perspective. In a nonrealistic style, the symmetry of the features can be distorted and the tension thereby enhanced (Figure 120). In cartoons, protruding noses, bulging eyes or lips, receding chins, etc., show in their exaggeration the expressive function of facial vectors.

In David's *Death of Marat* (Figure 121) the nude torso of the murdered man rises from the body's hidden center. Chest and arms are relatively undifferentiated volumes, whose vectorial meaning is spelled out by the terminal accents of the face and hands. The highly articulated face, framed by the towel,

FIGURE 120
(after Picasso)

contributes the decisive break in the body axis, the collapse, the loss of life. At the opposite extremities, the activity of the hands outlasts that of the body: the left hand still grasps the letter, the right hand the pen. The example illustrates the visual ambiguity inherent in any human figure. The volume of the torso as the base and center of the body feeds its extremities and achieves its own supreme articulation in the face and the hands, the seats of the mind and of action. This is, as it were, the centrifugal reading of the body. Conversely, centripetally, the head as the center of reasoning and control conveys its orders to the body and decrees life or death; the hands as the executors of activity give motion to the arms.

The hands may be called the most expressive nodes of dynamic action available to the artist. In the structure of the hand, the ratio between the volume of the palm and the vectorial digits favors the latter. In shape and flexibility the palm of the hand is inferior to the torso, but this disadvantage is made up by the variability of finger movements. The fingers, entirely controlled by the muscles of the hand, are all but independent of the gravitational pull, by which any action of arms and legs is severely constrained. This endows finger action with a freedom not available to the body as a whole—a difference that affects the kind of symbolic representation for which body and hands are suited. In dance and sculpture, no statement embodied by the figure as a whole ever excludes entirely the basic contrast between the downward-directed vector, the heaviness of weight, the rootedness in the ground, and the upward-directed aspiration to overcome inertia. This decisive theme is all but denied to the hand within its own range of expression. The hand must pay for its freedom.

FIGURE 121.
Jacques-Louis David, Death of Marat.
1793. Musées Royaux des
Beaux-Arts, Brussels.

FIGURE 122.
Matthias Grünewald, Details of hands from the *Crucifixion*.
Isenheim altar. 1515. Musée d'Unterlinden, Colmar, France.

But there are compensations. The hand, as part of the larger whole of arm
and body, profits from the additional meaning derived from the larger context
and acts as an executor for the body. The body is primarily alone, dependent
on its own resources; it must seek company to overcome that limitation. The
hands are a twin duo, predisposed to work together in a natural *pas de deux*. To
get a sense of the infinite wealth of constellations available to a pair of hands,
one need only glance at a survey of the hand gestures that have been codified as

FIGURE 123

mudra for use in Buddhist dance, sculpture, and painting.[3] More generally we can distinguish six types of behavior that the hands may represent: (1) expressive, e.g., the spasmodic spreading of the fingers when the hand has been pierced by a nail (Figure 122a), or the wringing of hands in despair (122d); (2) communicative, e.g., pointing or beckoning (Figure 122b); (3) symbolic, e.g., folding the hands for prayer, giving the blessing, or giving the communist clenched-fist salute (Figure 122c); (4) representational, e.g., the mudra of concentration, which represents the divine and the human law of the Buddha through the union of two rings, the ring shape meaning perfection (Figure 123); (5) functional, e.g., grasping, poking, tearing, pushing, for practical purposes; (6) sign language, e.g., a number of fingers raised to indicate quantity, or signaling victory.

With this extensive repertoire the hands are eminently suited to acting out "microthemes," that is, symbolic representations of a work's overall subject near the center of the composition. The hands are anatomically predisposed to take their place with ease at the middle of a standing or seated figure or to serve as links between figures. As simplified stand-ins for human figures they perform symbolic puppet plays that reflect the story of the work with striking immediacy.

HANDS IN CONTEXT

The expressive action of a whole figure and that of its hands, however, must not be considered only in tandem but also in their reciprocity. They determine each other's meaning. To cite the most famous example: the hands of the first man and of his Creator, all but touching each other in the compositional center of Michelangelo's Sistine fresco, surely replicate the scene as a whole (Figure 124). Adam's hand is still limp, barely able to lift itself up in response to the approaching giver of life; the hand of the Father actively reaches toward its target. But both hands acquire their full meaning only as the extremities of the two figures, just as the figures find their consummation only in the en-

3. See Saunders (50).

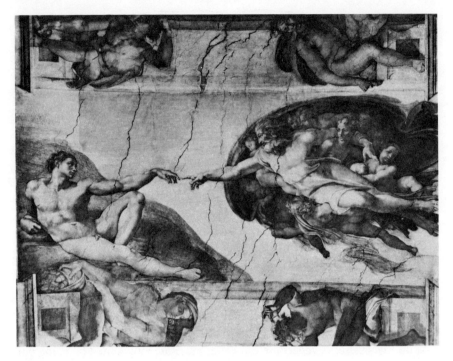

FIGURE 124.
Michelangelo, The Creation of Man. 1508.
Sistine Chapel, Vatican, Rome. Photo, Alinari.

counter of the hands, which they watch so intently. Adam's hand acquires the
limpness of its wrist only by contrast with the actively rising arm to which it
is attached, whereas the hand of the Father pushes forward as the pointed
executive of his arm.

One might say that when a person is shown as attending to something he
is doing with his hands, the figure is controlled by two principal nodes, the
face and the hands. But the vectors of the eyes are directed toward the hands so
that the hands and what they are doing become the center of the dynamics for
the whole figure. At the same time, this center of the action must be related to
the balancing center of the figure, which is located somewhere in the middle of
the torso. In relation to that umbilical base of reference in the torso of Adam as
well as in that of his Creator, the actual performance takes place at the farthest
extremity. The contact between Creator and creature is obtained by the utmost
straining away from the centers of both parties—surely an essential aspect of
the statement. Now note, however, that while in relation to the two actors

the performance occurs at the farthest extremity, it is located at the very cen-
ter of the total composition, somewhat to the left of the geometrical middle
of the rectangular painting. We begin to sense the complexity of the spatial
symbolism conveyed by the bare elements of Michelangelo's invention.

Or take the opposite relationship between faces and hands in another dia-
logue, Fra Angelico's *Annunciation* in the Monastery of San Marco (Fig-
ure 60). Here the crossed hands of angel and virgin display the same gesture.
They do not perform the action but merely supply the common denominator,
on the base of which the heavenly and the earthly figure can communicate.
Physical action as might be executed by the hands is suspended. The message is
a purely spiritual one, transmitted from face to face. Here again the vectorial
operators are at some distance from the centers of the figures, but the power-
ful stretch needed for the contact between Creator and creature is reduced
to a gentle rapprochement of the heads. The exchange of energy takes place
more nearly between equals.

The foregoing examples will have shown that the constellations of vectors,
which I have called nodes, organize the visual matter of works of art into
readable patterns. By watching what happens at these centers we understand
what the work of art is about. An observation of the poet Bertolt Brecht
suggests that the same is true for other media. Speaking about the theater he
says: "Since the public is not to throw itself into the fable as though it were a
river in which to float uncontrolled in this or that direction, the single hap-
penings must be intertwined in such a way that the knots become apparent."

SINGING MAN

I will conclude with a look at a piece of sculpture of our century, Ernst
Barlach's *Singing Man* (Figure 125). In seated figures, the main balancing
center is close to the floor, producing a solidly fastened focus, from which the
various elements sprout upward and sideways in different directions. This is
the basic constellation of vectors formed by the figure as a whole. In Barlach's
figure three principal volumes give body to the constellation: the two legs and
the torso with the head. The two legs, placed at right angles to each other,
strongly represent two coordinates of the Cartesian grid, one a towering
upright, the other providing a solid foundation on the ground. Thus the
bronze figure is stably rooted like a building. Within the vertical/horizontal
framework the body rises as a powerful diagonal, kept by the bracing arms
from falling backward, yet not reposing within itself. It hovers between rise
and fall. Song, the subject of the work, is an action, and it is an upward-
directed action as is revealed by the position of the head, which is raised like

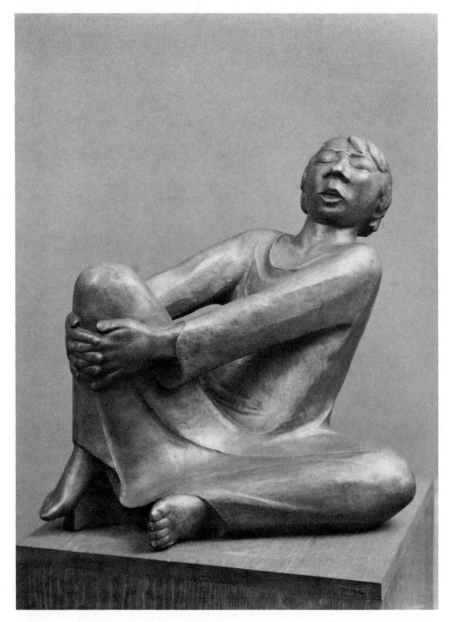

FIGURE 125.
Ernst Barlach, Singing Man. 1928.
Museum of Modern Art, New York.

that of a singing bird. This mighty sounding, sent from the ground to heaven, is reflected in the opening and spreading shapes of the figure as a whole, the wide spaces between the legs and between legs and torso. And we notice that under the impact of the rousing song the right foot lifts from the ground, as though the column of the vertical were pulled up and soaring.

But this is only half the story. The intelligence of Barlach's sculptural invention derives from the interplay of contractive vs. expansive features. Although wholeheartedly given over to his song, our man is not addressing anybody. His eyes are tightly closed so that his attention is focused on the music from within. This countertheme of concentration, indicated in the face, is spelled out more thoroughly in the other secondary node, the folded hands. They lock the brace of the arms, without whose grip the figure would fall apart. Severely contracted and safely tied to the ground, the sturdy figure lets forth its powerful music without exploding or being torn from its mooring.

MORE IN DEPTH

WHEN WE REDUCE Barlach's sculpture of the *Singing Man* to the underlying configuration of forces, we find it to be organized around a center close to the ground. The figure acknowledges the vertical and horizontal coordinates of space and projects itself upward and outward. It moves actively into space and at the same time responds passively to intrusions from the outside. Any piece of sculpture will modulate the space around it. If several such pieces are placed within one another's range, they can be made to respond to one another and together to form a coherent overall spatial organization. The double and triple pieces of Henry Moore offer convincing examples of such an interaction, but unfortunately the effect is all but impossible to preserve in the projection provided by a photographic reproduction.

OBJECTS BEHAVING IN SPACE

When the interplay of three-dimensional volumes is represented in a painting, it can be comfortably perceived in its two-dimensional projection. The painter has organized the projection for us. I shall therefore resort to such pictorial examples to show what is gained when one looks at a composition as an arrangement of dynamically expressive volumes in space. Some of the still lifes of Chardin lend themselves well to such a demonstration because they convincingly reduce the objects of daily life to their basic geometrical shapes and relate them to one another in so superior an order that we can read them with confidence.

If after a first glance at Figure 126 we refer back to the Matisse painting I analyzed earlier (Figure 22), the principal difference is clear. Matisse's five objects spread their network of relations essentially through a two-dimensional plane. In that plane we can identify the balancing center of the whole composition as well as the centers of the individual objects. Chardin's arrangement of six objects is preeminently three-dimensional. In this case,

therefore, the balancing center around which the objects on the table top are grouped lies somewhere between them, at some distance from the frontal plane; similarly, each object carries its own center and central axis internally. The specific projection resulting from the viewer's assumed station point is most carefully controlled and thus the picture differs in principle from photographs of the aforementioned Henry Moore groupings, which reveal their spatial order only through an integrated multiplicity of views. In Chardin's painting it matters that the little mortar stands in the foreground, with just enough space to stay apart from the central group. The same grouping viewed from an even slightly different angle would offer a very different statement, or, more likely, a disorderly agglomeration of things and therefore no statement at all.

The relation between the "objective" three-dimensional situation and its two-dimensional projection will be taken up soon. For the moment we are concentrating on the objective situation as suggested by the projection—almost as if the scene were presented on a stage. Two principal centers provide the main theme of Chardin's composition. The little tower of the mortar rises in central symmetry, complete, independent, unconcerned. By contrast, the large cylindrical hollow of the copper pot is all outward-directed, sending out energy like a film studio's klieg light projector, or, conversely, receiving energy by its gaping openness. It collects and reflects energy. The axis of the one-sided communication between these two principal centers of the scene is modulated by the supporting group of the bowl and two onions. They are intermediaries and mediators: the bowl is symmetrical around an upright axis like the mortar, but open like the copper pot; and the onions are tilted forward and backward, enlivening the back-and-forth of the principal motion. Add to this the sneaky introduction of the horizontal dimension by the knife, and you get a sense of what one might call the choreography of the scene.

The still life is held together by the substantial table top, which supports the action but at the same time confines it from below. This explicit support offers much solidity and security, needed to cope with the openness of the pictorial space to the left and right and the barely suggested back wall. The knife does not succeed in cutting the rounded objects off from the base on which they rest so safely.

By now we could retell in human terms the story enacted by Chardin's lively household goods.[1] We also can guess what kind of compositional change

1. The art critic John Russell wrote in the *New York Times* of November 2, 1980: "In every still-life painting worthy of the name, what we see is a scale model of society. The objects live together, mutually incongruous as they may be; and it is for the painter to persuade us that in their way of doing it there is a universal lesson for us. That was one of the great themes of European painting, from Chardin through Cézanne to Picasso, Matisse and Braque."

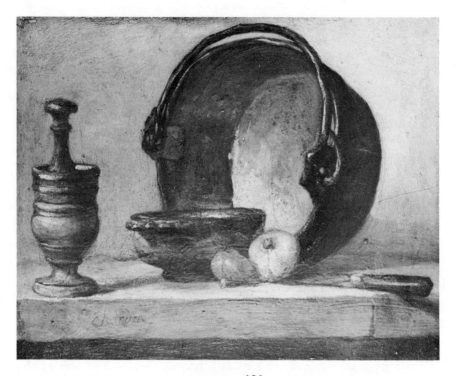

FIGURE 126.
Jean Siméon Chardin, Still Life with Copper Pot. 1734-1735.
Musée Cognacq Jay, Paris. Photo, Bulloz.

would modify the story. There is another still life by Chardin, using some of the same objects (Figure 127), in which dialogue is replaced by the coordination of self-sufficient objects, each of which minds its own business. In fact, the casserole turns its handle ostentatiously away from the gathering. The order of the arrangement is as perfect as that of Figure 126, but it is a more architectural order, in which each element limits itself to holding a clearly defined place in the hierarchy and to contributing its particular character to the whole composition. There is no reciprocal acknowledgment, no intercourse between the neighbors, no give and take or demand and reply. Each element contributes by its being, not by its response.

Chardin works not only with different degrees of clustering, but also with different levels of internal order. There are works in which the entire subject matter is fitted into one indivisible shape, for example, a triangle made up of a hunter's "bag" and equipment—two rabbits, a partridge, a pouch and powder flask—all hanging from a nail on the wall and adding up to a simple geometric

FIGURE 127
(after Chardin)

composition, as perfect as any Raphael group of figures. Yet, the components of such a tightly integrated shape can be made deliberately chaotic. They can challenge and undercut one another in a most disorderly fashion. These artfully controlled conglomerations seem to be reserved for still lifes in the *vanitas* tradition, those popular displays of attractive wares of luxury and consumption, which were shown in paintings on the pretext of representing the transience of worldly wealth. The helter-skelter of such unbridled exuberance contrasts with other, equally compact arrangements of objects by which the painter represents the dignity and conceptual order of themes like "the attributes of the arts and their rewards."

Similar differences of arrangement with corresponding differences of meaning can be found in pictorial groupings of human figures, e.g., the noisy tavern scenes as against the ceremonial group portraits in Dutch painting; and it seems to me important to realize that the paraphernalia of the still lifes express essentially the same messages as the scenes populated with human actors. They all embody configurations of visual forces that symbolize the basic theme of a work abstractly but at the same time with striking immediacy. This may be illustrated by one more painting by Chardin, in which human and nonhuman elements work together.

The weariness of the kitchen maid returning from the market (Figure 128) is expressed not only in the gesture of leaning on the wooden chest, whose top serves as the central horizontal of the composition, but also through the basic contrast between the girl's holding herself precariously in the upper half of the picture and the heavy bag of meat pulling her down toward the lower half. In the lower right corner, like the directional indicator on a map, two bottles

FIGURE 128.
Jean Siméon Chardin, Return from the Market.
1738. Staatliche Schlösser und Gärten,
Berlin, Schloss Charlottenburg.

give the dimensions of the Cartesian grid, the vertical and the horizontal. And in contrast to the isolated bowl on the floor, a tight node of woman, bread loaves, plate, jar, and chest creates the compositional center near the right side of the picture, a focus of maximum heaviness. Who would be willing to decide where in this picture human behavior leaves off and the simply material presence of objects takes over? Are not all participating elements equally

FIGURE 129
(after Degas)

engaged in producing a spatial configuration in which they interact through their location, weight, and mutual relation to make the point of the story?

The geometrical simplicity of the objects and walls surrounding the inhabitants of typical human settings embodies the spatial vectors of a visual situation with a directness not easily matched by the complex attitudes of the figures. Think of a container surrounding a person, e.g., the numerous bathtubs in the paintings of Degas, an artist who likes to constrain his personages in tight surroundings that move in on them. Sometimes the water is provided by a shallow basin, which gives the squatting figure only a foundation or frame, defining its location in space. Sometimes the tub acts as a narrow enclosure, which confines the expansive flesh of the bather and from which a leg, reaching across the rim, tries to escape (Figure 129). There is within the subject matter of such a picture an interplay of core and container similar to the one we observed in Chapter III between the frame and the painting.

But the relation between enclosure and central core can also be that of a vehicle carrying an immobile focus of energy toward its goal, as in a remarkable composition, destroyed during the Second World War, by Carl Hofer (Figure 130). The boat, propelled by no other power than the crescendo of its swinging contours, moves the poet, whose gesture enigmatically signals, proclaims, and arrests. The intense hidden action, locked up behind the closed eyes, has its visible focus in the central node of the left hand holding the tablet. Here again there is no way of distinguishing between the behavior of the human actor and the supporting role of the inanimate vehicle. The vigorously advancing boat is as much a part of the poet's striving as the poet is the soul and motor of the boat. And the nested set of enclosures—boat, tablet, eyelids—is indivisible.

FIGURE 130.
Carl Hofer, The Poet. 1942.
Destroyed by fire.

The spatial interaction between human figures and the props of the setting is particularly dramatic in Degas's *Absinth Drinkers*. The melancholy presence of the man and the woman is squeezed between bench and tables (Figure 131). The central node of the composition shows the woman compressed from the left by the bottle and the right by the glass and stabbed quite viciously by the two opposing wedges of the table corners. In the background the partially open vista, from which the two persons are separated by the back of the bench, reduces their images to shadows. As the viewer enters the scene from the front, he stumbles across a table cluttered with newspapers. And when the sitting man's glance is abruptly arrested by the frame of the painting, we realize that Degas's method of cutting across the elements of his scene does not only indicate that the pictorial space continues beyond what is shown; it also effects the opposite: the frame joins the barriers and containers within the paint-

FIGURE 131.
Edgar Degas, L'Absinthe. 1876.
Louvre, Paris.

ing as yet another enclosure, constricting the whole scene and damming the action in it.

The interplay between inhabitants and architectural spaces also illustrates the relations I am trying to describe. A portrait figure may be backed and supported by the wall in front of which he is posing but be free to act in all other directions. When shown in the corner of a room, perhaps in a Flemish portrait of the fifteenth century, the person is more sheltered and more securely anchored, but also has a more limited range of freedom. The architect Moshe Safdie has given a good example of how the variable shaping of an internal space can facilitate and control the different uses to which schoolrooms might be put: "Was there some way the rooms could be instantly changed from a pit to terraced seating to flat floor? . . . The room floor was arranged as three layers of cubes above the fixed floor. Each of these cubes opened up to become a chair and a table. By taking the cubes from the center of the room and arranging them at the periphery, you could make a sunken pit. By arranging them in rows you could make a terraced room. By filling the center of the room with the cubes you could make a flat floor." Each different arrangement of the cubic volumes, provided for practical purposes, creates at the same time a different symbolic constellation. It translates the character of the intended social setting into its visual equivalent, and thereby not only solves problems of living space but also qualifies as making an artistic statement. This is also true for stage design, e.g., for the stereometric shapes by which Isamu Noguchi created spaces for choreography, and for sculptural ensembles and paintings.

From the time Western painting began to represent coherent interior spaces, it preferred closed rooms. Although there were vistas offering a glimpse of distant landscapes or a peek into an adjoining room through an open door, the pictorial space of the picture was essentially identical with the one frontal room. The center of that room was the center of the world represented. It was a view reflecting a self-centered conception, which identified the viewer's dwelling place with the navel of the creation. A glance at Japanese pictures, especially the woodcuts of the eighteenth century, reminds us that a world without such a center is equally plausible (Figure 132). Those scenes of popular and courtly life show no closed, cubic interiors. There are no ceilings. The world is open, although subdivided, and the space described in the foreground is one among many—it just happens to be the one we are closest to. There are no true walls for either eyes or ears, only partitions or screens, which provide no isolation. They are coy pretenses at concealment, like a fan hiding the smile on a lady's face. Murasaki Shikibu's eleventh-century novel *The Tale of Genji* describes a code of social relations based on conversations through

FIGURE 132.
Kitagawa Utamaro, New Year's Day Celebration with Performing Monkey.
1789. Boston Museum of Fine Arts.

closed partitions, on fleeting glimpses, transparent disguises, noises, and shadows. The world thus depicted is a boundless concatenation of living centers, but without a center of its own.

THE ADDED VIEW OF PROJECTION

So far in this chapter I have treated spatial arrangements in pictures as though we were viewing them in and by themselves and were free to walk around them and look from all sides. At the same time we profited from the order created by the painter through the particular projection he presented, and inevitably certain features provided by this particular aspect entered the description. Thus Degas's absinth drinkers (Figure 131) are so compellingly coerced by the café tables because they are cut across by the tables perspectively, and the wedges of the tables, which I described as stabbing the woman, are converted from right angles to acute angles only by the magic of optical projection. Therefore we must now consider the compositional consequences of the interaction between projection and depth effect.

Physiologically all vision derives from the projection of optical images on the flat though curved surfaces of the retinae. I need hardly spell out the formal factors that create depth perception when someone looks at the "real" physical

world or at pictures: the partial superposition of objects, the gradients of size or brightness, the geometry of perspective systems. Suffice it to remind the reader that the most powerful indicators of depth—stereoscopic vision, based on the combination of two images; the muscular contractions controlling the curvature of the eyes' lenses; and the so-called motion parallax, obtained by head movements—alert us to the absence of "real" depth when we look at flat pictures of the conventional kind. Unless we are dealing with stereoscopic devices or holograms, those powerful neural indicators counteract a painter's or photographer's attempt to create a sense of the third dimension.

In principle, a picture of some perceptual depth offers two radically different views. If we were to see the picture according to the optical projection alone, it would look completely flat, all objects would lie in the same plane, and sizes would be controlled by distance. The picture would correspond to the description a flea-sized surveyor crawling across a canvas might make. No space interval would separate the frame from the picture; the picture would end where the frame began. The center of the picture would coincide approximately with the geometrical center of the framed surface.

At the other extreme, the viewer would see the represented shapes with the very same spatial properties they have in the "real" physical world. The distance in depth would be seen to its full extent, all things would be their objective size, and the intervals between them would be seen "correctly." The frame would be a window through which the viewer would observe a segment of unlimited space, and the center of three-dimensional pictorial space would be located at a distance halfway between the frontal frame and the limit of the visible space at the far side. A downward motion on the picture surface could be seen as running from the back to the front in "objective" pictorial space.

Psychologists speak of the "constancy" of size and shape to indicate the degree to which the distortions of optical projection are compensated for in perception. The flat picture I described as the first of the two extreme views would result from 0 percent constancy, whereas the totally faithful second view of space would exemplify 100 percent constancy. In practice neither extreme is ever realized. Whether one looks at a portion of the physical world or at a picture, the resultant depth effect lies somewhere between the two extremes. The exact nature of such visual experiences is not easily described. Looking along the nave of a traditional church, we see the depth of the interior somewhat contracted and the columns and walls as diminishing in size and converging toward the vanishing point. But although modified, the space we see looks walkable: we are willing to entrust ourselves to it without hesitation. On the other hand a photograph of a similar scene or a painting constructed with all the arts of Renaissance perspective will convey the sense of some depth

FIGURE 133
(after Degas)

but almost never the illusion of walkable space—an experience different in principle from an illusion.

The reasoning mind notes a contradiction when space is perceived as having depth but not physical reality. Phenomenologically no such contradiction results. The photograph or picture lets us perceive a distinction between front and back, albeit within a more or less limited range. Yet we also observe a qualitative difference between the physical space, which contains the viewer and the picture as physical objects, and the pictorial space created within the picture. What matters for my present purpose is that when we observe perceptual depth we can voluntarily shift from a more projection-oriented to a more "objective" view. I can focus on the large size of a Degas ballerina standing in close-up as against the much smaller ballet master at some distance, but I can also focus on the closeness of the ballerina and the remoteness of her teacher (Figure 133). And while in the first state I see sizes without losing my awareness of the distance, in the second I see distance without losing the sense of size difference. There is no either/or. But the two emphases convey two different compositions with two different meanings, which interact to create the work as a whole.

Once this is said, it may be safe to distinguish between the two components of depth perception as the two-dimensional or projective view and the three-dimensional or objective view. The particular ratio between the two views that characterizes any individual case depends on a number of factors. The flat frame of the picture and its adherence to the flat wall on which it hangs tend to strengthen the physiologically derived information that the viewer is facing a flat object. So does the visible surface grain of oil paintings.

As far as the picture itself is concerned, the decisive factor is the tendency toward the simplest available perceptual structure. This rule, formulated in gestalt psychology, predicts that when the structure of the projective pattern has a higher degree of simplicity than the three-dimensional one, the former will prevail.[2] If, for example, the projective pattern is strongly symmetrical, it will influence the percept in the direction of flatness. This can be observed particularly in pictures relying on central perspective. When the vanishing point is located in the middle of the picture, a symmetrical scaffolding of edges is created, which tends to reduce depth and flatten the image; but when the vanishing point is off center, the depth effect is enhanced.

In addition, as I mentioned earlier, the depth effect is favored by the viewer's glance. The strongly dynamic "beam" sent out from the station point of the eyes whenever we look at anything tends to penetrate space in an orthogonal direction. Most objects stop this advance effectively. But any depth-promoting factors in an image will be enhanced by it.

On the other hand, when we look at the development of the representation of space in picture-making, we find that at early stages the depth dimension does not exist. I am referring here primarily not to chronological periods in the history of art or the course of a person's life, but to the growth of perceptual organization as a process inherent in any such development. In the early drawings of children, for example, the depth dimension is absent. This does not mean that objects are presented as flat rather than three-dimensional—a misinterpretation that applies the principles of a more advanced stage to the earlier one—but that the depth dimension is not yet differentiated. The picture presents no fore or aft. The distinction between figure and ground is not yet one between what is in front and what is in back but only one between positive object and negative, empty ground.

The next step is to add a background, for example, a landscape or the back wall of a room behind a frontal figure. This introduces the depth dimension and implies a distance between the two planes, but that distance is not yet spelled out as a continuous space. It is an interval that implies no connecting floor, nor can it accommodate any other object located within it. It is a discontinuous leap between two scenes that are limited to displays in their frontal dimensions. While the compositional center in the frontal plane is readily discernible, there is no way of looking in such pictures for the center of the three-dimensional space. Strictly speaking, we are still in the second dimension, a set of two or more frontal displays, like a stage set made up entirely of flat wings and a backdrop.

2. See Arnheim (4), pp. 248ff.

This hiatus, this unstructured distance between front and back, still occurs in otherwise highly developed compositions of the Renaissance and later, especially in portraits. Think of Leonardo's *Mona Lisa*. The gap between the parapet against which she is leaning and the background landscape exists almost entirely by virtue of our knowledge of size differences. It is not spelled out. You might be able to look for a center within the landscape but not in the space between foreground and background. Striking examples can be found in certain other Italian paintings of the fifteenth century that apply the newly acquired art of central perspective to the architectural setting but not to the figures. The angel of the Annunciation and the Virgin dwell in a flat foreground plane, quite detached from the scenery that extends into depth. In the nineteenth century, Degas produces a shocking clash between the fantasy world of the theater and the "real" world beyond the footlights by juxtaposing stage and orchestra as though they were pasted together in a collage.

Whenever figures or other subjects are kept strictly in the foreground of a painting, they preserve some of this primordial depthlessness. They are not really in the front portion of the scene and thus a part of it, but independent of it, outside of space as far as the third dimension is concerned. Or to put it another way: as long as an object is not assigned a definite place on the depth scale by means of some perceptual device, it remains in the spatial no-man's-land of early representation. Gradually, the setting closes in behind and around it. The traditional interior with its back and side walls may surround the frontal scene without as yet providing a continuous space. And the front wall cannot be said to be "missing"—it has never been there. The introduction of a frontal partition is a drastic compositional act, intended to produce separation and concealment.[3]

THE CHARTING OF THE VISTA

Once we look at the acquisition of space genetically we realize that a system of linear perspective is introduced not primarily for the purpose of creating a likeness of optical projection, but in order to provide a continuum of space in depth. When such a system takes over, the no-man's-land between foreground and background becomes occupied. In fact, the very distinction between different zones of distance competes with the conception of an indivisible depth dimension, in which any object finds its particular place in a system of coor-

3. Erwin Panofsky (46) gives an interesting example of an in-between stage. In Ambrogio Lorenzetti's *Annunciation* in the Accademia of Siena, the two figures are still placed against an empty gold ground, but three-dimensional depth is partly supplied by what Panofsky calls an "interior by implication." A checkerboard floor presents space as a horizontal base—a first step toward a more complete enclosure. (P. 144 and Figure 104).

dinates. The same kind of system that rules frontal space with its two con-
tinuous dimensions of vertical and horizontal is now applied to three-dimen-
sional space.

When, as in Japanese art, the picture space is based on a system of
parallel lines running obliquely toward (or away from) the frontal plane, the
space has neither a beginning nor an end (Figure 134). It appears from
somewhere beyond the limits of the picture, perhaps from the upper left,
traverses the visible area, and vanishes at the lower right. The movement may
be traced either way, it may approach from the distance and advance past the
viewer or the other way round, but it does not stop. Limitation is provided
by the frame only for the projective image of the frontal plane, and therefore
the composition as a whole has something like a true center only in the projec-
tion. This center of the rectangular frontal plane gives visual prominence
to the small costumed monkey in the Utamaro print we looked at earlier
(Figure 132).

But the more effectively the oblique axis pervades the pictorial space, the
less power is available for a compositional center in three-dimensional space as
a whole. Instead, the enclosures partitioned-off from the flow of spaces create
their own centers, as can be seen in the circle of shells around which the players
are grouped in Figure 134. Viewed projectively, this center of course lies at
some distance from the balancing center of the picture as a whole, and in
most European paintings this eccentric position would create tension. Very lit-
tle such tension seems to be generated in the Japanese scene because the pro-
jective version of the composition is too weak to assert itself. Our eyes
move almost unrestrained through the three-dimensional expanse.

Compare this with a composition in which the main axis of pictorial space
runs not diagonally but parallel to the viewer's line of sight, as it can when
one-point perspective is used. Central perspective does have a center of its
own, the vanishing point, which by the partial depth effect of such a picture is
seen as located somewhere in the far distance. From that distant point the
picture space opens up like the inside of a pyramid looked into from the base.
The edges and surfaces of the perspective construction offer a spatial contin-
uum, in which any location at any distance is exactly defined. This spatial
container, however, appoints no center for the enclosed area. On the contrary,
its own powerful peak, the vanishing point, opposes the painter's effort to
single out a place in the spatial continuum as the center for the scene he is
creating.

In Dieric Bouts's *Last Supper* (Figure 135), the main axis, defined by the
perspective convergence of the edges, is strictly orthogonal and thus coincides
with the viewer's line of sight. Since the vanishing point is placed on the

FIGURE 134.
Kitagawa Utamaro, Playing the Shell Game. c. 1790.
Boston Museum of Fine Arts.

central vertical, the spatial system provided by the setting is essentially sym-
metrical. So is the shape and position of the table with the thirteen diners
around it. This symmetry of the projective pattern tends to flatten the scene.
Although the checkered floor and window wall, looked at by themselves, create
considerable depth, the symmetry of the total composition tends to lessen the
distance between foreground and background and emphasizes the view pro-
vided by the frontal plane.

This frontal view is hierarchic. The figure of Christ, framed and enthroned
by the fireplace behind him, dominates the scene. He rises above the disciples
around and below him. His head is placed slightly higher than the frame's
geometrical center, which coincides with his blessing hand. The upright
format of the picture emphasizes this hierarchic dimension of verticality. On
this same vertical scale, however, the vanishing point of the surrounding
interior space lies considerably higher than the head of Christ, namely, on the
edge of the chimney hood. This powerful compositional node lowers the entire
saintly gathering and keeps it at the bottom of its earthly container, the
banquet room. (Compare this with Leonardo's *Last Supper* (Figure 23), where
the perspective edges converge in the head of Christ. There the spatial setting

FIGURE 135.
Dieric Bouts, The Last Supper. 1468.
St. Peter's Church, Louvain.

and the central figure are inseparable. The setting acts as an appurtenance of Christ, heightening his dominance over his surroundings.)

When the viewer focuses his attention on the three-dimensional aspect of the Bouts painting, his glance pushes into the pictorial scene, which now becomes more down-to-earth, less hierarchic. The walls, no longer a background foil, envelop and protect the dinner party. The fireplace has receded and no longer enshrines the figure of Christ, who sits as one man among others at the table. The group is now centered around the circular plate with the lamb roast. Judas and Christ are of equal height. The bare floor in the foreground, which seems to weaken the foundation of the scene in the projective view, now serves to move the gathering of diners from a frontal no-man's-land to the middle of the enclosed space.

Yet the centrality of the dinner group is not uncontested. Although the perspective edges of the room converge geometrically at the chimney hood, perception pushes them much farther back. Theoretically, of course, the vanishing point can lie at any distance on the orthogonal line of sight. If perceptual constancy were at 100 percent, it would dissolve into the infinite. In a picture such as ours the depth effect is much reduced; but it remains strong enough to disavow the finality of the back wall. At that wall, space is not yet at an end, and therefore the group we see holds the center only in a first approximation. More broadly perceived, the world continues behind the partition, and the particular scene we witness reaches beyond itself and receives its true meaning only from the wider spatial context.

The more compellingly the pictorial space is shown as boundless, the more precarious becomes the status of central location because centrality can be defined only in relation to the boundaries of space. We saw how in Japanese painting the bird's-eye view, known since the Heian period as the *fukinuki yatai* technique, succeeds in combining partitions with endless space. In the European tradition perspective space is more often conceived for the horizontal eye-level of a pedestrian viewer, so that partitions block the vista. It would be tempting to study in detail the degrees of openness and closedness obtained by Western painters through various kinds of partitions: the railing of a frontal balcony, the window opening in a frontal wall, the trees creating a loose arrangement of obstacles and interspaces, the more or less solid backdrops. In an *Adoration* probably painted in the workshop of Hieronymus Bosch (Figure 136), the Madonna sits outdoors, barely protected by a tarpaulin that is strung by the angels across the rudimentary walls of an enclosure. The walls create no interior, only a sketchy precinct, and it is instructive to observe how much the lack of defined space distracts from the relation between the worshippers and the central object of their attention. Does the continuous space of Renaissance painting lead to a crisis of centrality?

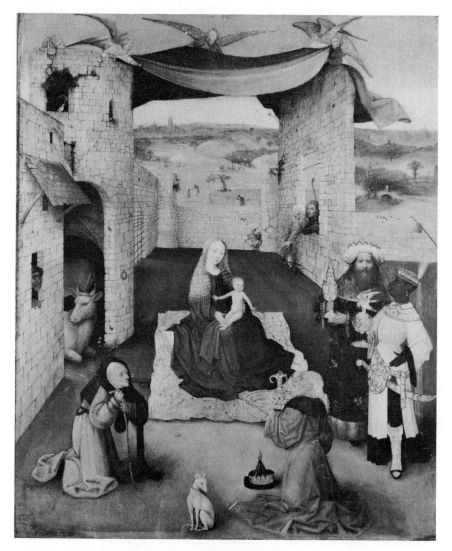

FIGURE 136.
Attributed to workshop of Hieronymus Bosch, Adoration. c. 1505.
Metropolitan Museum of Art, New York.

A curious device is sometimes used to buttress centrality in open pictorial space. Horizontal lines or edges that according to the rules of one-point perspective ought to run straight, that is, parallel to the bottom edge of the frame, are made to curve around the central scene. John White has pointed to examples in French book illuminations, especially in Jean Fouquet's *Grandes Chroniques de France*. In the "Arrival of the Emperor at St. Denis," for

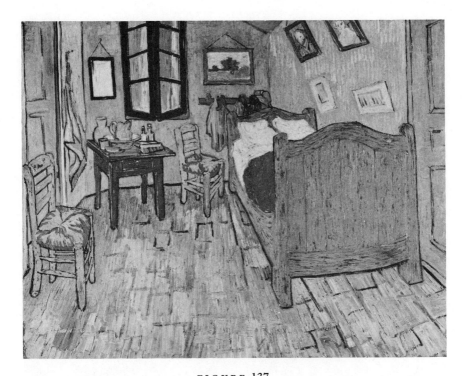

FIGURE 137.
Vincent Van Gogh, The Bedroom at Arles. 1888–1889.
Art Institute, Chicago.

FIGURE 138

example, a pavement is drawn in central perspective, but the horizontals crossing the converging orthogonals curve around the parading horses. As a comparable example of very different origin, I will cite Vincent Van Gogh's *Bedroom at Arles* (Figure 137), where the cracks across the boards curve similarly toward the perspective center. Psychologists may remember that in the so-called Hering Illusion (Figure 138), a straight line crossing a sunburst of radii is perceived as bent toward the center, thereby yielding to the field of forces created by the concentric beams. Our examples seem to indicate that

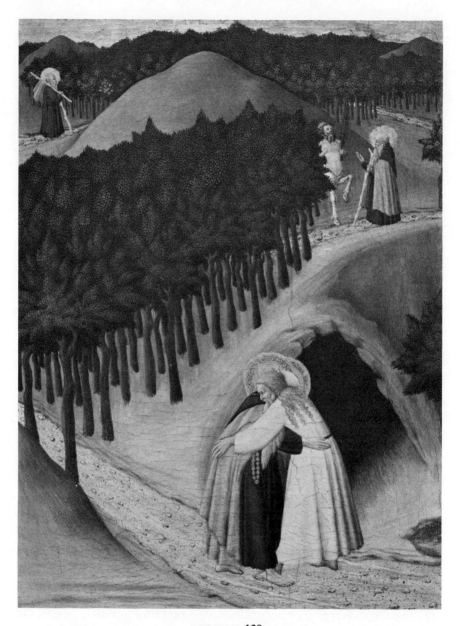

FIGURE 139.
Sassetta, The Meeting of St. Anthony and St. Paul. 1432/36.
National Gallery of Art. Washington, D.C.

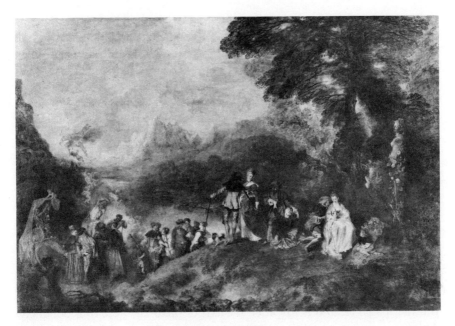

FIGURE 140.
Antoine Watteau, Embarquement pour l'île de Cythère.
1717. Louvre, Paris.

occasionally artists accede to such tensions in response to the demands of centricity generated by the perspective system. In this way they acknowledge and strengthen the compositional center, whose presence would be ignored by insensitively straight cross lines.[4]

As the depth dimension acquires spatial continuity it also impairs centrality by representing, explicitly or implicitly, the flow of time. Time can be conceived as moving from the back to the front of the pictorial space or vice versa, and the picture accordingly shows the past leading to the present, represented through its closeness to the viewer, or, conversely, the present as the base for events in the future. In a painting by Sassetta (Figure 139), Saint Anthony takes off at the far distance for a trip through the desert, consults a centaur on the way, and finally in the foreground embraces his fellow hermit, Saint Paul, whom he had set out to visit. Conversely, Watteau in his *Embarkation for the Island of Cythera* (Figure 140) has his pairs of lovers start their journey in the

4. There is a tendency among art historians to explain deviations from "correct" representation by searching for optical effects the artist is supposed to have discovered and reproduced while he was copying nature with mechanical faithfulness. In keeping with this tradition, John White

right foreground and leads them across the picture to the distant boat. It is true that Watteau presents his largest couple as the climax of the action in the middle of the picture and synthesizes in the attitudes of the man and woman the themes of advancing and retrospecting; but it took all the skill of a great painter to endow the picture with the stasis of a central theme without interrupting the flow of the progression. Even when no such explicit story is presented, the movement of space and time in any deep pictorial vista confronts the painter with the same problem.

LOOKING INTO ODD SPACES

Whenever a viewer concentrates his attention on a picture that conveys some depth, the pictorial three-dimensional space can be said to reach out from inside the frame and involve the viewer in its continuity. This condition is met most fully and smoothly when the main axis of the picture space coincides with the viewer's line of sight, as was the case in Bouts's *Last Supper* (Figure 135). But the spatial tie also holds when the axis of pictorial space runs obliquely. This is true even for traditional Japanese painting (Figure 134), although here the encounter occurs at an oblique angle and not only along the ground plane; the viewer looks downward from above.

In the psychological development of visual conception, oblique vistas represent a higher level of complexity than orthogonal ones. They differentiate between the approach of the viewer and the structure of the setting into which he is looking. The encounter can be perceived in two ways. If spatial orientation is anchored in the framework of the setting, the viewer perceives himself as being at odds with the situation he faces. This approach will almost always prevail in actual physical space, when a visitor is surrounded by the space he sees. But when it comes to looking at a picture, it is also possible to anchor the spatial orientation in the viewer's line of sight and perceive the depicted space as askew. What do we see when we look at one of Degas's ballet studios extending obliquely through the picture? Most commonly such a view is interpreted as a manifestation of subjectivism: the artist shows what the world looks like from the particular point of view of a particular individual. The center of the frame of reference is in the viewer. But it is also possible to defend the opposite position. Wolfgang Kemp, in an essay on perspective in

(65) asserts that such curvatures are renditions of what the artist sees when he turns his head sideways (pp. 226ff.). My own inclination is to show that such compositional features are responses to problems arising from the perceptual properties of the pictorial product, especially in works that are not done from the model. Those features come about during the interaction between the artist and his medium. On the Hering illusion see Arnheim (4), p. 420.

photography, has asserted that "the apparently subjective segment of reality can also be interpreted as the triumph of nature over man's formative intention. The omnipotence of the authoritative artist seems to have gone. The restriction of the visual angle, which suggests the continuance of reality outside the picture, replaces the artful limitation and construction of the objects for the purpose of the image. Such pictures presuppose the existence of a reality that does not need to be built and organized but simply exists and therefore can be depicted." Viewed in this fashion, the oblique vista points to the autonomy of the outer world, to whose framework the approaching visitor must adapt. Either way, in comparison with the easy access to orthogonal space, an estrangement is diagnosed by the artist. Entering the world poses a problem.

There are certain restrictions, however, that for good reason have been respected through the ages. One of them concerns spatial tilt. In the various systems of perspective, the verticality of the verticals has rarely been touched. Recall here my earlier observation that perspective was not introduced to imitate optical projection as faithfully as possible, but to provide a continuously organized space in the depth dimension. Now any depth effect comes about through an interference with the objective appearance of things. It changes sizes or angles and interrupts or distorts shapes. A system of perspective, therefore, represents a particular ratio between depth effect and distortion. Isometric or axonometric perspective changes only the angles, but can leave sizes intact. It profits from a minimum of distortion, but pays for its "objectivity" with a reduction of the depth effect. Central perspective obtains a stronger depth effect by means of more violent distortion.

Usually, central perspective limits itself to the one-point or two-point version. Additional vanishing points, however, are available, toward which verticals could converge upward or downward. Even so, it has taken photography to make use of that possibility, and the attempts to imitate the effect in painting have not been encouraging. Not that Western painters have hesitated to represent the world looked at from below or above. Degas shows the acrobat Miss Lala high up in the dome of the circus (Figure 141). The figure of the woman is foreshortened as a viewer would see it from below. But even though Degas had challenged his fellow painters to show "monuments or houses from below, from beneath, up close, as one sees them going by in the streets,"[5] a sure instinct led him to keep the vertical supports of the building unmodified.

According to Kemp, it was the Soviet artist Alexander Rodchenko who most loudly objected to the "navel shots" of traditional photography, that is, pic-

5. See Nochlin (44), p. 19.

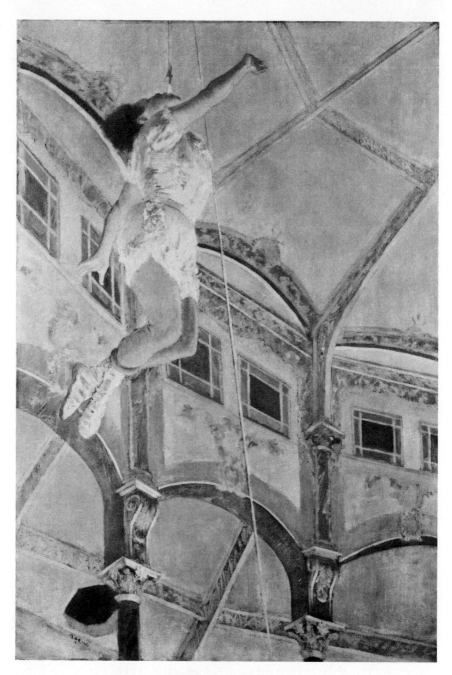

FIGURE 141.
Edgar Degas, Lala au Cirque Fernando. 1879.
National Gallery, London.

tures taken in the horizontal direction. Now the camera began to point freely in all directions, and many early photographs abandoned perpendicularity. In such images we see terrestrial space losing its relation to gravity. Space tumbles, whereas in Degas's painted circus interior, the building continues to respect the plumbline. It is the viewer in the role of the circus audience who tilts his line of sight.

Why this difference between painting and photography? In daily perceptual experience, visual orientation in space relates to the Cartesian coordinates of the gravitational field. Whenever our line of sight deviates from the horizontal, the verticals in the retinal image tilt. But such is the cooperation between the kinesthetic sense of equilibrium in the body and the sense of sight that any such deviation in angle is automatically attributed to a tilt in the viewer rather than in the world of the image. Of course, this correction does not occur when one looks at a picture of tilted space unless—and here is the difference between painting and photography—we understand the picture intellectually as a record of an act of viewing that took place at some other time somewhere in physical space. But this sort of indirect interpretation does not go well with aesthetic experience.

In painting, the surface grain of the canvas tends to keep the frontal plane perceptually alive and to maintain it as a frame of reference even for strongly deviant pictorial spaces. It is of a painting's essence that it be seen as something made by human hand on a surface. Photography is different. The smooth and even surface of photographic paper fails to create, as Ernst Kallai observed in 1927, the "optically perceivable tension between the material carrier and the image itself."[6] This neutrality of the carrier surface makes it possible to look into the picture as though through a mere opening, and to see its space upheld by the Cartesian framework inherent in that space.

There is another possibility. Such photographs can be seen in the manner of certain Expressionist cityscapes in which buildings tumbled obliquely in all directions. But those rebellious paintings, far from abandoning the Cartesian framework, derived their meaning from the framework's implicit presence even though in many cases there was not a vertical to be seen in the picture. They made sense only as deviations from that framework. It is difficult for photographs to emulate this effect. Not only does the realism of the photographic medium not take kindly to such distortions; more significantly, the oblique photographic views look like what they are: assemblies of shapes conforming to a tilted framework of their own rather than diverging from the framework of the viewer.

6. Kemp (37), p. 95.

THE TWO INTERPRETATIONS

It is the common Cartesian framework that unites the viewer with pictorial space. Within that common space the frontal plane, although often not represented in the pictorial image itself, stands for the upright dimension. The groundplane in depth stands for the horizontal. In the rightangular open space between the two surfaces, the image is displayed in its three-dimensional freedom. And depending on whether the viewer concentrates on the projective or the three-dimensionally "objective" aspect of the scene, he receives one of the two fundamental components of the composition. Of this interaction I will now discuss some further examples.

Since the early visual conception of pictures involves no depth, the primary distinction in the upright is that between up and down, not that between far away and close by. Thus in Van Eyck's *Adoration of the Lamb* (Figure 142), the dove in the aureole is meant to be suspended above the altar with the lamb, although the realistic landscape would locate it in the far distance, somewhere above the hills. It is an archaic vestige of an earlier conception of space. This is frequently the fate of apparitions in those still hesitant experiments with pictorial depth, if only because the needed height would not be available at closer distance. For example, in Bosch's *St. John on Patmos* (Figure 143), the evangelist looks directly at the angel on the hill and the Madonna in the skies, but only if the picture is read in straight, depthless projection. By the logic of the landscape both apparitions are way behind the apostle's line of sight. The same is true for Joos Van Cleve's representation of the same subject.

However, this archaic feature must be distinguished from the deliberate use of optical projection, which occurs after, rather than before, the mastery of pictorial depth. The Van Eyck painting, for example, is still essentially limited to a concentric arrangement in objective three-dimensional space. The altar stands in the middle of the landscape, and the four groups of worshippers approach the center symmetrically from different sides. To be sure, the scale of sizes is not without significance. But the prophets and apostles in the foreground are not only large but also close by, and it would seem to be proximity to the viewer that determines the place of honor rather than size. And the two angels with the censers are made to kneel before the altar rather than elsewhere in order to be clearly visible. In spite of the skillful control of the composition in the frontal plane, the emphasis that carries the principal meaning derives from the three-dimensional stage.

During the early experimentation with pictorial depth the meaning can remain visually ambiguous, and the correct reading must be inferred from the subject matter. In Dieric Bouts's *The Martyrdom of St. Erasmus* (Figure 144), the judges, led perhaps by the Roman emperor himself, tower above the

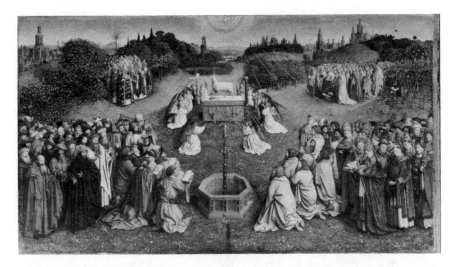

FIGURE 142.
Hubert and Jan Van Eyck, Adoration of the Lamb.
1432. St. Bavo, Ghent.

martyr. But the martyr is obviously intended to be the prominent figure, which means that his closeness on the distance scale rather than his low position on the vertical is intended to convey the meaning; that is, the picture is meant to be read as a scene in "objective space." The judges, barred by the axle of the torture instrument, are to be seen in the background.

This reading is supported by the two upright figures of St. Jerome and St. Bernard depicted on the wings of the triptych; the base on which they stand corresponds to that of the tortured Erasmus, which confirms his spatial level as the principal one.

We look, in comparison, at two centrically composed paintings by Pieter Bruegel. In his utopian *Luilekkerland* (Figure 145) the star pattern in which the three lazybones are arranged around the tree trunk works essentially in the third dimension. The tree is rooted in the center of the three-dimensional space, and the most that can be said for the projective distortion of the symmetrical trio is that it underlines the vulgarity of the scene by giving prominence to the peasant's behind and the spread-eagled legs of the clergyman. But in the same painter's more ambitious *Adoration of the Magi* (Figure 146), we cannot afford to overlook the additional meaning contributed by the projective view. The three-dimensional scene emphasizes as usual the more external aspects of the story: the Madonna surrounded by visitors and bystanders. In the projection, however, the kneeling king and the Madonna

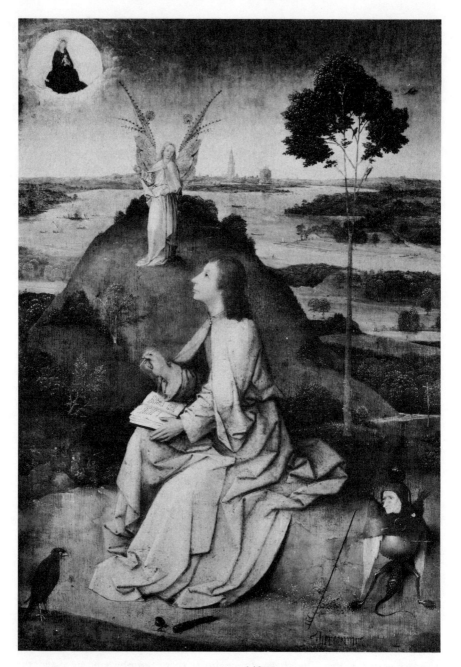

FIGURE 143.
Hieronymus Bosch, St. John on Patmos. 1504–1505.
Staatliche Museen, Berlin (West).

FIGURE 144.
Dieric Bouts, The Martyrdom of St. Erasmus.
1448. St. Peter's Church, Louvain.

are fitted to a unitary curve that combines convexity with concavity: the bent back of the worshipper with the receptive response of the Virgin. And the empty sleeve trailing on the floor introduces us to the scene with an abstract symbol of humility.

Even more significant is the impressive crowd, which, in the projection, bears down on the central scene rather than merely surrounding it in the background. As soon as we notice the spear of the soldier striking the head of the Madonna, we realize that the threat of violence, the whispers of skepticism and gossip, the thrust of the armed multitude, are no mere accessories but essential to the painter's interpretation. Similarly, the large figure of the black king cannot be considered simply a *repoussoir*, that is, a foreground foil by which the principal scene is pushed back to the center of the three-dimensional space. In the more direct projective relation, the powerful expanse of this all but faceless figure with the pointed aggressiveness of his red boot underscores by contrast the precarious frailty of the nativity.

As Western art moves toward the Baroque, the projective modifications of size and spatial relations begin to be taken literally. In *Christ on the Sea of Galilee* (Figure 147) Tintoretto uses projective size difference to express the hierarchic relation between master and disciples. The realism introduced by the Renaissance no longer permitted artists to make the Pharaoh larger than his

FIGURE 145
(after Bruegel)

captives, as did the ancient Egyptians, or the enthroned Madonna larger than her companions, as did medieval painters even in the age of Cimabue. But the reductive projection in the Tintoretto is sufficiently compelling to make us attribute the size differences to the figures themselves, rather than to their distances from the station point of the viewer. As Peter obeys the call and steps on the water, he crosses the central vertical that separates the two halves of the painting—the realm of the small disciples and the realm of the tall master; and the central horizontal stabilizes his path.

When the arts liberate themselves from their religious and monarchic commitments, the artist becomes entirely free to distribute his emphases as he pleases. He can impose his own scale of importance upon the logic of any situation he depicts. For example, in the nineteenth century Henri de Toulouse-Lautrec or Mary Cassatt pick a single spectator in a theater or circus loge and make him dominate the entire interior as a giant foreground figure.

Painters may use variability not only in size but also in distance. The latter serves to connect foreground and background, sometimes in a purely iconographic way, by making the viewer search for the tower of St. Barbara in the remote landscape or discover a relief with the expulsion of Adam and Eve on the back wall behind the scene of Christ expelling the money changers (Figure 56). In Titian's *Sacred and Profane Love* we would hardly be prepared to relate the tightly confined complex of buildings on the horizon symbolically to the

FIGURE 146.
Pieter Bruegel, Adoration. 1564.
National Gallery, London.

FIGURE 147.
Jacopo Tintoretto, Christ at the Sea of Galilee. 1591–1592.
National Gallery of Art. Washington, D.C.

dressed woman in the foreground, and the open lake with the phallic church steeple to the nude, if the reduced distance did not make the foreground adjacent to the background and put the two parties to each comparison into different size categories, as one might do to distinguish the signifier from the signified.

Occasionally Poussin stylizes the theme of a foreground scene in the geometry of the architecture behind it, for example, when the steep railing of a staircase in the background underscores the descent from the standing Jesus to the kneeling adulteress (Figure 148). Such a reduction may also serve purely formal purposes, for example, when in Manet's *Déjeuner sur l'herbe* the small figure in the back serves to complete the compositional triangle of the foreground group.

Furthermore, optical projection makes for compression, notably in central perspective, a system in which the projection shrinks all objects with increasing objective distance until at the horizon they are reduced to mere points. This means that the more projectively a scene is perceived, the shallower and more compressed it will look in the depth dimension. Artists who find the high-pitched tension of compression congenial, such as Tintoretto, Piranesi,

FIGURE 148
(after Poussin)

Van Gogh, or Munch, seek orthogonal vistas; artists like Poussin, Cézanne, or Matisse, who prefer the calmness of undisturbed shapes, avoid them. Take Van Gogh's painting of his bedroom (Figure 137), which he said he wanted to express "inviolable rest." If we read the picture as much as possible in its "objective" three-dimensionality, a sense of quietness may in fact be conveyed by the simple rectangularity of the room and the few equally simple objects conforming to the space. But unavoidably this version is overruled by the strong perspective, which compresses the interior with increasing distance. It crowds the furniture, pictures, and window in the back, and in doing so stifles breathing in the very area in which the sleeper will rest his head. The process repeats itself for the cubic space of the bed: the space between the headboard and footboard is contracted, the post pokes into the pillows, and an oblique angle squeezes the red quilt. This highly charged projective image conveys not rest but anxiety.

How different a composition can look depending on whether a viewer emphasizes the one or the other version may be illustrated by one of Degas's pastels (Figure 149). It is not easy to obtain a convincing three-dimensional view of the scene; by closing one eye one can strengthen the depth effect somewhat. Three-dimensionally one looks through a narrow opening into a space that extends limitlessly in all directions. A shelf, pointing toward and away from us, covers the area on the right at the level of the woman's lower back. From this shelf as the base the bent woman's body arches upward. A sagittal plane, parallel to the frontal plane, divides the picture space into two symmetrical halves. It cuts everything in two; the woman, the shallow tub, and the shelf. Among the objects on the shelf, this central plane singles out the large water pitcher, which, in its curviness and color range, offers a curious replica of the nude body, pitting its uprightness against the bendedness of the

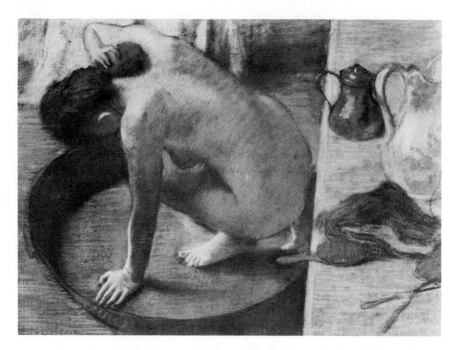

FIGURE 149.
Edgar Degas, Le Tub. 1886.
Louvre, Paris.

woman. The crouching figure is entirely enclosed by the tub but rises above that circular frame. The light, rushing in from the left, strengthens the lateral symmetry axis of the scene.

This lateral position of the main axis, which crosses the line of sight at right angles rather than coinciding with it, as it did, for example, in Figure 135, threatens to rupture the unitary space by which viewer and picture are commonly joined. We look into a detached world, to which it is difficult to gain access. There is a further reason for this detachment. Is the sagittal symmetry plane really vertical? We must take hold of the curtain in the background to assure ourselves that the gravitational framework is the one we share. So oblique is the view that we are in danger of seeing the vertical as tilted and thereby getting caught in one of those disorienting photographic deviations I mentioned earlier.

Much of this awkwardness is avoided when we perceive the picture in its projective version, which is favored by Degas's composition. Here the extent of the pictorial space is limited to the area left open by the frame. It is a space divided by the all but vertical edge that allots two-thirds to the bather,

one-third to the shelf. Everything has become tight and narrow. On top, the frame leaves barely enough room to show the raised arm, and below it skimpily accommodates the tub. On the right, the obtrusive shelf hardly allows the bottom of the woman and the rim of the tub to complete their curves. The figure breaks through the enclosing rim, but her face does not clear the enclosure. In the projection she enjoys none of the freedom that lets her rise above tub and shelf in "objective," unlimited space. In both versions she is curled around her center, but the projection fastens this center to that of the picture as a whole and thereby ties the figure down to a rather static, embryonic pose.

Hovering in the ambiguous realm between flatness and fully extended depth, the picture combines two mutually exclusive but complementary views. One of them, the "objective" view, presents the practical situation in the woman's bathroom. The other comments with insistent and subjective symbolism on the obstructions in the human condition. In combining the two, Degas's composition reflects the painter's way of making his world transmit a message without detracting from its reality.

THE BASIC COMPOSITIONAL SYSTEMS ONCE MORE

The two compositional systems that underlie our investigation are inherently at work in the examples I have analyzed in this chapter, but it may be useful to point out their role more explicitly. In the diagram that introduced our study (Figure 3) those systems were illustrated by two-dimensional patterns. It subsequently became evident, however, that they govern the objects and spaces of the third dimension as well. Objects such as the utensils in Chardin's still lifes are organized around their individual centers. They often show symmetry around a central axis, and the direction in which the symmetrical structure points derives its meaning from its relation to the gravitational framework of the Cartesian grid. An object may be stably upright or tilted toward some target in its surroundings.

The visual objects in a composition are like so many cosmic bodies attracting and repelling one another in space. If, as I have suggested, we think of the observer as one such center of forces, we conceive of the relation between the observer and the observed space as the interaction between two visual objects or "centers." Their structures either conform smoothly to each other or meet obliquely and thus create a more complex relation of higher tension. The central axis of the observed space may coincide with the observer's line of sight or run at cross-purposes to it.

Within a composition the visual objects may be relatively self-contained, but they may also surround one another as components of the same centric system. The basin surrounds the bather, and the walls of the room enclose the central scene. The room, in turn, can be coordinated with or subordinated to a larger setting and dwells ultimately in unlimited space, which threatens the object's defined location and thereby its meaning and function. The object risks being nowhere.

The threat of infinity also comes into play when we consider the interaction between the three-dimensional scene and its projection upon the frontal plane, which runs orthogonally to the viewer's line of sight. That plane, the original dwelling place of two-dimensional art, is framed in most cases and therefore defines the middle of the centric system quite firmly. Not so in the three-dimensional arena, of which the frontal plane becomes the projection. The confinements it offers are partial and provisional and leave the system's center, which depends upon them, in a precarious uncertainty. The three-dimensional aspect of a work shares this uncertainty with the "real," physical space it depicts.

The tentative nature of the three-dimensional center in relation to the firmly defined center of the projective plane is one aspect of the complex interaction between the three-dimensional and the two-dimensional views of the same work. We observed that, as a rule, the three-dimensional view represents the objective, "geographic" situation depicted in the work, whereas its projection profits from the freedom of a subjective perspective. The projection can offer symbolic interpretations of the scene by means of deformations and a whole new set of spatial relations for both the centric and the grid systems; but these modifications, being purely optical, leave the objective shapes and space un-touched. This is true for paintings, whose third dimension is purely visual, as well as for sculpture, buildings, or stage performances, which exist in physical space but whose projective images are what the observer sees.

PERSISTENCE IN TIME

AFTER EXTENDING our exploration into the dimension of depth, I shall conclude with a brief look at the fourth dimension. How do sequences in time affect the functioning of our two spatial systems in visual composition? What is the consequence of motion and change?

Since sequential action more often than not takes place in the horizontal plane, we must keep in mind that the dynamics which turns the Cartesian grid into a structure varies fundamentally, depending on whether the grid is oriented vertically or horizontally. In the vertical, the gravitational axis dominates the system. Its direction is unique and prescribed, and any deviation from it creates a special dynamic effect. In the horizontal plane, no direction is spatially privileged. But human beings limit their freedom of direction in horizontal space for two reasons: they prefer the straight line to any alternative course, and they construct right-angled grids because of the grids' perceptual simplicity. In spaces and objects of their own making, people often produce patterns and shapes to which the Cartesian grid applies a rational order.

What about the other spatial system—centricity? In daily life a person moves through the environment with himself as the persistent center. The environment arranges itself around this center in a constantly changing configuration. This most fundamental experience of centricity is modified by the fact that the viewer, the central node, is not symmetrical in all directions but oriented in one direction. The sagittal, bilateral symmetry of the body expresses itself visually in the line of sight. Thus the viewer experiences the world in relation to the axis sent out into space by his eyes.

This viewer-centered image, however, would be fatally misleading if it kept us from discovering the objective structure of the world we see before us. Only quite rarely is that structure centrical, as it would be, for example, if we wandered through a circular arena, finally to discover the one point at which its center coincides with ours. Even in that case, however, it would take a per-

ceptual effort to understand the relation between our own subjective centricity and the objective center of the setting.

More often the setting is organized according to a very different pattern. Buildings, for example, are usually designed on the basis of a right-angled grid, which means that a visitor's effort to bring his own centric conception of space into harmony with the structure of buildings resembles the analogous compositional problem we found to be typical of paintings. In buildings as in paintings, a centric system must come to terms with a right-angled grid.

The visitor explores a building by moving through it, that is, by constantly changing the relation of his own center to the structure of the setting. He tries to integrate the totality of the passing views he receives one after another and in doing so to construct the objective order around him. The precise sequence of views may be essentially irrelevant; it drops out of the final image in any case.

The more or less accidental path of such an exploration, however, must be distinguished from the sequence inherent in a building's design. The order in which various components of many a building are arranged is determined not only by their timeless simultaneity—the way the corners of a cube coexist in a timeless configuration—but by a particular sequence. Walking up the steps to a doorway, being received by the sudden expanse of the entrance hall, ascending a winding staircase, etc.—the visitor's progress can be as essential to a building's design as melodic sequence is to music. And there is, in a good building, a correspondence between the structure of the sequence in time and that of the organization in space. For example, when a sequence of spatial experiences leads to a climax at a distinguished place, say, the large reception room on the *piano nobile*, that same place will also be prominent in the "frozen" composition of the building.

When a visitor's route through a building accords with the building's design, he is rewarded by a pleasing sense of harmony. This correspondence between the structure's inherent sequence and the visitor's path, however, is not essential. It suffices for the visitor to perceive and understand the sequence. Once he has done so, he is aware of its presence and whether he is moving with it, against it, or across it.

In painting, the path of perusal is even more independent of the work's compositional vectors, notably the movement from left to right. Many recent recordings of eye movements have shown that viewers tend to concentrate on a picture's compositional high spots; but that the directions they choose for their exploration of the picture space are quite arbitrary. Only in few instances is a prescribed viewing sequence essential to a painting. The oriental picture scrolls come to mind. Even they, however, resemble architecture in the sense that what counts is the work in its spatial totality. The viewer, as he unrolls the

scroll, is aware of moving through a pre-existing entity. In this respect the picture scroll differs fundamentally from a reel of film. A motion picture exists only as a visual event on the screen. The ribbon in the projection machine is a purely technical implement, nonexistent in the perceptual experience of the viewer. Not so the picture scroll. The viewer is conscious of its presence in its entirety. His center of attention scans the continuous picture from right to left, giving each episode a moment of central importance, and building up the structure of the whole by accretion. He outruns the galloping horsemen and foot soldiers, passes between the posts of a wooden gate, plunges into the black smoke and flames of a conflagration, is caught in a crowd of paralyzed watchers, and is suddenly left in an empty landscape with the lone figure of the villainous court official who is fleeing the site of his wicked deed.

The experience is as sequential as listening to a piece of music, but the movement is that of the viewer, who performs actively in the time dimension. The event taking place consists in the exploration of a given spatial entity, unrolled at a speed controlled by the explorer. At each point in the presentation, a delimited section of the image establishes a center and thereby provides the scene with a compositional base. It shows, let us say, an empty expanse in which a dark figure on the lower right balances and faces the roof of a temple emerging from the upper left. But the scene is perceived as transitory. The temple is about to vanish to the right, and the figure will be left behind when the viewer moves beyond it to what follows it on the left. Thus each element's place and function is essentially a spatial one within the edifice of the total story and becomes temporal only through its encounter with the viewer's moving focus. There is no difference in principle between scrolls that tell a story and others that display the panorama of an extended landscape. The world of events is presented essentially as a state of being, into which time is introduced by the viewer's act of sequential witnessing.

A different situation obtains when the action comes about through changes in the perceived scene. Think of a sports event in which the ball is the center, moving back and forth across the field. To accommodate this moving center, the structure of the playing teams is continuously reorganized. This is a centralized system transforming itself over time. Here the viewer does not provide the center but is provided with one, to which he remains riveted, or, at the least, to which he must constantly relate his perception of the situation.

There need not be a central object like a ball. Take a chess game, for example. The two teams of chessmen, the active elements of the game, are arranged in accord with the Cartesian grid of the chessboard. Dynamically each piece is characterized by the nature of its potential action, just as in a painting each object is endowed visually with certain capacities by its shape, size, direction, etc. But whereas the elements in a painting are timelessly

balanced around their immobile center, the chess figures, through their moves, create nodes of action, which constantly change place and character. It is the changing configuration of those nodes that the players watch in order to understand what is going on, forecast the future, and decide on the next moves.

As distinguished from the balancing center of a painting, the middle of the chessboard wields no power. It does not exist dynamically because mere location has no dynamic effect in the game. The queen has no more and no less power when she is in the center than when she is in a corner, even though her spatial opportunities differ in the two places. The focal centers of the game are determined entirely by the interplay of the chessmen's inherent powers.

In the mobile arts, as distinguished from football or chess, the power of all components is defined by their visual properties, and therefore space exercises the same kind of influence I have illustrated by examples from painting, sculpture, and architecture. In film, particularly, the sharply outlined rectangle of the screen imposes its structural skeleton upon the photographed action. The screen determines the balancing center, the coordinates of vertical and horizontal, and the secondary axes of the diagonals. This is especially true when the image is strongly projective, that is, when depth is restricted and the frontal plane serves as the principal frame of reference. But even when the scene offers a compelling vista in depth, the borders of the screen determine the range of the action and influence the position of the center.

In the early years of film the camera was rooted in place and simply recorded what passed before its lens. This made the viewer a persistent witness, who observed events passively through the window of the screen. The situation has not changed substantially since the camera was set in motion. The seated viewer is informed by his body that he is at rest. Motion is therefore attributed to the setting through which the camera traveled when the film was taken. As a result, the film typically portrays not a world at standstill, through which the viewer moves together with the other performers, but a world drifting past an immobile observation post. The viewer's fixed station point eliminates the relativity of location and movement. The relation to that station point distinguishes what is far away and approaching from what is close and moving away; it determines what moves to the right and what moves to the left. Hence the difficulty of having the viewer really accept changes in camera angle that show different aspects of the same scene. Basically the viewer remains anchored to the same place.

The center of the screen image is much more closely tied to the viewer than that of a painting. The center of a painting is perceived as established by the painting itself. The viewer must acknowledge it and conform to it in order to grasp the structure of what he sees. The framed screen of the movie theater, on

the contrary, belongs not to the picture but to the viewer. Viewer and screen are as rigidly connected as the eyes are to a pair of field glasses, and the structural skeleton of the visual field is not the skeleton of the picture itself, but the reticle in the viewer's instrument. Like those crossed threads in a telescope or gunsight, the compositional framework is imposed by the viewer upon the passing scene, which during the moment of its visibility must conform to this imposed order to become readable.

Thus, with respect to space, the film is a most egocentric medium. It makes the viewer sit back inactively while the world and its changing contents move around and past him. With respect to time, however, the viewer need not remain a detached outsider. His seated body anchors him to a point in space but not to a moment in time. The sequence presented in the film can capture him so that he moves along with the story. He struggles and races with the actors, he is stopped by obstacles, he reaches the goal. In the time dimension, composition is not imposed upon the spectacle but is inherent in the spectacle's structure, and that structure imposes itself upon the viewer. Like the reader of a novel or the listener at a concert, the viewer is caught up in the course of events, which he perceives from the constantly changing vantage point of the present moment.

As we look back from the mobile arts to painting and sculpture, to which most of our attention has been directed, we see the latter as a special case, in which both the action performed and the viewer have been stopped in their tracks. In consequence, the two have lost much of their independence; they are fused into one unitary system. The structure inherent in the work and the structure imposed upon it as the condition for the work's visibility have come to coincide, making it pointless to ask how much of a painting's composition is due to its need to be seen and how much derives from the inherent requirements of the represented object. This distinguishes a painting or sculpture from a work of choreography, a constellation of forces that unfolds in sequence, organizing itself around its own inherent structural centers. Only at the moment of its exposure to public view is a segment of the constellation of the dance submitted to the conditions of projective visibility. But whatever can be seen of a work of painting or sculpture belongs to its own objective structure, and visibility is a property belonging to it all. The viewer and the viewed have attained an easy functional unity, for which visual experience elsewhere would struggle in vain.

It is time for a last and broader look at the two protagonists of the foregoing study, the viewer of a work of art and the object of his attention, as they meet in space.

The viewer is persuaded by his senses that he occupies the center of the world around him—a world he changes at will as he moves through it. It is a hierarchic world, filled in concentric layers with some things that are close by and of immediate importance, others that remain intangibly remote. Even without using his limbs to act upon the world, the viewer penetrates it with his eyes, touching the objects he experiences as targets and as obstacles, that is, as things to reach and things that block his path. There is an interchange of visual forces; the objects act as generators, sending out the effects of their visual weight, whereas the viewer's glance moves outward, bouncing back from whatever it meets, running through openings and passages, digging into cavities and vistas. Sensory exploration is a constant effort of expansion and conquest, from the center outward.

Although the viewer's centric world is subjective and seriously onesided, it is a genuine example of the kind of structure that comes about when, as I said in the beginning of this book, systems are left alone, free to organize according to their inherent disposition. We saw how works of sculpture or architecture cluster around their hidden centers, from which their influences issue into the environment. We saw pictures compose their matter around the center of the frontal plane or around that of pictorial space in depth, and we watched the complex statements that emerge from the interaction of those two centers. There were also the even more intricate relations between the system controlled by the visual center within the viewer and that holding the weight of the work.

Centers of visual energy may send out their vectors in all directions at once, or they may concentrate their activity on only one of those directions. In addition, however, they can be subject to attraction by other such centers, which subjects them to the framework of the straight line. This framework, the grid of verticals and horizontals, has no center of its own but defines the locations of such centers and the directions of their linear interrelations. The integration of the two systems, so characteristic of the spatial behavior of human beings and other organisms, enables the composition of works of art to carry out their task of reflecting the nature of human experience: it shows the forces that constitute life organizing themselves around their own center with all their self-contained perfection, even as they struggle with the outer powers that pull and push from their own centers. It is this interplay of harmony and drama that our look at the two spatial systems has helped us to understand.

GLOSSARY

ANCHORING. A visual object's dependence on a base whose forces influence the object's dynamics. For example, visual weight can be affected by a center of attraction to which the object is anchored.

ANISOTROPISM. The asymmetry of gravitational space, by which the nature and behavior of perceptual objects change with their location and the direction of the forces they emit and receive.

ART. The ability of perceptual objects or actions, either natural or man-made, to represent, through their appearance, constellations of forces that reflect relevant aspects of the dynamics of human experience. A work of art is a human artifact intended to represent such dynamic aspects by means of ordered, balanced, concentrated form.

BALANCE. The dynamic state in which the forces constituting a visual configuration compensate for one another. The mutual neutralization of directed tensions produces an effect of immobility at the *balancing center*.

CARTESIAN COORDINATES. A framework of two axes on a flat surface or three axes in three-dimensional space. Centrally placed and meeting at right angles, the coordinates can serve as a frame of reference for the location of objects in visual composition. Dynamically, these axes cross at the balancing center of the composition and also serve as bases for visual forces. Locations on the axes possess a maximum of visual balance.

CARTESIAN GRID. A system of straight lines meeting at right angles, either on a two-dimensional surface or in three-dimensional space.

CENTER. Geometrically, the center is defined purely by location as the point equidistant from all homologous points of a regular figure. Physically, the center is the fulcrum around which an object balances. Perceptually, the *balancing center* is the point at which all the vectors constituting a visual pattern are in equilibrium. In a broader sense and irrespective of location, any visual object constitutes a *dynamic center* because it is the seat of forces issuing from it and converging toward it.

CENTRIC SYSTEM. A system organized around a center, either two-dimensionally or three-dimensionally.

COMPOSITION. An arrangement of visual elements creating a self-contained, balanced whole, which is structured in such a way that the configuration of forces

reflects the meaning of the artistic statement. Composition of shape concerns the arrangement of elements in two- or three-dimensional space; composition of color is based on syntactic relations such as similarity, complementarity, and contrast, as well as the relations between primary and secondary hues.

CONSTANCY. The degree to which objects of the physical world are seen as possessing the same shape and size they have physically. Objective space (q.v.) has 100 percent constancy, whereas projective space (q.v.) has none. Actual visual experiences have an intermediate degree of constancy.

DEVIATION. Shapes or directions are often perceived as deviations from a norm. Certain ellipses appear as deviations from the circle. Slanted lines may be seen as striving toward, or straining away from, the base of reference. Deviation is a principal source of visual dynamics (q.v.).

DISPLACEMENT. The visual location of the center point or a central axis may deviate from its geometrical location. This happens, for example, when a mass or column or a dividing line usurps the function of a neighboring central axis, or when the components of a pattern balance around a point somewhat off the geometrical center.

DYNAMICS. The directed tension perceived in visual objects. The carriers of dynamics are vectors (q.v.).

EXPRESSION. The ability of visual dynamics to represent the dynamics of states of being through the attributes of shape, color, and movement. Expression makes it possible for works of art to act as statements or propositions.

FIELD. The reach of a system of forces. With increasing distance from the generating centers, a field is reduced to empty space.

FIGURE AND GROUND. The distinction between perceptual objects and the space surrounding them. A figure is generally observed as lying in front of an uninterrupted ground—the most elementary representation of depth in drawing and painting. Dynamically, the figures and the "negative spaces" of the ground are centers of forces that keep one another in balance.

FORCES. See Vectors.

FORMAT. The shape and spatial orientation of a framed picture, particularly the difference between an upright and a transverse rectangle. The ratio between height and width determines the format.

GESTALT. A field whose forces are organized in a self-contained, balanced whole. In a gestalt, components interact to such an extent that changes in the whole influence the nature of the parts, and vice versa.

HEMISPHERIC SPECIALIZATION. The difference in the psychological functions performed by each of the hemispheres of the cerebrum. Broadly speaking, it seems that more of the linear functions are fulfilled by the nerve centers in the left hemisphere, whereas spatial synopsis is effected mainly by those of the right hemisphere. The synthesis of these abilities makes for a properly operating mind, in the arts and elsewhere.

HIERARCHY. A scale of power, weight, or importance created visually by perceptual gradients. The height at which an object is placed, size, distance from the viewer, etc., are factors determining the position of a component on the hierarchic scale.

HORIZONTAL. The direction at right angles to the vertical (q.v.). Oriented symmetrically in relation to the pull of gravity, the horizontal provides the most balanced location. It coordinates rather than subordinates objects. The central horizontal

serves as one of the Cartesian coordinates (q.v.). The point at which it crosses the central vertical defines the balancing center. As dividing lines, horizontals distinguish the upper from the lower areas of compositions.

IMAGINATION. A term commonly used to describe the mind's ability to create images of things not supplied by direct perceptual stimulation or to complete incompletely given percepts. In the arts, imagination is the ability to present objects, behavior, or ideas by the invention of strikingly appropriate form.

INDUCTION. A visual object may come about entirely through the dynamic effects issuing from its environment. The center of a circle or rectangle functions as a visual object even when it is not marked by any optical stimulus. An induced visual feature generates visual dynamics just as an explicitly given shape does.

INTUITIVE JUDGMENT. The evaluation of relations on the basis of the perceptual sense of balance and structural order, as distinguished from evaluation by measurement or other defined standards.

INVERTED PERSPECTIVE. The erroneous notion that the technique of making the sidefaces of objects converge, rather than diverge, toward the front is a variation of the principle of central perspective. Actually, this device of making sidefaces visible is used mostly by artists unaware of central perspective.

LATCH. A shape or other visual feature reaching beyond a central line to counteract the division. In Figure 60 the space continuing behind the frontal column provides such a connection between the two halves of the composition.

MICROTHEME. A small, highly abstracted version of a painting's subject. Usually located near the center of the composition, the microtheme is often acted out by a pantomime of hands.

NODES. Places of structural density, obtained through the concentration and intertwining of vectors. The nodes and their interrelations constitute the basic skeleton of a composition.

NONMIMETIC ART. One of several terms applied to works of art that do not depict objects as found in nature. Other adjectives used for the purpose are abstract, concrete, nonrepresentational—none truly satisfactory.

OBJECT. A visual object is a segregated entity perceived as part of a visual pattern.

OBJECTIVE SPACE. In representational art the theoretical case in which an array of objects is seen as having exactly the same distances and sizes they have in physical space. In practice, the effect of objective space is never obtained.

PERSPECTIVE. A means of projectively representing three-dimensional objects on a flat surface. Perspective creates visual depth by modifying the shape and spatial interrelation of objects through superposition, deformation, change of size, etc. *Central perspective* imitates some of the attributes of optical projection by a geometrical construct that makes some systems of objectively parallel edges or lines converge in vanishing points. A single vanishing point is used in one-point perspective, whereas in two-point perspective two sheaves of parallels converge each to its own vanishing point. In principle, an unlimited number of vanishing points is available because parallels can converge toward any location in pictorial space.

PISTON EFFECT. A dynamic effect produced when a compositional shape pushes beyond the boundary set by the central vertical or horizontal. In Figure 71, for example, a white area pushes beyond the center and compresses the dark area. Expansion and compression are the dynamic consequences of such transgression.

PRIMARY COLORS. The three fundamental primaries are the pure, unmixed colors red, yellow, and blue. This triad is the basis of all compositional color relations, obtained by mixture, contrast, similarity, and complementarity.

PROJECTION. An optical image brought about on a surface by the light rays reflected from an array of objects in three-dimensional space. *Projective space* is the theoretical case in which a visual array would be seen as completely flat, that is, in total accord with its optical projection. The effect of projective space is never obtained in practice.

RETINAL PRESENCE. A term applied to visual objects that are represented in the visual field, by actual stimuli of shape, color, or movement as distinguished from those brought about merely by induction (q.v.).

RUBBER BAND EFFECT. The strengthening of dynamic pull with increasing distance of a visual object from the base of attraction to which it is anchored. The resistance to this pull adds to the object's visual weight.

SELF. A viewer's awareness of his location in space and the direction of his activity. Although outside the reach of the work of art, the position of the self determines the spatial aspect of three-dimensional works and is accommodated to by two-dimensional ones. The self acts as a center of forces in the field (q.v.) that comprises the viewer and the work of art.

SPACE. The medium constituted by the totality of shape, color, and movement relations. Every visual experience involves all three dimensions of space. The perception of flatness is the limiting case in which depth, the third dimension, is at a minimum. *Pictorial space* has the degree of depth yielded by projection (q.v.). Laterally, pictorial space may be confined by a frame or extend somewhat behind and beyond that frame.

SPELLING OUT. The actual representation of structural features by means of stimulus material, e.g., a black spot marking a center or a wall marking a partition.

STATION POINT. The location of the viewer's eyes in physical space. The station point appropriate for the viewing of a painting lies in the sagittal plane that runs through the geometrical center of the painting. The optically correct station point for a system of one-point perspective is located opposite the vanishing point at a prescribed distance from the picture.

STRUCTURE. A configuration of forces, as distinguished from a pattern of mere shapes, devoid of dynamics. Art or engineering is concerned with structure; geometry is not.

SYMBOLS. The visual interpretation of a more abstract subject through the translation of the subject's dynamic features into attributes of shape, color, and movement. Symbols should be distinguished from mere *signs*, which are conventional shapes, colors, actions, or objects designated to transmit standardized messages.

SYMMETRY. The "exact correspondence of form and constituent configuration on opposite sides of a dividing line or plane or about a center or axis" (*American Heritage Dictionary*). A vertical axis produces more compelling visual symmetry than a horizontal axis.

VECTORS. Forces generated by the shapes and configurations of visual objects. A vector is characterized by its magnitude, direction, and base of attack. Visual vectors are seen as oriented in both directions unless a special base determines the origin of

the vector's attack and thereby its direction. Not all vectors are supported by explicit retinal presence (q.v.). The direction of the glance, for example, is not.

WEIGHT. Physically and kinesthetically, weight is the effect of gravitational attraction. Visually, weight is the dynamic power inherent in an object by virtue of its conspicuousness, size, shape, location, etc.

BIBLIOGRAPHY

1. Albers, Josef. Bilder. Catalogue of the Hamburger Kunsthalle. 1970.
2. ___.The interaction of colors. New Haven, Conn.: Yale University Press, 1963.
3. Arnheim, Rudolf. Accident and the necessity of art. *In* (12), pp. 162–180.
4. ___.Art and visual perception: a psychology of the creative eye. The new version. Berkeley and Los Angeles: University of California Press, 1974.
5. ___.The dynamics of architectural form. Berkeley and Los Angeles: University of California Press, 1977.
6. ___.Entropy and art. Berkeley and Los Angeles: University of California Press, 1971.
7. ___.Inverted perspective in art: display and expression. *Leonardo*, 1972, vol. 5, pp. 125–135.
8. ___.The perception of maps. *American Cartographer*, 1976, vol. 3, pp. 5–10.
9. ___.Perception of perspective pictorial space from different viewing points. *Leonardo*, 1977, vol. 10, pp. 283–288.
10. ___.A review of proportion. *In* (12), pp. 102–119.
11. ___.Spatial aspects of graphological expression. *Visible Language*, Spring 1978, vol. 12, pp. 163–169.
12. ___.Toward a psychology of art. Berkeley and Los Angeles: University of California Press, 1972.
13. ___.Visual thinking. Berkeley and Los Angeles: University of California Press, 1969.
14. Blotkamp, Carel. Mondrian's first diamond compositions. *Art Forum*, Dec. 1979, vol. 18, pp. 33–39.
15. Brecht, Bert. Kleines Organon für das Theater. *In* Schriften zum Theater. Frankfurt: Suhrkamp, 1957.
16. Broude, Norma. Degas's "misogyny." *Art Bulletin*, March 1977, vol. 59, pp. 95–107.
17. Brunius, Teddy. Inside and outside the frame of a work of art. *In* Nils Gösta Sandblad, ed., Idea and form: studies in the history of art. Stockholm: Almquist and Wiksell, 1959, pp. 1–23.
18. Burckhardt, Jacob. Format und Bild. *In* Burckhardt, Vorträge. Basel: Schwabe, 1918, pp. 312–323.
19. Cailleux, Jean. Eloge de l'ovale: Peintures et pastels du XVIIIe siècle français. Paris: Cailleux, 1975.

20. Carmean, E. A., Jr. Mondrian: the diamond compositions. Washington, D. C.: National Gallery, 1979.
21. Chamberlain, Harriet F. The influence of Galileo on Bernini's "Saint Mary Magdalen" and "Saint Jerome." *Art Bulletin*, March 1977, vol. 59, pp. 71–84.
22. Coomaraswamy, A. K. The iconography of Dürer's knots and Leonardo's concatenation. *Art Quarterly*, 1944, vol. 7, pp. 109–128.
23. Corballis, Michael C. Laterality and myth. *American Psychologist*, March 1980, vol. 35, pp. 284–295.
24. Duncker, Karl. Ueber induzierte Bewegung. *Psychologische Forschung*, 1929, vol. 12, pp. 181–259. Engl. summary in Ellis (25), pp. 161–172.
25. Ellis, Willis D. A source book of gestalt psychology. New York: Harcourt Brace, 1939.
26. Fechner, Gustav Theodor. Zur experimentalen Aesthetik. Abhandl. der Sächs. Ges. der Wiss., XIV. Leipzig: Hirzel, 1871.
27. ____.Vorschule der Aesthetik. Leipzig: Breitkopf & Härtel, 1925.
28. Ferguson, George. Signs and symbols in Christian art. London: Oxford University Press, 1954.
29. Fuller, R. Buckminster. Centrality of fundamental structures. *In* Gyorgy Kepes, ed., Structure in art and in science. New York: Braziller, 1965.
30. Füssel, Stephan. Mnemosyne. Göttingen: Gratia, 1979.
31. Gelb, Adhémar. Zur medizinischen Psychologie und philosophischen Anthropologie. Darmstadt: Wiss. Buchgesellschaft, 1969.
32. Van Gogh, Vincent. Complete Letters. Greenwich, Conn.: New York Graphic Society, 1959.
33. Gombrich, E. H. The sense of order. Ithaca, N.Y.: Cornell University Press, 1979.
34. Hauptmann, Moritz. Der Tondo. Frankfurt a/M.: Klostermann, 1936.
35. Hayashi, Mikio. On the compositions of Emakimono scrolls. *Hiroshima Forum for Psychology*, 1977, vol. 4, pp. 3–7.
36. Kauffmann, Hans. Rembrandts Bildgestaltung, ein Beitrag zur Analyse seines Stils. Stuttgart: Kohlhammer, 1922.
37. Kemp, Wolfgang. Foto-Essays zur Geschichte und Theorie der Fotografie. Munich: Schirmer/Mosel, 1978.
38. Kitao, Timothy K. Circle and oval in the square of St. Peter's. New York : New York University Press, 1974.
39. Klee, Paul. Unendliche Naturgeschichte. Basel: Schwabe, 1970. Engl.: The nature of nature. New York: Wittenborn, 1973.
40. Knott, Robert. Paul Klee and the mystic center. *Art Journal*, Winter 1978–79, vol. 38, pp. 114–118.
41. Krauss, Elaine. The dynamics of the tondo. Ann Arbor: Senior thesis, University of Michigan, 1977.
42. Lynch, Kevin. The image of the city. Cambridge, Mass.: MIT Press, 1960.
43. Neumeyer, Alfred. Der Blick aus dem Bilde. Berlin: Mann, 1964.
44. Nochlin, Linda. Realism. Harmondsworth, Eng.: Pelican, 1971.
45. Panofsky, Erwin. Galileo as a critic of the arts. The Hague: Nijhoff, 1954.
46. ____.Renaissance and renascences in Western art. New York : Harper & Row, 1960.
47. Pérouse de Montclos, Jean-Marie. Etienne-Louis Boullée. New York: Braziller, 1974.

48. Portoghesi, Paolo. Le inibizioni dell'architettura moderna. Rome: Laterza, 1974.
49. Reinle, Adolf. Zeichensprache der Architektur. Zurich: Artemis, 1976.
50. Saunders, E. Dade. Mudra, a study of symbolic gestures in Japanese Buddhist sculpture. New York: Bollingen, 1960.
51. Schapiro, Meyer. Modern art: 19th and 20th centuries. New York: Braziller, 1978.
52. Schöne, Wolfgang. Zur Bedeutung der Schrägsicht für die Deckenmalerei des Barock. Festschrift Kurt Badt. Berlin: De Gruyter, 1961.
53. Seitz, William C. The responsive eye. New York: Museum of Modern Art, 1965.
54. Shafdie, Moshe. Beyond Habitat. Cambridge, Mass.: MIT Press, 1970.
55. Simson, Otto von. The Gothic cathedral. Princeton, N.J.: Princeton University Press, 1956.
56. Sjöström, Ingrid. Quadratura: studies in Italian ceiling painting. Stockholm Studies in the History of Art, # 30. Stockholm: Almquist & Wiksell, 1978.
57. Steinberg, Leo. Leonardo's "Last Supper." *Art Quarterly*, Winter 1973, vol. 36, pp. 297-410.
58. Summers, David. Contrapposto. Style and meaning in Renaissance art. *Art Bulletin*, Sept. 1977, vol. 59, pp. 336-361.
59. ____.Figure come fratelli: a transformation of symmetry in Renaissance painting. *Art Quarterly*, Autumn 1977, vol. 1, #1, pp. 59-88.
60. ____.Maniera and movement: the figura serpentinata. *Art Quarterly*, 1972, vol. 35, pp. 269-301.
61. Uspensky, Boris. A poetics of composition. Berkeley and Los Angeles: University of California Press, 1973.
62. Volk, Mary Crawford. On Velásquez and the liberal arts. *Art Bulletin*, March 1978, vol. 60, pp. 69-86.
63. Webster, T. B. L. Tondo composition in Archaic and Classical Greek art. *Journal of Hellenic Studies*, vol. 59, 1939, pp. 103-123.
64. Welsh, Robert. The place of "Composition 12 with Small Blue Square" in the art of Piet Mondrian. Ottawa: National Gallery of Canada, 1977.
65. White, John. The birth and rebirth of pictorial space. London: Faber & Faber, 1957.
66. Wittkower, Rudolf. Architectural principles in the age of humanism. New York: Random House, 1962.
67. Zevi, Bruno. Il linguaggio moderno dell'architettura. Turin: Einaudi, 1973. Engl.: The modern language of architecture. Seattle: University of Washington Press, 1978.

ACKNOWLEDGMENTS

The author is indebted to:

Mrs. Karin Einaudi of the Fototeca Unione, Rome, for her help in obtaining photographs.

Mr. John Gay, for his photograph of Troyes, Fig. 86.

Mr. Christian Heck, conservator of the Musée d'Unterlinden for photos of Grünewald's *Crucifixion*, Fig. 122.

Mme. Dominique de Menil, for a photograph of Newman's *Broken Obelisk*, Fig. 21.

Mr. Ben Nicholson, for permission to reproduce his relief, Fig. 96.

Messrs. Schwabe & Co. Verlag, Basle, for permission to use a drawing by Paul Klee, Fig. 2.

Prof. Hann Trier, Cologne, for the photograph of his baldachin, Fig. 10.

De Vrienden Van Sint Pieterskerk, for slides of Dieric Bouts's triptych, Figs. 135 and 144.

INDEX

Abstract Expressionists, 93
Abstract painting, 71, 130, 154
Albers, Josef, 145
Anchoring, 22, 38, 49, 215
Angelico, Fra, 87, 169
Anisotropic space, 10, 36, 140, 145, 215
Attraction, 23. *See also* Gravity

Background and foreground, 184, 185
Balance. *See* Equilibrium
Balancing center, 5
Barlach, Ernst, 169, 172
Barthes, Roland, 92
Bellini, Giovanni, 104
Bernini, Gian Lorenzo, 29, 134
Blotkamp, Carel, 151
Bosch, Hieronymus, 189, 198
Botticelli, Sandro, 115, 122, 125, 126
Boucher, François, 135, 136, 137
Boullée, Etienne-Louis, 132
Boundaries, 42
Bouts, Dieric, 186, 194, 198
Braque, Georges, 173
Brecht, Bertolt, 169
Bruegel, Pieter, 75, 93, 155, 199
Brunius, Teddy, 57
Buddha, Kamakura, 50
Buddhist painting, 14
Burckhardt, Jacob, 122, 129
Butler, Reg, 31
Byzantine art, 14, 73

Caduceus, 80
Cailleux, Jean, 137
Canova, Antonio, 29, 50
Capitol Square, Rome, 13
Caravaggio, Michelangelo, 77, 97, 157
Cassatt, Mary, 202
Cassirer, Ernst, 136
Ceiling painting, 17

Centric system, vii, 215
Cézanne, Paul, 93, 96, 155, 173, 205
Chardin, Jean Baptiste Siméon, 155, 172, 207
Charlier, Jacques, 137
Chess game, 211
Choreography, 14
Chuang Tzu, 87
Cimabue, Giovanni, 202
Circle, Chapter VI *passim*
Cleve, Joos van, 198
Cologne town hall, 18
Color, 78, 103, 112, 147, 148
Column, 21
Compression, 204
Configuration, 41
Constancy of size and shape, 182, 216
Constructivism, 130
Contraction, 158, 160, 171, 204
Contrapposto, 81
Convergence, 158
Cortona, Pietro da, 17
Cosmic system, vii
Courbet, Gustave, 161
Cranach, Lucas, 108
Crossings, 157

Daumier, Honoré, 99
David, Jacques-Louis, 107, 108, 158, 163
Degas, Edgar, 57, 58, 91, 157, 158, 177, 178, 181, 183, 185, 194, 195, 197, 205
Della Robbia, Luca, 115
Depth, 37, 146, 158, Chapter VIII *passim*
Descartes, René, viii
Deschi da parto, 115
Diagonals, 106, 145, 151
Diamond, 59
Diatonic music, 93
Dinesen, Isak, 102
Dioscuri, 44

225

Distance, 24, 202
Doors, 54
Duncker, Karl, 22
Duris, 119, 122

Egocentrism, 4
Ellipse, 135
Enclosure, 177, 186, 189, 206
Equilibrium, 6, 64, 71, 78, 92, 153, 215
Expansion, 160, 171
Eyck, Hubert and Jan van, 52, 198
Eye movements, 37, 210

Faces, 162
Fechner, Gustav Theodor, 60
Ferguson, George, 117
Figure and ground, 55, 56, 150, 184, 216
Film, 211, 212
Floor painting, 13
Foreground and background, 184, 185
Formats, 60, 216. *See also* Frame
Fouquet, Jean, 190
Fragmentation, 57
Frame, 36, Chapter III *passim*, 117, 150,
 Chapter VI *passim*, 178; rectangular, 53
Fuller, Buckminster, 132

Galla Placidia, Mausoleum of, 159
Gauguin, Paul, 105
Gentileschi, Orazio, 75
Gestalt, 216
Giotto di Bondone, 84
Gogh, Vincent van, 130, 191, 205
Gombrich, E. H., 54
Goya, Francisco de, 99
Gravity, 1, 10, 20, 132, 145, 148, 153, 164,
 197
Greco, El, 78, 84
Greek cross, 12, 134
Greek cups, 119
Grid, Cartesian, viii, 215
Guggenheim Museum, 50

Hands, 162, 164
Hemispheric specialization, 216
Hering illusion, 191, 194
Hierarchy, 127, 187, 201, 216
Hofer, Carl, 177
Hogarth, William, 84
Holbein, Hans, 56
Horizontality, 11, 13, 60, 96, 102, 209, 216
Human figure, 29, 98, 135, 158, 159, 164

Induction, 3, 58, 217
Ingres, Jean Auguste Dominique, 73
Intelligence, 114
Isidor of Seville, 122

Kallai, Ernst, 197
Kauffmann, Hans, 72
Kemp, Wolfgang, 195
Kinesthesis, 10
Klee, Paul, vii, 99
Kline, Franz, 71, 92
Knots, 157

Lachaise, Gaston, 29
Latch, 87, 217
Latin cross, 12, 134
La Tour, Georges de, 91
Left to right, 37, 40, 107
Leonardo da Vinci, 43, 67, 69, 185, 187
Lincoln Memorial, Washington, 50
Line of beauty, 84
Lissitzky, El, 130, 159
Lorenzetti, Ambrogio, 185
Lynch, Kevin, 157

Madonna and child, 122, 123, 125
Maillol, Aristide, 8
Mandala, 117
Manet, Edouard, 89, 158, 160, 204
Manfredi, Bartolomeo, 93, 96
Maps, 20, 122
Marini, Marino, 32
Masaccio, Tommasio, 115, 122
Matisse, Henri, 38, 55, 59, 93, 172, 173, 205
Michelangelo, 29, 45, 49, 50, 62, 73, 80, 83,
 105, 123, 128, 129, 130, 153, 167
Microtheme, 94, 120, 122, 125, 145, 167,
 217
Moholy-Nagy, Laszlo, 130
Mondrian, Piet, 56, 59, 145, 148, 155
Monet, Claude, 57, 64, 67, 150
Moore, Henry, 172, 173
Moreau, Gustave, 155
Motion, Chapter IX *passim*
Mudra, 167
Munch, Edvard, 102, 151, 153, 160, 205
Murasaki Shikibu, 180

Newman, Barnett, 34
Nicholson, Ben, 130
Niobe's daughter, 63
Nodes, 155, 176, 217
Noguchi, Isamu, 180
Noh stage, 108
Notre Dame, Paris, 7, 27, 131

Optical art, 129
Order, 174
Oval, 135
Ovato tondo, 135

Palazzo Vecchio, Florence, 25

Palladio, Andrea, 61
Panofsky, Erwin, 185
Pantheon, Rome, 66, 85
Perspective, 185, 195, 217; central, 66, 184, 186; inverted, 51, 217; isometric, 186, 195
Photography, 195, 197
Picasso, Pablo, 85, 90, 98, 162, 173
Piero della Francesca, 141, 143
Piranesi, Giovanni Battista, 204
Piston effect, 99, 131, 217
Plato, 136
Pollock, Jackson, 155
Polyclitus, 81
Poussin, Nicolas, 52, 204, 205
Pozzo, Andrea, 17
Projection, 66, 172, 181, 198, 218

Quadro riportato, 17

Raphael, 123, 129, 140, 144, 145, 175
Reims, Cathedral of, 131
Reinle, Adolf, 131
Rembrandt, 72, 78, 80, 158
Retinal presence, 3, 58, 218
Rodchenko, Alexander, 130, 195
Rubber band effect, 24, 25, 38, 218
Russell, John, 173

Safdie, Moshe, 180
St. Peter's, Rome, 134
St. Peter's, Toscanella, 27, 132
San Apollinare Nuovo, Ravenna, 43
San Ignazio, Rome, 17
San Vitale, Ravenna, 14
San Zeno Maggiore, Verona, 132
Santa Maria delle Grazie, Milan, 69
Sassetta, Stefano, 193
Schapiro, Meyer, 56
Schöne, Wolfgang, 17
Scroll paintings, 55, 210
Seitz, William C., 129
Sekine, Nobuo, frontispiece
Sequence, 210
Serpentine figure, 83, 84
Seurat, Georges, 55, 57, 109
Side view, 14, 189
Similarity, 40
Square, 53, 59, 139, Chapter VI *passim*
Stability, 72, 141

Stereoscopic vision, 182
Still lifes, 172
Structure, 41, 218
Substitution, 87
Summers, David, 83
Superposition, 157
Suprematism, 130
Symmetry, 73, 80, 98, 139, 187, 218

Temple of Vesta, Rome, 21
Tension, 96, 155
Theater stage, 13, 108
Theme, 153, 154, 173
Time, 193, Chapter IX *passim*
Tintoretto, Jacopo, 67, 68, 89, 157, 201, 204
Titian, 49, 50, 103, 112, 114, 202
Tondo, 52, Chapter VI *passim*
Torso of the Belvedere, 159
Toulouse-Lautrec, Henri de, 57, 58, 202
Trier, Hann, 18

Uspensky, Boris, 52
Utamaro, Kitagawa, 181, 186

Vectors, 154, 218
Velázquez, Diego, 46
Venus pudica, 160
Vermeer, Johannes, 100
Verticality, 12, 60, 78, 96, 127, 187, 209
Viewer, 12, 36, 49, 65, 69, 184, 194, 209, 212
Vista, 185, 194
Vitruvian figure, 98
Volumes, Chapter VII *passim*

Warburg, Aby, 136
Washington, D.C., 134
Watteau, Antoine, 193, 194
Webster, T. B. L., 119, 120
Weight, 10, 21, 38, 153, 219
Welsh, Robert, 149
Wheel window, 27, 85, 119, 131
White, John, 190, 193
Windows, 54
Wittkower, Rudolf, 134
World's fairs, 132
Wright, Frank Lloyd, 50

Zevi, Bruno, 92

Designer: Al Burkhardt
Compositor: Dharma Press
Printer: Vail-Ballou Press, Inc.
Binder: Vail-Ballou Press, Inc.
Text: 10/13 Plantin
Display: Plantin